PURE STYLE

HOME & GARDEN

PURE STYLE
HOME & GARDEN

JANE CUMBERBATCH

WITH PHOTOGRAPHY BY **HENRY BOURNE AND PIA TRYDE**

RYLAND
PETERS
& SMALL

LONDON NEW YORK

For original Editions
Creative Director **Jacqui Small**
Editorial Director **Anne Ryland**
Art Editor **Penny Stock**
Senior Editor **Sian Parkhouse**
Editors **Zia Mattocks & Sophie Pearse**
Production **Kate Mackillop**
 & Vincent Smith
DTP Manager **Caroline Wollen**
Stylist **Jane Cumberbatch**
Assistant Stylist **Fiona Craig-McFeely**
Assistant Stylist **Alice Douglas**
For this edition
Designer **Paul Tilby**
Senior editor **Catherine Osborne**
Production **Gordana Simakovic**
Art Director **Leslie Harrington**
Publishing Director **Alison Starling**

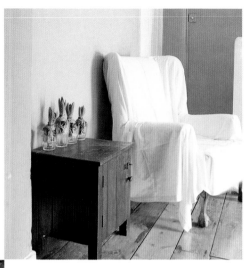

First published as *Pure Style* and *Pure Style Outside*. This
combined edition first published in the United Kingdom
in 2008 by Ryland Peters & Small
20–21 Jockey's Fields, London WC1R 4BW
and
First published in the United States
in 2008 by Ryland Peters & Small Inc.
519 Broadway, 5th Floor
New York, NY 10012
www.rylandpeters.com

10 9 8 7 6 5 4 3 2 1

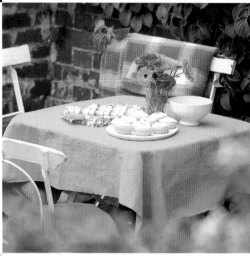

ISBN: 978-1-84597-754-2

Printed in China

A CIP record for this book is available from the
British Library.

Library of Congress Cataloging-in-Publication Data has
been applied for.

Text copyright © Jane Cumberbatch 1996, 1998, 2008.
Design and photographs copyright © Ryland Peters & Small
1996, 1998, 2008.

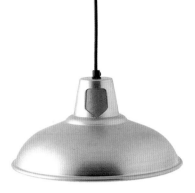

Contents

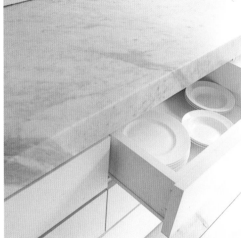

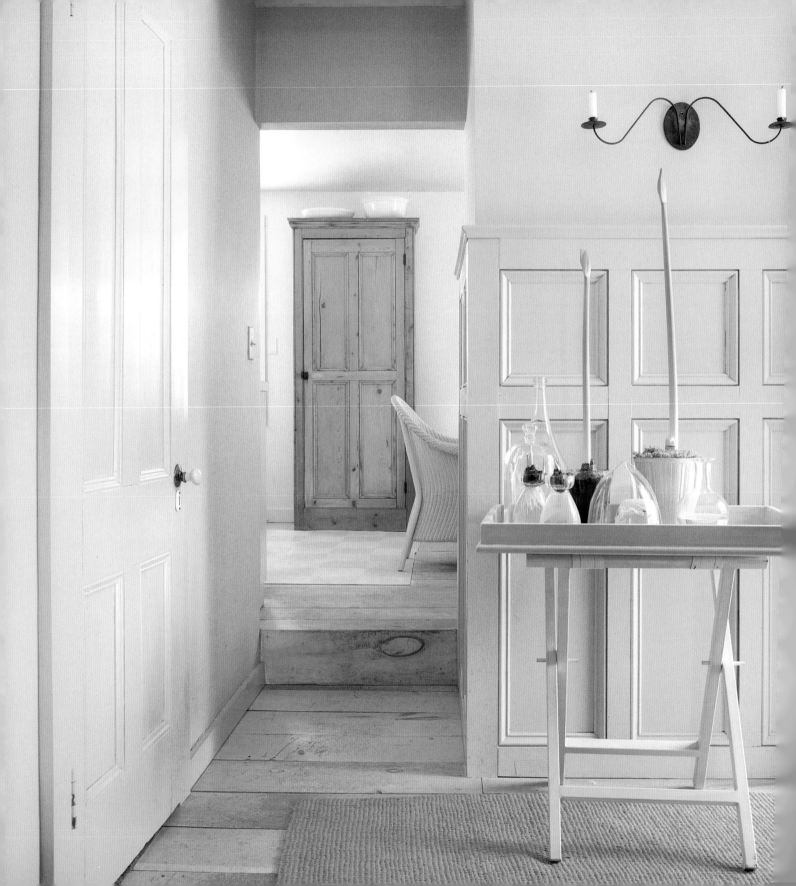

INTRODUCTION

PURE STYLE HOME: INNOVATIVE IDEAS FOR CRISP, CLEAN, CONTEMPORARY LIVING.

Pure Style Home is not just about rooms and furnishings, or about trying to achieve an impossibly perfect glossy lifestyle – Pure Style Home is about trying to achieve a balance. It's about making life luxurious, not in a costly, glitzy sense, but in a more matter-of-fact, practical and natural way. Pure Style Home is about paring down and trying to live with less clutter (the fewer things we have to fuss about, the more we can get on with living). It's about simple, basic design that combines function and beauty of form – crisp, clean, classic and timeless.

Pure Style Garden is not about daunting Latin names, impossible planting schemes, trendy plant varieties and grand ideas for outdoor furniture.

PURE STYLE GARDEN: NEW IDEAS FOR SIMPLE, STYLISH OUTDOOR LIVING.

It is about making the best of your outside space – however small – whether it is a balcony, a vegetable patch or a back yard. Pure Style Garden is about being practical, using functional but pleasing tools in a stylish, simple way, and looking at resourceful solutions for making your outside area as colourful, textural, sensuous, and as pleasing to be in as any room inside your home.

Pure Style Garden is about colour: the shades that appear in nature, such as sky blues, rose pinks, sunflower yellows and cabbage greens, and the decorative ideas which will work well with these

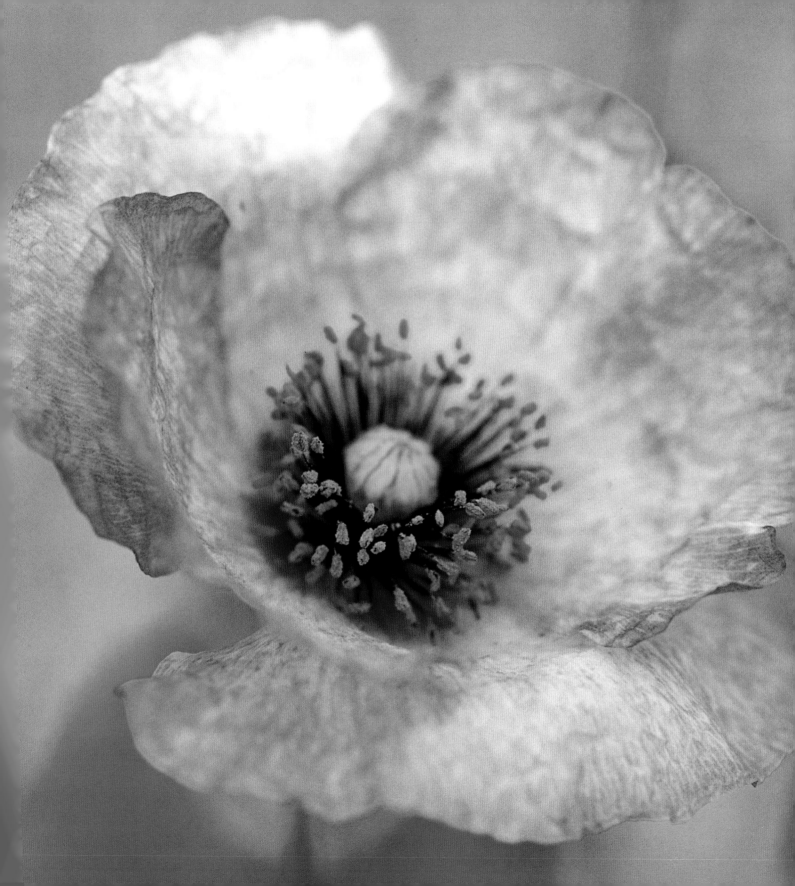

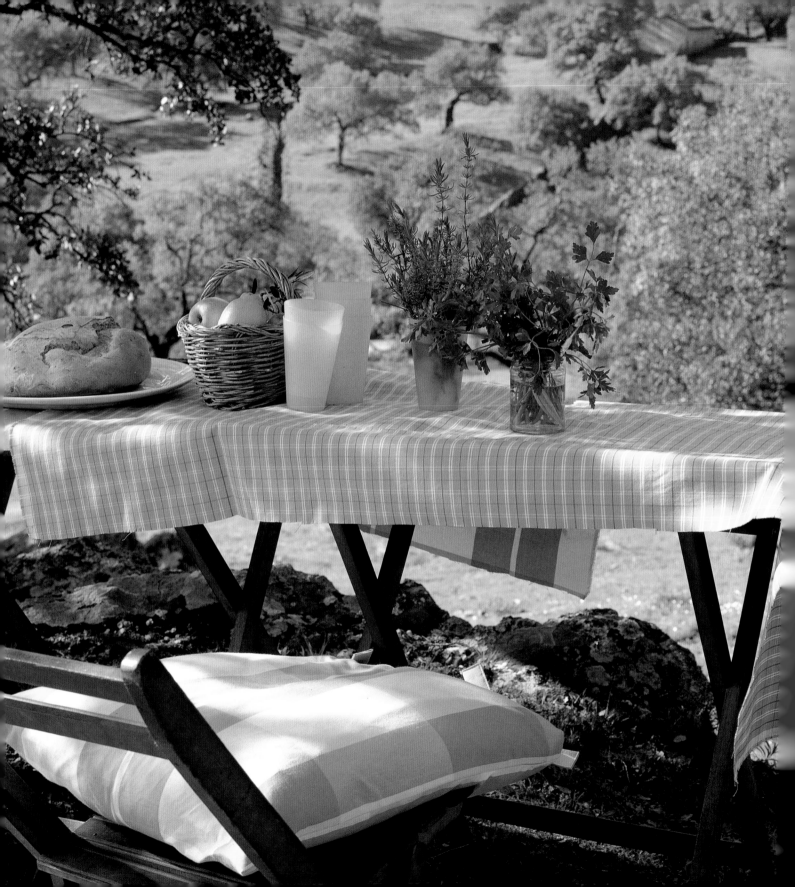

natural elements, like soft white cotton canvas, trellis painted minty green or terracotta coloured walls. It looks at the surfaces and textures – both natural and artificial – that work together to make the outside a living, organic space, such as blistered, peeling paintwork on doors and walls; old rusting metal furniture and shiny clean tools; earthy, weathered flowerpots and mossy, worn red-brick paving stones. Pure Style Garden is about being practical and adopting vernacular styles for everything from fencing to garden tools. There are loads of ideas for planting rows of vibrant dahlias, climbing roses, clematis and morning glory, towering foxgloves and delphiniums; pots or beds of basil, rosemary, thyme and mint; and other edible produce like tomatoes, courgettes/zucchini, beans and lettuces. Most plants are quite ordinary, yet they are either beautiful to look at or delicious to eat; and they are all possible to grow from readily available seeds, tubers or young plants.

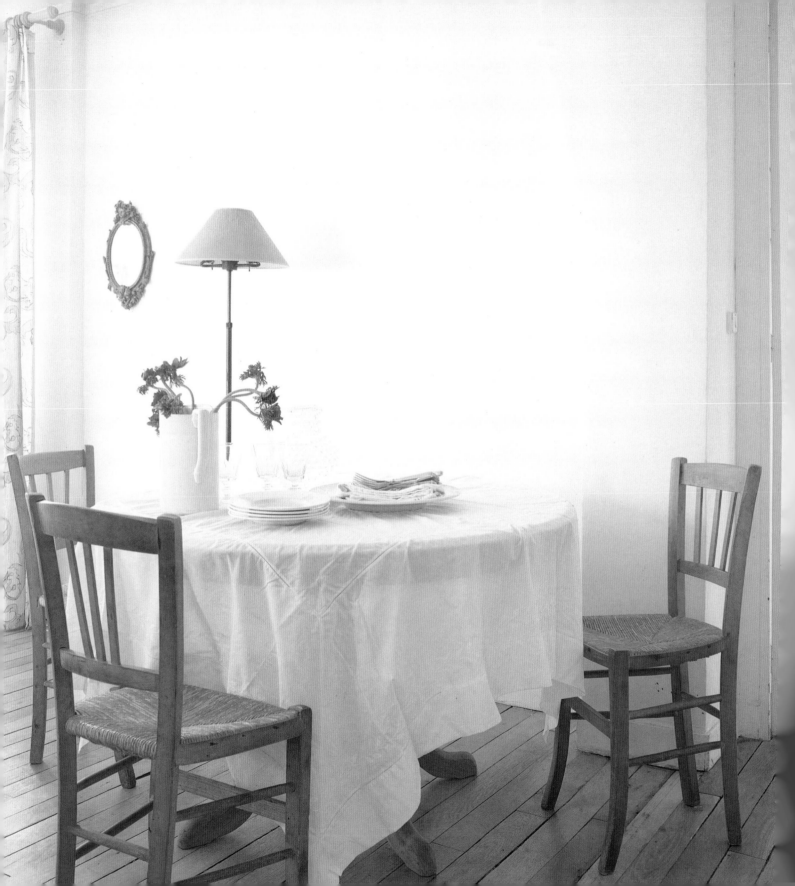

PURE STYLE
HOME

PURE STYLE
HOME IS

about being economical but without skimping on essential things like good food or a decent bed. Pure Style Home is not all about slavishly following fashions in interiors, it's about being practical and resourceful – tracking down great domestic staples that have been around forever, using department stores for good basic buys, or seeking out second-hand furniture that can be revitalized with a lick of paint. Pure Style Home focuses on the sensual side of living: such as texture – frothing soap, rough log baskets, string bags, a twiggy wreath entwined with fresh rosemary sprigs, or the bliss of sleeping in pure white cotton sheets; smell – fresh flowers, sweetly scented candles or laundry aired outside in the

hot sun; tastes — good bread or new potatoes cooked with fresh mint; colour — light, bright, airy, matt shades inspired by nature, cow parsley, egg and calico whites, butter and straw yellows, bean greens, sea and sky blues, and earth tones; natural things — moss, lichen, shells, pebbles; scents — great coffee, chocolate and delicious fruit; fabrics — good value, durable and decorative, in simple patterns like checks and stripes; basics— functional items that look good, such as a tin mug, a dessert bowl or glass Kilner jars. Pure Style Home is about creating living, breathing spaces throughout the house. This section shows you how to be functional and practical in the kitchen, with durable work surfaces, proper cupboards and essential kitchen gear. Pure Style Home is about making the rituals of eating as sensual as is practicable or possible and shows you how simple ideas — white plates, starched linen and jars of cut flowers — can create pleasing and visually satisfying arrangements. Pure Style Home also demonstrates how plain but delicious basic ingredients — good cheese, fresh fish, fresh fruit and vegetables — are the key to hassle-free food preparation. In the sitting room, Pure Style Home illustrates how a combination of elements and textures, such as comfortable seating, beautiful fabrics in cotton, wool and muslin, and candlelight and blazing fires, help to make living rooms relaxing and peaceful. To help you slumber more soundly, this section shows you the benefits of well-made beds and proper mattresses as well as the luscious qualities of crisp cotton bedlinen, snug warm woollen blankets and quilts. In the bathroom, this section demonstrates how soft cotton towels and wonderful scented soaps can make bathing a truly sybaritic experience.

ELEMEN

T S

To touch, to hold, to look, to smell, to taste: the sensual aspects of life are there to be nurtured and encouraged. Engage the senses and explore the visceral elements around you. Douse your sensibilities with tactile elements; encourage and incorporate colour and texture into your home to make life an altogether more spirited and rewarding affair.

Colour

Use colour to make daily living more pleasurable, spirited and uplifting. Thinking about how colour appears in nature gives clues to choosing the sorts of colours you might want to have in your home. Neutrals are timeless and easy to live with, while white is unifying, restful and a favourite with those who seek a simple approach to living. Greens are versatile, ranging from the brightest lime to much darker tones, and earthy hues of brown can be used for a variety of looks. The sea and sky colours found in denim, on china, bedlinen and in paint give clarity and crispness to interior settings. Look at garden borders to appreciate the range of pinks and transfer these indoors as soft lilac walls or muted floral cottons. Creams and yellows are cheerful, optimistic colours and have universal appeal. Pure Style Home is not about slavishly coordinated colour schemes, although it does show you how to put together rooms and interiors with accents on colour. It is more about consider-ing the colours of everything around and incorporating them in our daily lives. Colour is a vital element in charac-terizing an interior and it need not be expensive. If you can't afford to redecorate, change the emphasis with different cushions, covers and splashes of floral detail.

Whites

Milk

Egg white

Wax white

Bone

Oatmeal

Calico

Brilliant white, eggshell white, bone white, lime white, even plain old white, all come in a plethora of contrasting hues and tones. White creates a peaceful and timeless ambience which benefits both period, and starker contemporary settings equally. It is a minimalist's dream shade and makes for harmonious, unifying spaces. In today's super-charged, techno world it's good for the soul to retreat into a reviving white oasis where simplicity rules. For an all-white scheme, strip then paint floorboards in white floor paint and seal with a yacht varnish; use white emulsion on the walls and ceil-ings. So that the whole interior does not finish up looking too much like the inside of an icebox, create toning contrasts by giving the woodwork

touches of off-white, bone, or white with grey. For a unifying effect paint furniture in similar shades and add cotton drill slip-on covers, calico cushions and filmy muslin drapes. Complete with accessories such as white china and bedlinen, available from big department stores at bargain prices during the sales.

Blues

Blue spans a host of colour variations, from deep hyacinth to very pale ice. Blue can turn to lavender when mixed with violet, and turquoise when blended with green. In the middle of the spectrum are the purer blues of cornflower and bright powder blue. Take a cue from the fashion world and look at the soft blues that characterize denim as it is washed and worn. These shades adapt as easily to home furnishings as they do to jeans and jackets. Pale shades are the tones most likely to appear cold, especially in north-facing rooms. The trick here is to use warming devices, such as faded kelims or terracotta flower pots, perhaps in a room with duck-egg blue walls. If a pure blue is too strong for your taste then try a more dull mix of grey, green and blue – this works well with highlights of white; or try a dining room scheme in a dull blue, offset with white-painted furniture, curtains in blue-and-white check and bowls of white narcissi. For a more homespun look, combine the muted Shaker blues with red-and-white striped or checked cotton.

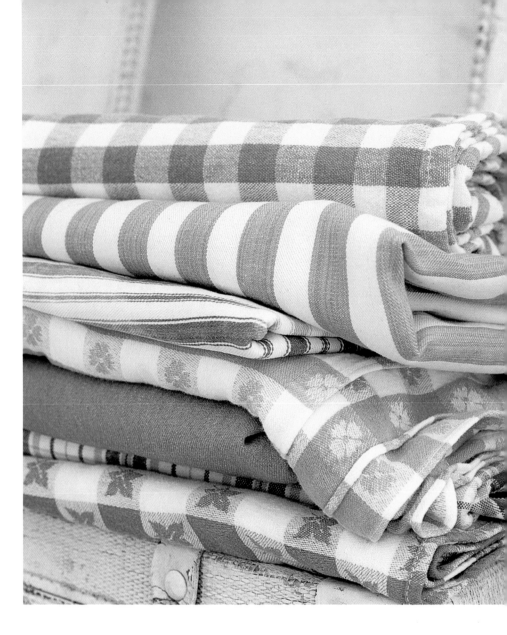

Washed blue

Sea

Beach-hut blue

Denim

Checked blue

Useful decorating details in blue include plaid china and clear glass. There is blue-and-white striped ticking for loose covers/slipcases and storage bags. And for a jaunty beach-house theme, make chair covers in bright lavender-blue cricket stripe cotton, together with faded blue-jean cotton cushions (various denim weights are available from fabric wholesalers).

23

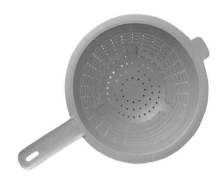

Leek

Spring green

Pea

Herb

Cabbage

Garden

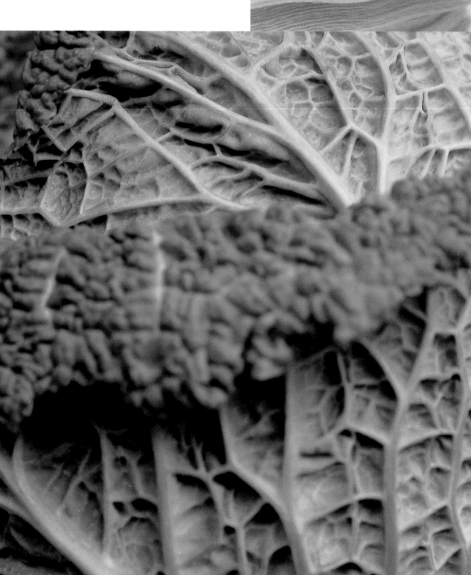

Green

Green is one of the most accommodating colours for interiors. In a contemporary setting a vivid apple green or lime teamed with flourishes of fuchsia pink can work well, while traditional interiors call for duller shades mixed with grey, such as hopsack and olive. Take inspiration from the range of greens in nature; look at the bright lime-green stems of hyacinths or blades of fresh spring grass. Peas in their pods and cabbage leaves provide another source of vibrant and sometimes variegated greens. Try using sage-and-white striped cotton for chair covers with bursts of lime-green for cushions.

Pink and lavender

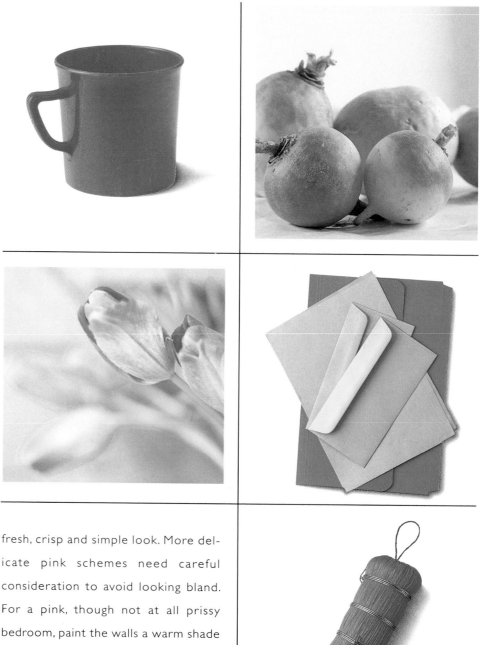

Pink needn't be the sickly colour we associate with frilly, little-girl bedrooms, over-the-top chintzy floral drawing rooms, or the monotonous peach-coloured bathrooms that are perennial in mass-produced home design catalogues. At the other extreme, shocking pink walls and ceilings are hardly a recipe for subtle, understated living. Careful selection and combining of pinks with other colours is therefore the key to making a stylish, comfortable statement. In contemporary settings fuchsia pink, lavender and green combine well – just look to the garden border for inspiration and think of purply lavender heads on sage-green foliage or foxglove bells with bright-green stalks and leaves. For a smart, up-to-the-minute scheme for a sitting room paint the walls white, cover chairs and sofas in pale lavender and make up cushions in plain fuchsia and lime-green cottons. Hot pink floral prints look great married with white walls and loose covers/slipcases, creating a fresh, crisp and simple look. More delicate pink schemes need careful consideration to avoid looking bland. For a pink, though not at all prissy bedroom, paint the walls a warm shade such as a pale rose with a hint of brown and furnish with an antique lavender-coloured patchwork quilt and calico Roman blinds/shades – the whole effect will be clean and subtle.

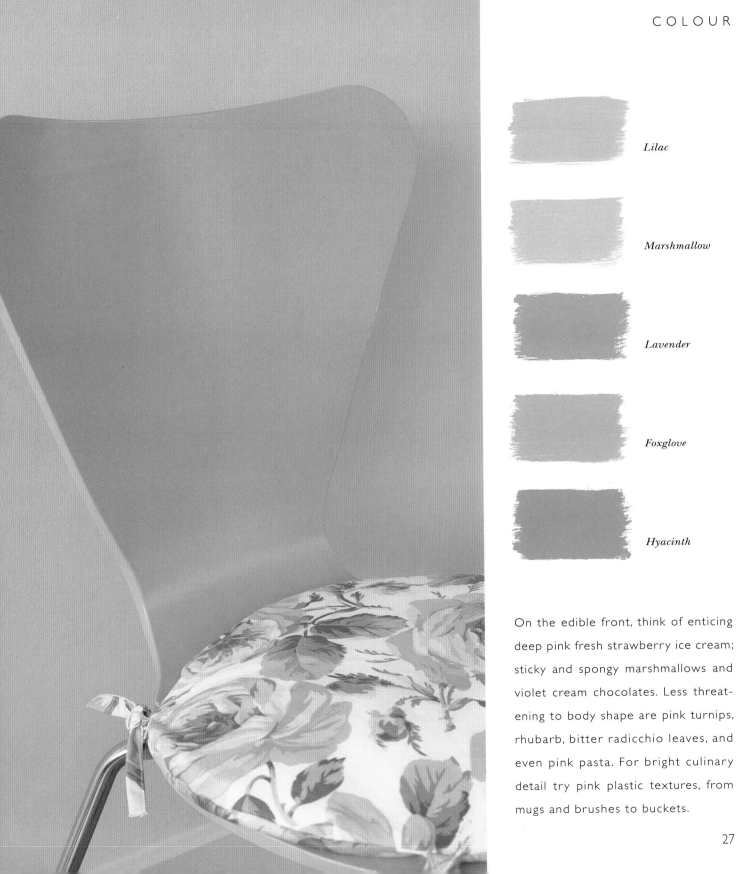

Lilac

Marshmallow

Lavender

Foxglove

Hyacinth

On the edible front, think of enticing deep pink fresh strawberry ice cream; sticky and spongy marshmallows and violet cream chocolates. Less threatening to body shape are pink turnips, rhubarb, bitter radicchio leaves, and even pink pasta. For bright culinary detail try pink plastic textures, from mugs and brushes to buckets.

Earth and terracotta

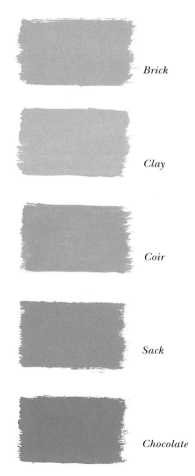

Brick

Clay

Coir

Sack

Chocolate

Because earthy hues are universally adaptable base colours it is hard to go wrong with them, except for those really drab mud-coloured schemes that were so popular during the seventies. Ranging from dark chocolate to cream, brown accents work in rustic and contemporary settings equally well. Consider the terracotta-

coloured façades prevalent throughout Provençe and Spain, the brown woodwork and detailing of an English cottage kitchen, or the terracotta flags and wood beams in a New England farmhouse. In contrast imagine a white, utilitarian urban loft with dark wood schoolhouse-style desks, tables, chairs and filing cabinets. Study the shades of soil,

from a clay-based red to a rich dark brown, and see how they act as a foil for brighter colours in nature. Clay pots are perfect for setting off the foliage and flowers of emerging spring bulbs. Be bold with earthy tones; for instance paint a dining room in a rich Etruscan shade for a warm effect both night and day.

Even boring beige is still a favourite shade and fabric companies love it for its versatility. Beige looks smart in various clever contemporary reworkings such as coir and natural fibre matting for floors, tough neutral linen for curtains and chair covers, or brown office files and filing boxes. Use striped and checked cotton in pinkish terracotta and white to make up chair covers and curtains with a wonderful natural feel.

Yellow

Creamy country yellows are wonderfully adaptable and open up the meanest and darkest rooms to increase a sense of space. When decorating, opt for the softer end of the yellow spectrum as acidic yellows are harder to live with because of their sharpness. However, don't go too pale, as at the other end of the scale very clear, light primrose shades can appear insipid. Creams and yellows look great with white, or even orange. Some shades look quite brown in the pot, but once on the walls are wonderfully rich and very well-suited to period hallways and kitchens. A slightly more acidic yellow will be lighter yet still rich in colour and should look good in artificial light and really glowing when the sun shines. There are also some very rich, bright yellows available and if you can stomach their intensity these gutsy shades illuminate and cheer up even the pokiest spaces, and look fabulous against blue-and-white china and furnishings. Cream or yellow looks good as paint on walls and as a decorative colour for furniture.

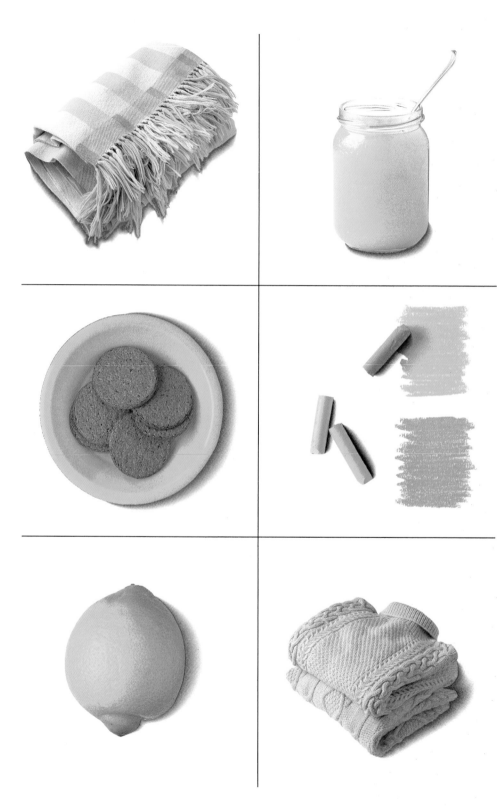

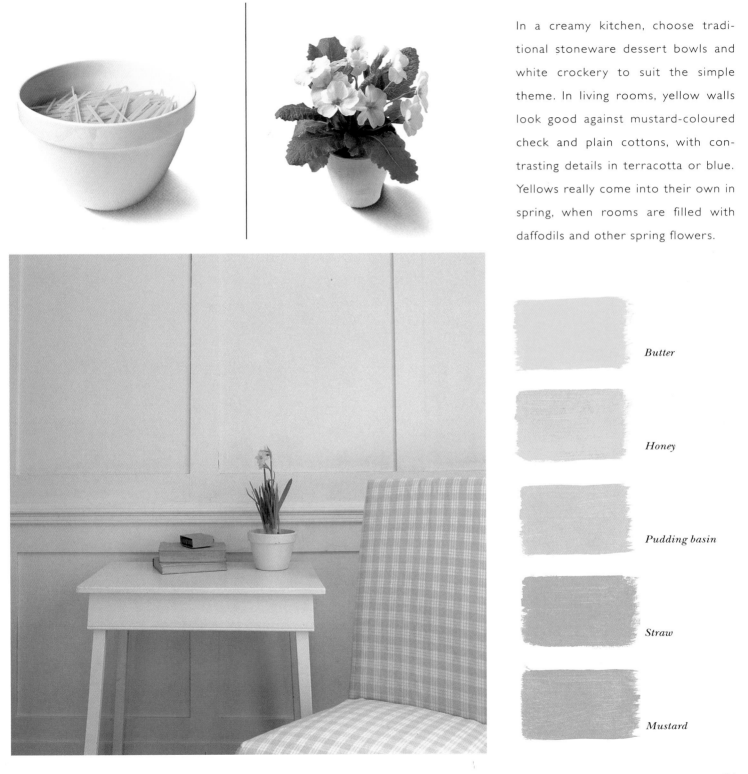

In a creamy kitchen, choose traditional stoneware dessert bowls and white crockery to suit the simple theme. In living rooms, yellow walls look good against mustard-coloured check and plain cottons, with contrasting details in terracotta or blue. Yellows really come into their own in spring, when rooms are filled with daffodils and other spring flowers.

Butter

Honey

Pudding basin

Straw

Mustard

Texture

Scant attention is paid to our senses by the purveyors of today's technological gadgetry with their ever-increasing obsession for convenience and labour-saving devices. There is not much textural appeal, for example, about computer hardware, or mass-produced, static-inducing synthetic carpets and fabrics. In complete contrast, sensual textures like soft, wool blankets, crisp cotton bedlinen and light and downy pillows are the domestic staples handed down from past generations that help to bolster us against the more soulless elements of modern living. From the perfect smoothness of a baby's skin to the gnarled and ridged bark on a tree, natural textures are there for us to take notice of and appreciate. They often combine an alluring mix of qualities. For instance, lumps of volcanic pumice stone, logs and shells are defined as rough or smooth, depending on the degree of erosion upon them by wind, sun, fire and rain. It is this very naturalness that compels us to gather such things about the house.

Our homes need natural textures to transform them into living, breathing spaces – and polished wooden floors, rough log baskets, and pure cotton fabrics are just some of the organic ideas we can introduce to suggest this effect.

Smooth

Smooth things are often fresh, clean things and appear all round the house, especially in the kitchen and bathroom. Washing activities spring to mind, such as a handful of frothing soap, or a big plastic bucketful of hot soapy water. Satisfyingly smooth surfaces of crisp white tiling, marble or utilitarian stainless steel conjure up a sense of clinical, streamlined efficiency. In kitchens, culinary preparation is made more efficient and hygienic when work surfaces can simply be sluiced, wiped down and made pristine. Utensils such as sparkling stainless steel pots and pans also help to keep culinary operations running smoothly. I love to cook with a selection of worn wooden spoons which have somehow moulded to my grip after years of devoted use.

Smooth, cast-iron bath surfaces and ceramic tiled walls can be scoured and scrubbed, so helping to keep bathrooms squeaky clean. Indoors as well as out, natural surfaces such as slate or well-worn flags are texturally pleasing. Smooth elements exist in a diversity of guises, from crisp white tissue paper tied up with silk ribbon to polished floorboards. On a food theme, goodies include the wonderful slippery-smooth waxed/greaseproof paper that serious shops wrap cheese in, slender glass bottles of olive oil, or slivers of fine chocolate in layers of the thinnest silver paper. You can also bring naturally smooth objects, such as ancient weathered pebbles and scoured driftwood collected on an impromptu beach hunt, indoors for textural decoration.

Rough

One of my favourite possessions is a roughly hewn olive wood basket from Spain. Made from the winter prunings of olive trees it is silvery-grey in colour, robust in design and a sheer pleasure to touch and hold. The locals in Spain use such baskets to transport eggs and wild mushrooms, oranges or tomatoes from their vegetable patches – while mine in London is filled with kindling for the fire. Rough, tough and hairy flooring in sisal and coir is durable and even when woven into patterns it still looks like a simple texture. Equally, a rough terracotta tiled floor is not only satisfying to walk on but if it is not laid in exact uniformity it has the appearance of having been in place forever.

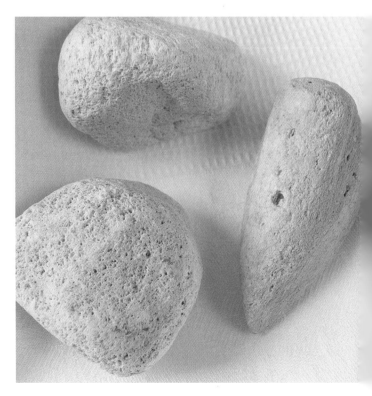

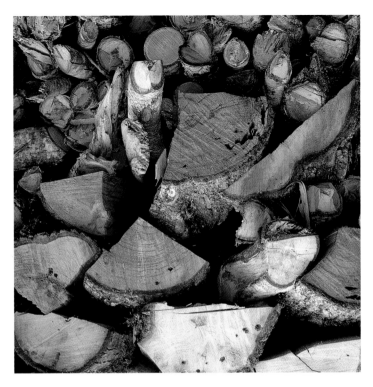

Rough textures in nature have usually been created by the elements, and even sun-blistered paint, a painter and decorator's nightmare, can create a visually pleasing finish on a weathered old outbuilding. This sense of roughness allied to age means that unevenly plastered or distemper-covered walls, or features such as reclaimed battered tongue-and-groove panelled doors, can make even a new house look rustic. Rough can mean contemporary too, and utilitarian concrete walls and floors are common features in industrial buildings converted to open, loft-style living spaces.

Roughness isn't always a pleasing texture, as anyone with chapped hands or prickly wool next to the skin knows, yet some fabrics such as cotton towels worn rough by repeated washing are perfect for an exhilarating rub down after a shower. And tools such as pumice stones and hard bristle brushes assist exfoliation and improve circulation.

Scent and taste

Scents and tastes are so evocative that childhood memories may be unexpectedly recollected with a certain waft of perfume or the aroma of a particular food. As a small girl on holiday in provincial hotels I invariably associated France with a cocktail of scents that included furniture polish, smelly plumbing and cooked garlic. In the same way, the first sweet grass cuttings of spring, evident as I pass by a newly mown field, park or suburban back garden, transport me back to games played on the lawn at my grandmother's house in Devon. Smells quicken our senses, increase anticipation and act as powerful stimuli – there is nothing like the whiff of strong coffee and toast to entice slothful risers out of bed. Taste is crucial to the pleasure we take in eating. Fresh ingredients are vital to making things taste good, together with a knowledge and appreciation of basic cooking skills. There is a world of difference between a home-made hamburger and the cardboard creations served up at fast-food outlets.

Smell and taste are closely related, and one without the other would diminish the intensity of many edible experiences. Consider the first strawberry of summer; the heady flowery scent is a beguiling hint of the sweetness to come.

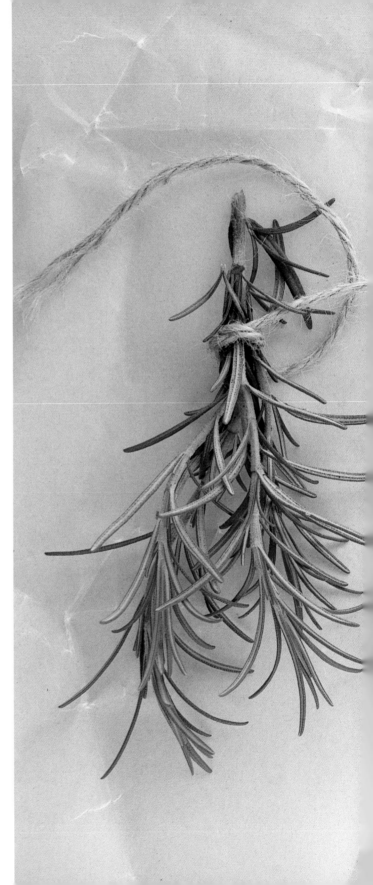

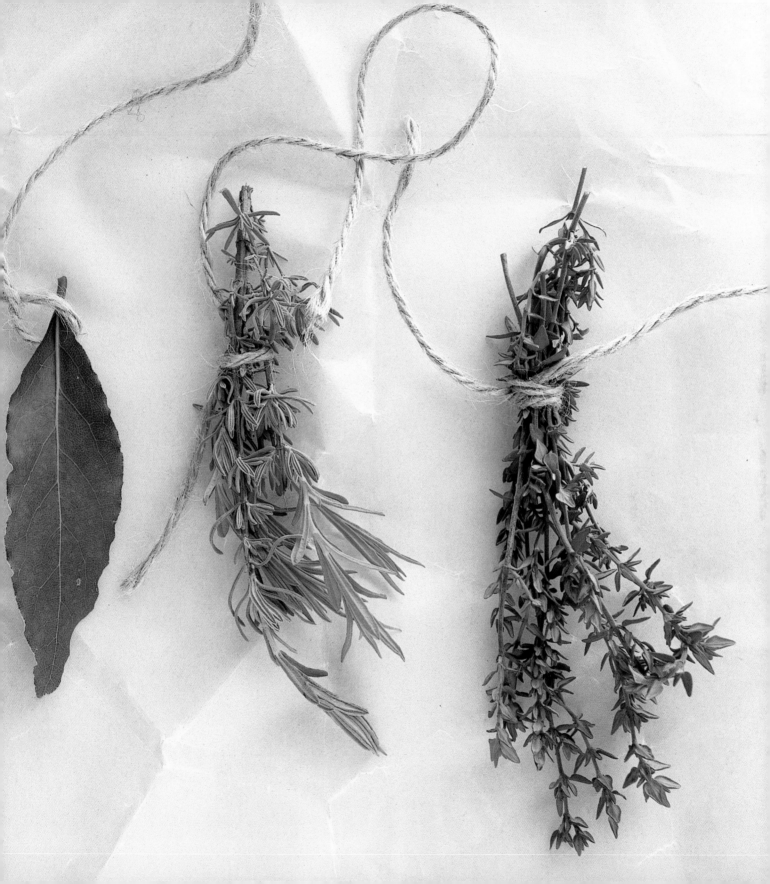

Flavour and fragrance

It is invigorating to have good smells around the house. I love paper-white narcissi whose flowers emit the most delicious sweet smell. Scented candles and bowls of pot pourri are other sources of floral scents. In the kitchen, scents and tastes come to the fore: the fragrant citrus tang of grated lemon peel accompanies the preparation of sauces and desserts and the

earthy scent of mushrooms being fried rapidly in butter is any food lover's idea of heaven. Simple tastes are often the most sublime. What could be more enticing than a bowl of pasta mixed with garlic and a little olive oil, or a good, strong cheese? Herbs such as basil, rosemary, thyme and dill smell delicious and help to draw out the flavours of food.

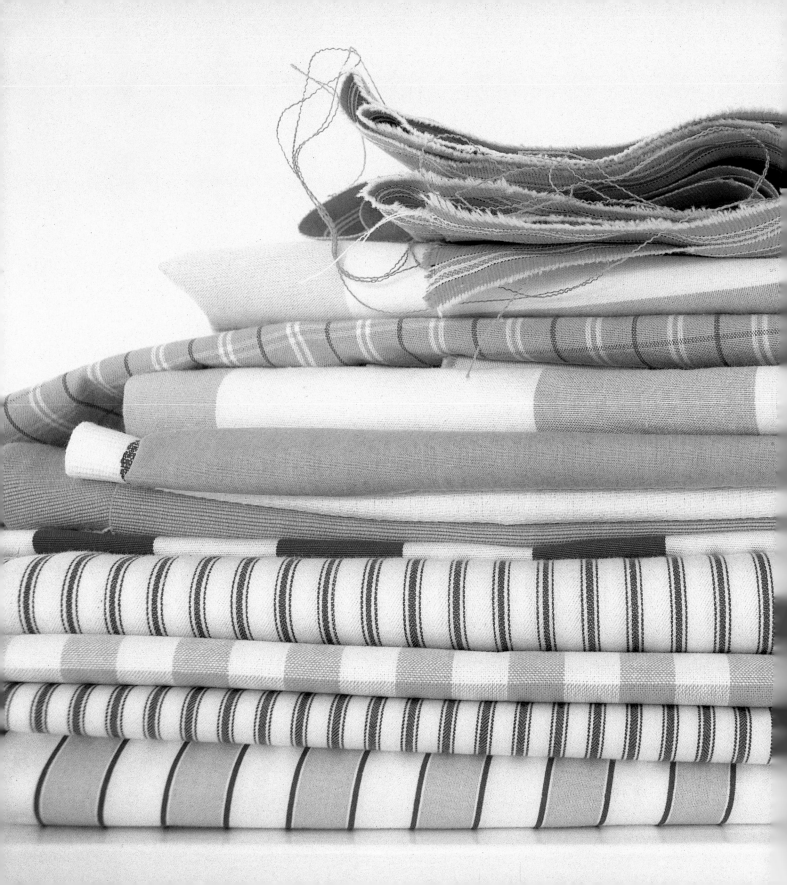

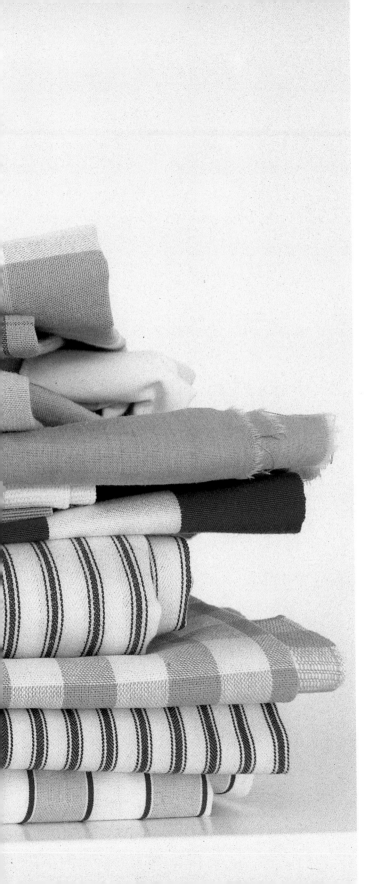

Fabrics

Setting taste and aesthetic considerations aside, criteria for choosing one type of furnishing fabric over another include the suitability of the weight and weave for a type of furnishing and the fabric's ability to withstand the effects of wear and tear. Furnishing cotton, linen, wool, silk, synthetic and mixed fibres exist in a wealth of colours, textures and weights and with a little effort it should be possible to find just about anything you want at a price you can afford. If you fall for a really expensive fabric bigger than your budget, invest in a small amount for a cushion or two instead. Otherwise it's worth hunting in the sales for the larger quantities needed for upholstery. For good value basics go to an old-fashioned haberdashers and track down companies who supply television, film, theatre and artist's trades. These are great places to find varied weights of calico like those used for toiles in the fashion business, or extra wide widths of canvas used as stage backdrops, and

cheap rolls of muslin that are employed by designers for costumes and sets. One popular silk specialist I know of carries stocks of coloured silks, including the type used for parachutes. Over the next six pages you will find lots of examples of utility fabrics.

Light

Lighter weight fabrics are brilliant for simple, floaty window treatments. Make decorative half curtains from voile or muslin (see 24 and 27) panels with cased headings. Thread them onto narrow rods and anchor them within the window frame. Other lightweight curtain ideas include unlined cotton (see 6, 7, 8) or linen (see 22) drops with tapes or ribbon loops at the top. Basic roller blinds/shades in fine fabrics (see 9) look subtle and understated in a cream or white decoration scheme. Spray stiffener might be useful to give body to some gauzy fabrics. Perfect for bedrooms and bathrooms are filmy transparent loose covers/slipcases in voile (see 12) for chairs with pretty, curvy shapes. Soft Indian cotton in bright lime green (see 26) and other hot up-to-the-minute shades are great for making up colourful and inexpensive cushion covers. If you're in the mood, run up your own sheets, duvet covers and pillowcases in cotton sheeting (see 1), which comes in very wide widths. Covers should fit loosely around a duvet and have a generous opening secured with buttons, Velcro, or simple ties to make them easy to slip on and off. Printed cotton lawn dress fabric is also worth considering for sprigged floral pillow cases and cushion covers. Cotton sheeting is also a great staple for lightweight tablecloths and napkins. I keep a huge length in white for parties indoors and out, when we have to fit lots of people around mis-matching tables.

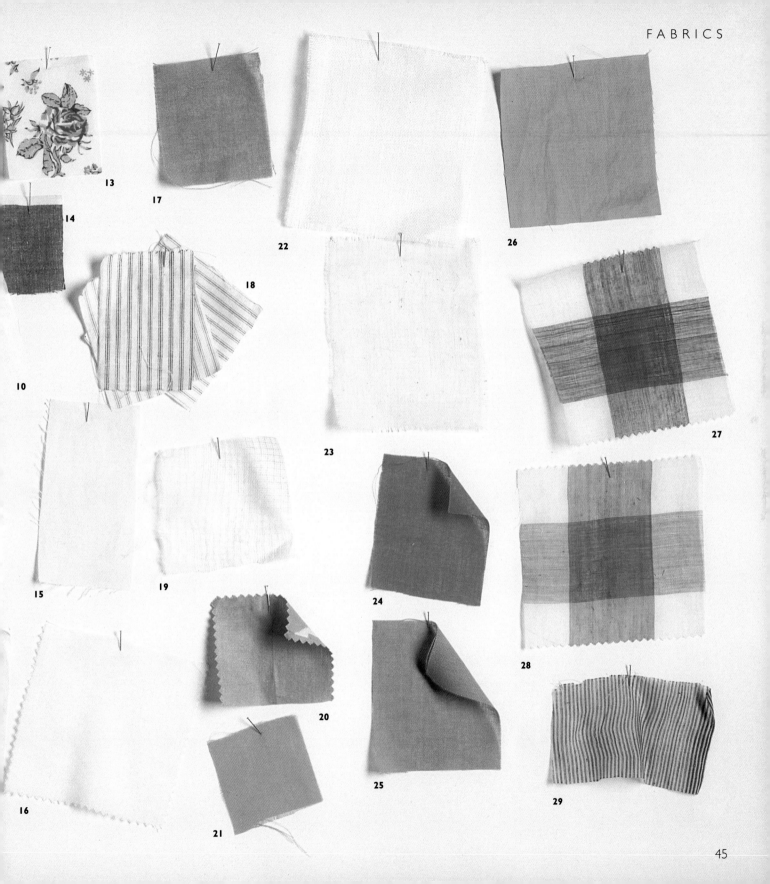

13

14

17

22

26

18

10

27

23

15

19

24

28

16

20

25

29

21

Versatile

I have a passion for blue checked cotton (see 34 and 60) and use it all around the house for crisp colour and detail; as cushions (see 58 and 59) for assorted chairs and as Roman blinds/shades (see 34 and 59) in the dining and sitting room. Blue checked loose covers/slipcases also look good, and can be as basic or as decorative as you want — with bows, piping/cording, ties or button detailing, simple pleats, short skirts or flowing hemlines. Window seat cushions in cream linen with a piped trim are smart, and this fabric also works well as an idea for covers on daybed bolster cushions. If the fabric is not shrink resistant, and covers are to be washed rather than dry-cleaned, pre-wash all materials including piping/cording before making up. Blue-and-white striped ticking, a robust cotton twill closely woven in narrow stripes and traditionally used for pillows and mattress covers, is also another favourite (see 45) and looks especially good as simple curtains with ties at my attic windows, and across an alcove that houses children's clothes. Ticking is also a smart, classic idea for chair and sofa covers. Continuing on a striped theme, an all-time favourite is a lightish weight lavender-blue-and-white printed cotton (see 47) that I've used for tablecloths and chair covers for summer suppers out in the garden (see it made up as a flirty loose chair cover on pages 126–27). Another discovery is woven cotton roller towel, bought from a company that supplies towels to hospitals and other institutions. Supplied on a seemingly endless roll in convenient widths, it makes simple and useful chair covers.

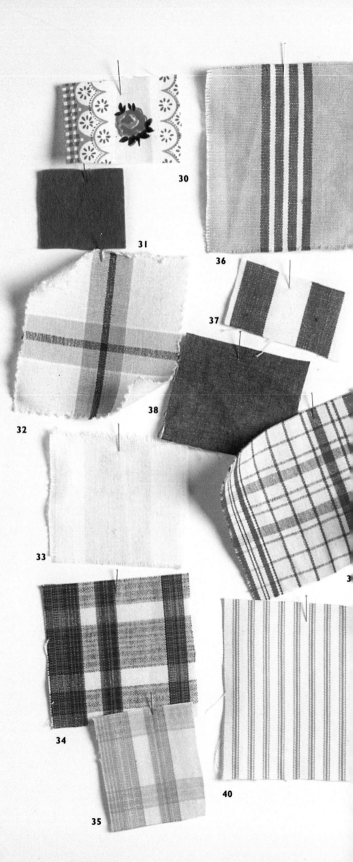

30

31

36

37

32

38

33

34

35

40

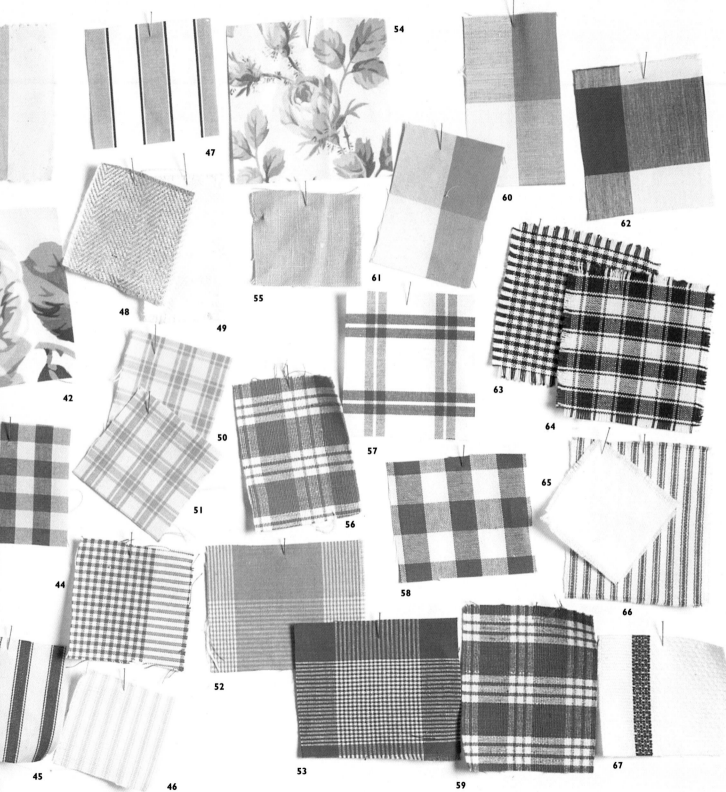

47

Durable

Tough all-purpose fabrics include canvas (see 82 and 83), sometimes known as duck, that is great for garden chairs and awnings. It's also good for Roman blinds, bolster covers and as heavy duty laundry bags (see pages 144–45). Creamy coloured calico is one of the best fabrics ever invented – it's incredibly cheap but it manages to look smart and understated, and is durable, washable and perfectly practical. Calico comes in a number of weights; the finer qualities are more appropriate for loose covers/slipcases or cushions, while thicker weights work well as insulating blinds/shades (see 75), particularly if made in double thickness (see the Roman blind/shade project on pages 106–107) or for making curtains. Tough cotton denim (see 69) looks good on chairs after it's been put through several very hot washes to fade its dark indigo colour. For a crisp, tailored look, or to show off techniques such as deep buttoning, chairs demand tight coverings to emphasize their shape. A self-patterned herby green cotton and viscose with simple tulips is one of my favourite upholstery fabrics (see it in yellow 87), and it looks great on one of my secondhand armchairs. Sofas with a contemporary feel look wonderful in solid sea green and blue colours in tightly woven cottons (see 88, 89, 90). Alternatively, plain cream cotton is stylish, but sensible for the dogless and childless only; choose some slightly more forgiving muddy-coloured linen if you have a family. Wool tartan (see 79) is another smart idea for upholstering the seats of dining chairs or sofas, and it also works well as throws for keeping warm on cold winter evenings.

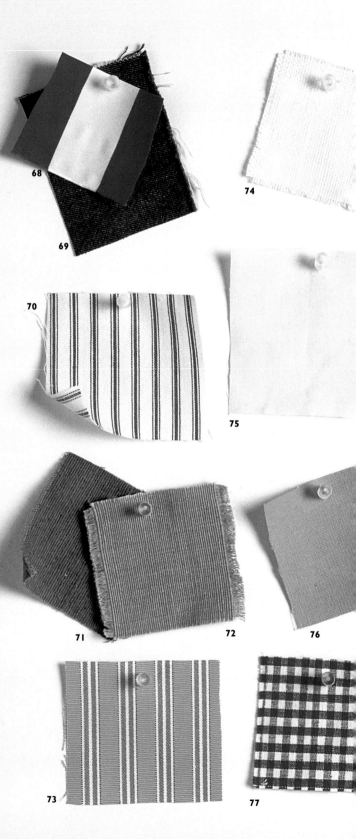

68

69

74

70

75

71

72

76

73

77

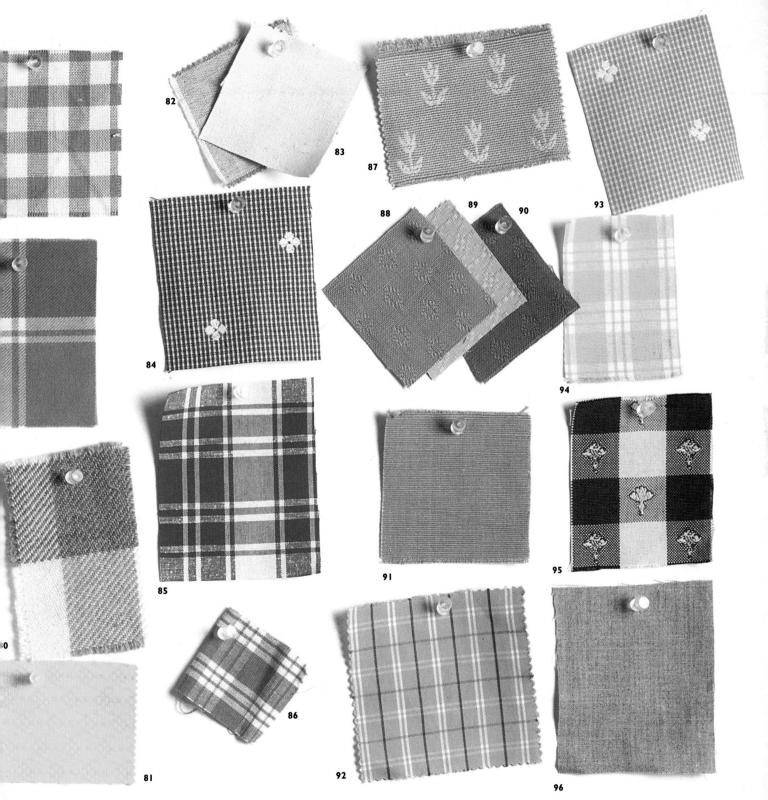

82

83

87

93

84

88 89 90

94

85

91

95

86

81

92

96

Furniture

It may seem paradoxical, but I think that a diversity of objects can imbue an interior with a sense of character and uniformity. Old, new, decorative, industrial, contemporary or utilitarian, it's possible to combine a variety of furniture styles under one roof and yet create a strong visual statement. Fashion pundits and supermodels dictate the length of hemlines from season to season, but thankfully trends in interiors are less mercurial. But it is worth putting the same energies into assembling a look for your home as you would your wardrobe. As with desirable outfits, buy your furniture only after considering texture, comfort, shape and form. At home I have gathered together a hotchpotch of furniture from sales, junk/thrift stores and family – from 18th-century oak country dining chairs and old sofas to fold-up tables, painted junk sixties filing cabinets and kitchen chairs. My only proviso has been to weed out or revamp anything that I haven't liked the look of. Second-hand furniture

designed for industrial and commercial use, such as swivel architect's chairs, bookcases from libraries and pattern-cutting tables from factories, can be re-invented happily in a domestic setting, and is better quality than mass-produced equivalents.

50

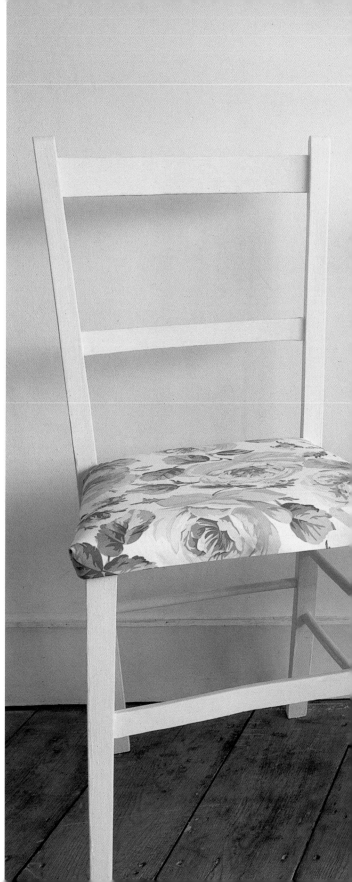

Tables and chairs

A fold-up slatted beech chair, ideal for stowing away in small spaces, and an old wooden church chair – excellent durable seating for kitchens and dining rooms.

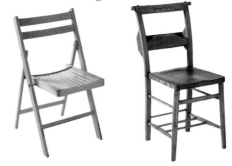

Stackable contemporary seating with beech-ply frame and splayed metal legs, inspired by the fifties butterfly chair by Arne Jacobsen.

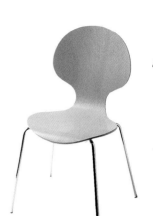

Sturdy shapes in solid wood: a rustic beech chair with rush seating and a classic beech stool.

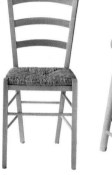

I like chairs that have no frills or gimmicky details, in other words, chairs that look good, are robustly constructed and comfortable to sit on. Classic country chairs with rush seats are ideal for kitchens and dining rooms. Fold-up wooden slatted seats, the staples of church halls the world over, can be stowed away and are excellent for use in small spaces.

A crisp bright pink cotton loose cover/slipcover and a lick of white paint have given a junk chair a new lease of life.

A simple trestle table like this one in birchwood-ply has a multitude of uses, ranging from a work desk to an impromtu dining table.

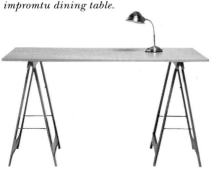

You can see examples of this sixties-style weather-proof aluminium café chair in bars and cafés throughout Europe – a great idea for urban backyards and loft spaces.

Robust and utilitarian, a Swedish-style pine side table such as this could be used for displaying and storing china, or books and flowers.

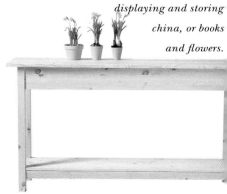

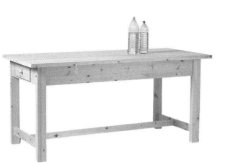

Big, basic and in solid pine: a definitive kitchen shape that would suit all kinds of interiors.

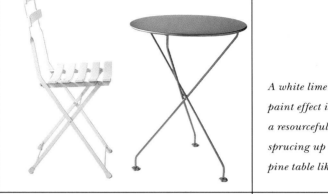

Essential folding shapes for indoors and out: a white slatted chair and a metal dining table.

A white lime paint effect is a resourceful device for sprucing up an old turn-of-the-century pine table like this one.

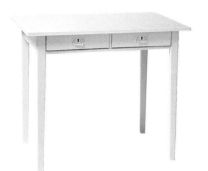

Customized with eggshell paint, this simple pine table would make a smart desk or sidetable anywhere in the house.

Like chairs, a table should look good, be strong and a pleasure to sit at. A basic table top perched on trestles is probably one of the most useful and portable shapes which can be set up or collapsed instantly. Junk/thrift stores are always good sources of chairs and tables alike — take your pick and revamp battered examples with a coat of paint.

Perfectly angled to support the sitter's back, this worn but elegant little factory chair is a good example of functional but stylish seating.

This crisp cotton checked cover with button detailing is a good idea for reinventing a basic calico-covered dining room chair.

Based on a fifties shape, a zinc-topped wooden table is a streamlined idea for a gleaming contemporary kitchen.

Beds

Beds should be chosen for both practical and visual considerations. To ensure many peaceful nights of slumber it is crucial at the outset of any bed-buying exercise to invest in a decent mattress, and a solid base or frame. If you have limited funds think about ways of revamping your existing bed. For instance, lovely bed linen and blankets can disguise even the ugliest of divan shapes.

right *A traditional cast iron bed frame suits all kinds of interiors.*

below right *A Shaker-inspired pine four-poster (an amazingly good value flat-pack) is painted in white eggshell for a smart understated finish.*

below *Spare in shape and detail, and perfectly functional, this superbly streamlined bed in Douglas fir is a minimalist's dream.*

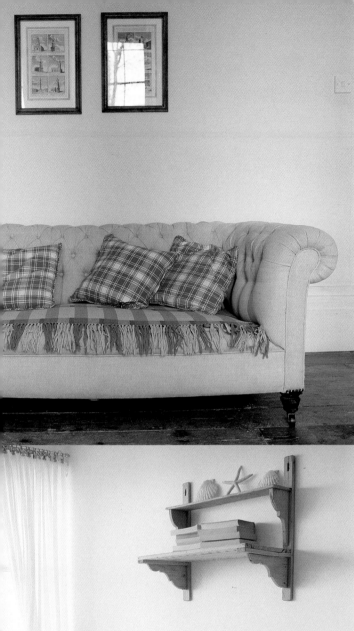

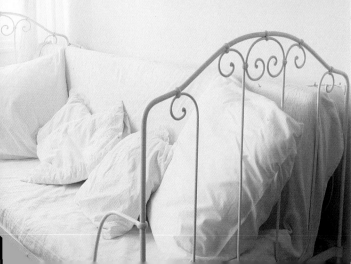

Sofas and seating

Good springs and sound construction are essential for comfortable upholstered seating. It's worth buying a good second-hand sofa or armchair with a wooden frame and strong interior springs, stuffing and webbing, rather than something new and less sturdily put together. Cover sofas in tough upholstery weights of linen and wool, or devise loose covers/slipcases that can be as basic as a throwover sheet, or opt for a tailored pull-on design in cotton.

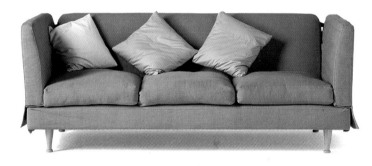

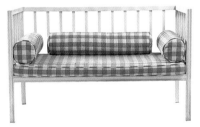

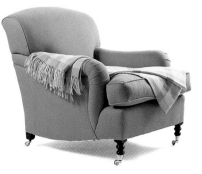

top left *A Victorian chesterfield sports decorative button detailing.*
left *This romantic French daybed is good for tight spaces.*
above *A contemporary shape, excellent for sprawling out on.*
right *A Swedish-style wooden sofa with check covers, and a generously proportioned armchair.*

Cupboards and storage

In an ideal world storage should be devised to leave maximum living and breathing space. In reality we are hampered by budget, cramped rooms, too little time, too many occupants and too much clutter to set about the task of arranging ourselves a little more efficiently. Here are some ideas to make clearing away a more fruitful and inspiring exercise. Basic wooden shelving is one of the cheapest means of stowing everything from kitchen paraphernalia to bathroom towels, or scores of books. Free-standing storage notions include simple flat-pack systems – these are basic structures in pine that are good for utility rooms and children's rooms. If home is a loft with poor access, put together flat-pack cupboards or wardrobes on site.

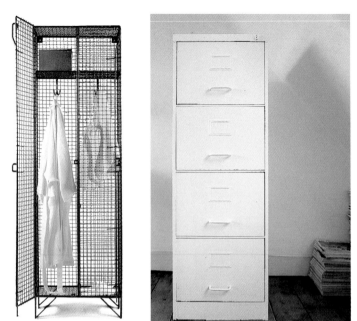

top left *This metal mesh wardrobe is great for small spaces.*

top and far right *Bought cheaply from second-hand shops, this filing cabinet and simple chest of drawers were improved by a coat of paint.*

right *Inexpensive but stylish flat-pack cardboard drawers, designed for papers and home office work, but also ideal for storing odds and ends.*

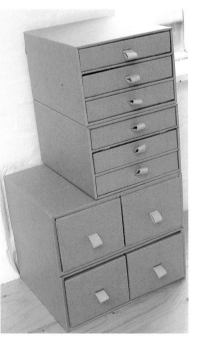

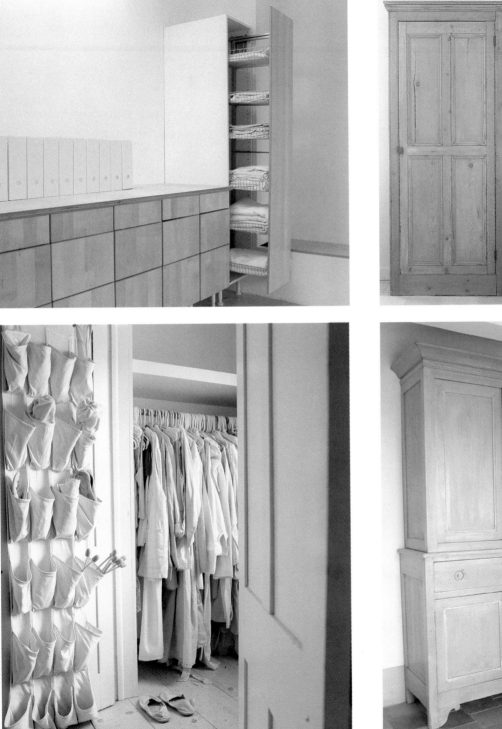

far left *Laminated drawers with wire baskets are a clever reincarnation for flat-pack kitchen units.*
left *In natural wood, a classic pine cupboard is a smart kitchen staple.*
below left *A walk-in wardrobe is one of the most effective ways of stowing away everything from clothes to suitcases.*
below *A decorative wooden dresser or* visellier *like this looks at home in country settings.*

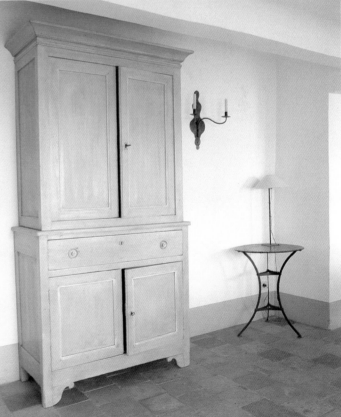

Objects

If we all made inventories of our possessions how many things could we designate as being not really useful, or something we hate but can't give away because it was a present or a family heirloom? It might be painful for your conscience, but in the long run paring down unnecessary household clutter eases the path to a more practical and soothing existence. Don't be sentimental about hoarding items that you'll never use. Identify the things that give you pleasure to hold, to use and look at. It's more useful to have one really good saucepan rather than have three second-rate ones that burn everything you cook. Even something as basic and utilitarian as a slender wood and bristle broom is a thing of beauty and just as humbly aesthetic as the rough mesh structure of a metal sieve, or a good old-fashioned mixing bowl whose deep curvy proportions are perfectly evolved to perform its tasks. Do away with those dusty lampshade bases made from Chianti wine bottles that your mother gave you for your first home. But resurrect classic anglepoise desk lights, as those in the know continue to appreciate their supple proportions. Vernacular objects so perfectly designed to fulfil their function are works of art in their own right.

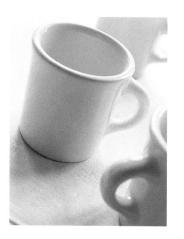

Utensils

Wooden chopping boards are kitchen staples: from slicing vegetables to serving up bread, and beech trivets protect kitchen surfaces from hot pans.

String is indispensable, from sealing jam pots to making an emergency washing line. And keep a supply of wooden spoons, for all mixing, stirring and beating operations. To extract spaghetti from a pan use a spoon with teeth.

A capacious flip-top stainless steel bin will take large amounts of kitchen rubbish, while a wood and bristle broom, found in any hardware store, is an essential tool for clearing up.

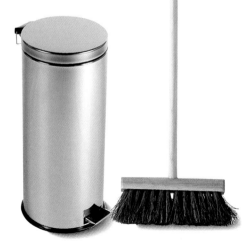

Whenever I have to make do with a temporary or makeshift kitchen during house renovations the surrounding chaos is bearable so long as I've had access to water, something to cook on (even if it's just a two-ringed portable stove) and a fridge. My survival kit of kitchen tools under such siege conditions includes a cast-iron enamelled cooking pot in which

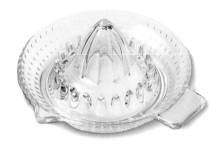

A glass citrus fruit squeezer is a great tool for producing small amounts of orange, lemon, lime or grapefruit juice.

Found in just about every continental kitchen, a classic stove-top espresso maker is an easy way to make steaming-hot strong coffee.

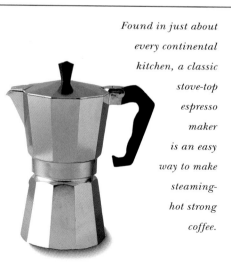

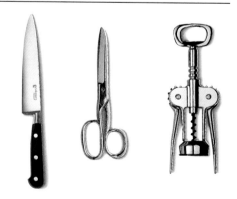

Life would be impossible without a really good sharp stainless steel knife, a pair of scissors and a corkscrew!

Produce mounds of crisp, crunchy vegetables that really keep their flavour, or poach small pieces of fish, with a heavy-bottomed stainless steel steamer.

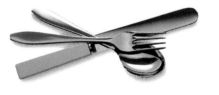

A robust cast-iron enamelled casserole is excellent, whether you are cooking for a crowd of friends, a simple family meal or just for one or two.

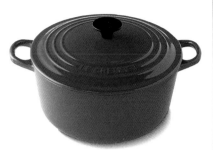

Drain everything from pasta and rice to salad leaves with a simple metal colander, and borrow or buy a fish kettle to take the angst out of cooking large fish like salmon in one piece.

For fishy treats: a strong oyster knife with a protective guard, and classic cutlery with bone-handled knives.

to conjure up everything from early-morning breakfast porridge to herby chicken casseroles, a sharp knife, a solid chopping board, a pile of wooden spoons, and, to keep spirits from flagging and the caffeine levels high, a metal stove-top espresso maker. Other crucial equipment includes scissors, a garlic crusher and, of course, a decent corkscrew.

Some of my favourite tools: a garlic crusher (that also stones olives), a balloon whisk and fish crackers, ideal for attacking crab.

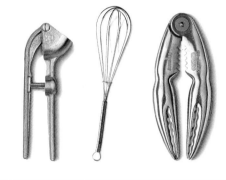

Some basic metal tools: a sieve for sifting flour or draining vegetables and a boxy grater for demolishing chunks of cheese such as Parmesan.

What kitchen would be complete without a kettle? Invest in a sturdy and hard-wearing metal catering one for endless rounds of satisfying tea.

Wonderful to hold, and perfectly proportioned, a stainless steel frying pan/skillet for rustling up everything from risotto to fishsteaks.

Lighting

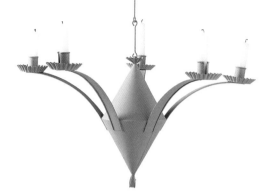

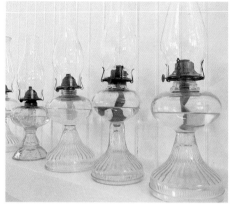

We can appreciate that daylight is the perfect light, because there is the dark with which to compare it. But night suffuses everything with its own particular mood and bestows its own impressions and textures. Without darkness we would be deprived of the luxury of candlelight, which is the most sensual, calming and benign of all sources of light. Lit candles highlight a dark room with luminous flickering qualities that bring us in touch with the sensations of a pre-electric age. For a really romantic dining room, invest in a simple metal or wooden chandelier and light it with candles at every opportunity. At its best, artificial lighting is subtle and effective. At its worst, the glaring horrors of naked light bulbs or the bland brightness of supermarkets and airport lounges speak for themselves. The most sensitive way to light interiors is with pools of subtle illumination, achieved with lamps set in designated corners, or with recessed low-voltage downlighters.

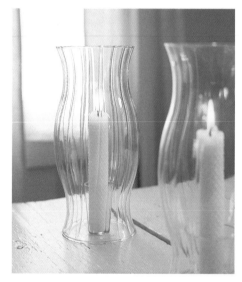

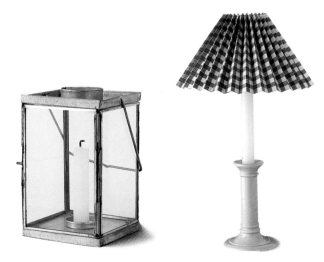

Different ideas for candle holders range from simple painted wood or metal chandeliers to pleated flameproof shades with brass supports – as the candle burns the shade moves with it. For summer evenings, choose from curvy glass hurricane shades, lanterns and candles.

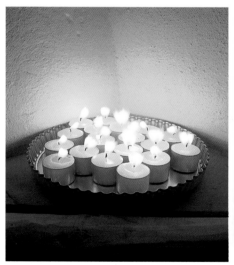

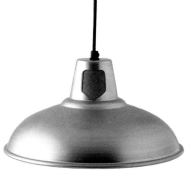

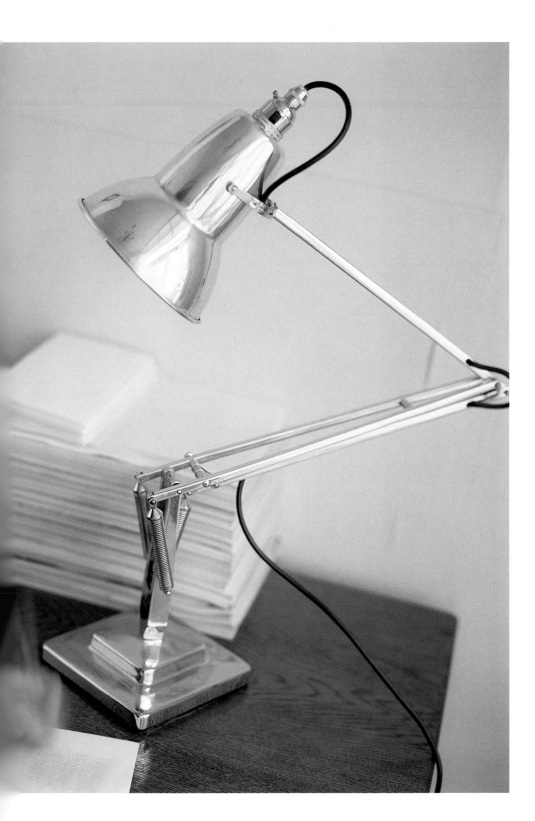

Utilitarian lamps and
worklights look great in
contemporary and more
traditional settings alike.
Overhead pendant lights
in spun aluminium work
well in kitchen and dining
rooms, or as stylish hall
lighting. For desk tops,
thirties-style anglepoise
lights are not only smart
but flexible practical
gadgets that help illumi-
nate all kinds of tasks.

Storage

Many small-scale storage ideas can be customized to look individual and imaginative. Reinvent old shoe boxes, for example, by covering them with fabric or paint to make colourful storage for your home office or for children's toys. Or use a lick of white paint to transform an ugly black clothes rail into a stylish moveable wardrobe, ideal for small living spaces; it can be covered with a white sheet to keep the dust off. I am an avid collector of old jam jars, and other domestic basics that double up as stylish containers include metal buckets (good for vegetables) and glass Kilner jars (they make even staples like rice, flour and pasta look good). Industrial meat hooks are available from good kitchen shops and are a great way to hang up your *batterie de cuisine*.

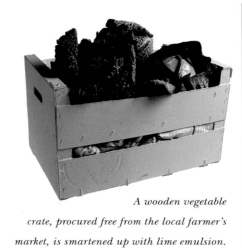

A wooden vegetable crate, procured free from the local farmer's market, is smartened up with lime emulsion.

Empty jam jars with neat, good-looking proportions are ideal for accommodating anything from pens and pencils to flowers.

Empty wall space can be put to good use with a simple Shaker-style peg rack. These bags are made from washable cotton.

A junk/thrift store basket is a useful solution for bulky items such as this thick checked blanket and cushions covered in blue and green cotton.

A simple pine chest of drawers has all manner of uses, from organizing an untidy desk top, to housing fabric samples in a studio.

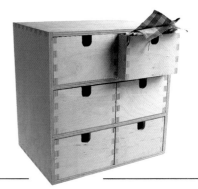

Paint a stack of boxes in a single colour like these Shaker-style ones, coated in bright blue paint.

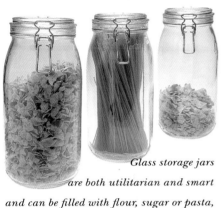

Glass storage jars are both utilitarian and smart and can be filled with flour, sugar or pasta, or used for their original purpose, preserving.

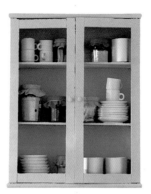

A painted flat-pack cabinet is decorative and practical, for display and storage.

Hang meat hooks from poles for instant hanging space. This old broom handle is supported by metal fittings.

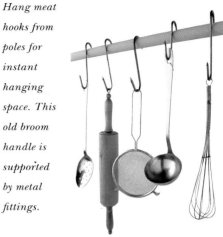

An ugly black clothes rail has been transformed by a lick of white paint into a stylish and moveable wardrobe, ideal for small living spaces. It can be covered with a white sheet to keep the dust off.

Recycle old shoe boxes and cover them with bright cotton fabric as an attractive storage solution in the office, or for children's toys.

Display vegetables and other kitchen ingredients in classic aluminum buckets.

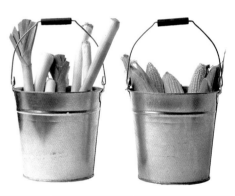

For a smart contemporary look stash spoons and cutlery in metal pots and arrange them in rows on shelves and kitchen surfaces, where they are handy for use.

A wooden two-tiered shoe rack, reminiscent of school cloakrooms, is useful for hallways and bedrooms.

Display

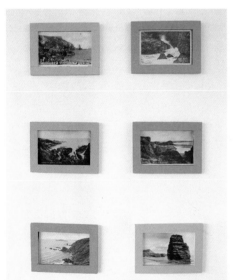

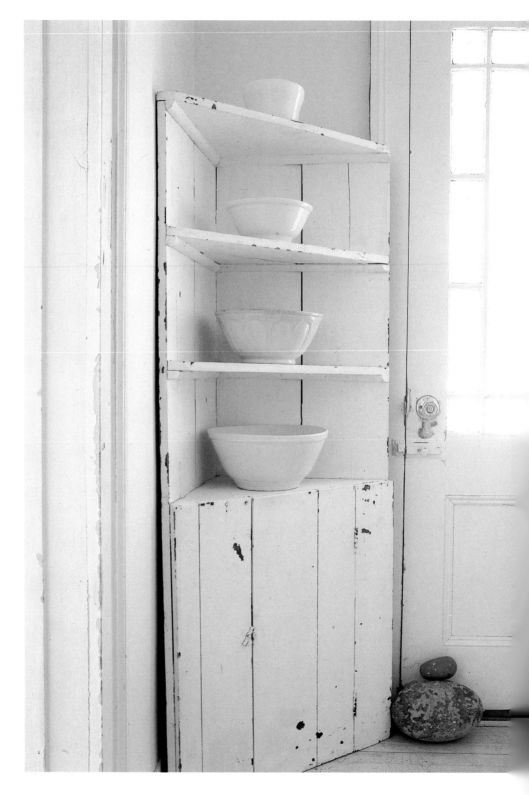

above *Cheap wooden frames painted in varying earthy shades of paint, mounted with old postcards of beach scenes, look great arranged in serried rows on plain white walls.*
right *A favourite collection of old mixing bowls is arranged simply in an old corner cupboard.*

Making a statement about the way you display favourite things, from photographs to kitchen pots and pans, is all part of creating order and giving your living space a characteristic look. There is something arresting to the eye to see collections of basic vernacular objects – even something as common or garden as plain white mugs can look good en masse.

Use natural elements to devise beautifully simple display ideas such as collections of pebbles from the beach; shadow boxes filled with leaves, shells and china fragments from the shoreline; bowls or jars planted with your favourite spring bulbs; and collections of roughly hewn olive baskets.

China and glass

Chunky white china mugs from just about any department store are essential kitchen gear.

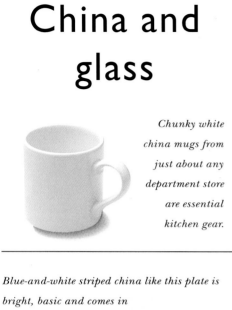

A fabric design of blue-and-white tartanware for serving up shortbread, oatcakes and other Scottish treats.

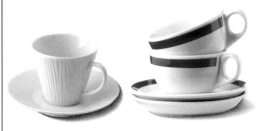

Any self-respecting café dispenses strong black espresso coffee in little heavy-bottomed cups with saucers. Imbibing out of anything larger, or flimsier would diminish the experience.

Blue-and-white striped china like this plate is bright, basic and comes in lots of versatile shapes. It's great for everyday use.

The quality, shape and size of what you drink out of or eat off is pivotal to really relishing what is in your glass or on your plate. I like the ribbed, chunky qualities of glasses that are robust and a pleasure to drink from. The classic proportions of plain white plates also make eating a really pleasing affair; food looks good on them too.

In contemporary sea green, tableware that looks good in kitchen and dining rooms, with green or cream schemes.

Tables decorated on a clean white theme look good with injections of bright colour like this vibrant yellow glass.

Workaday glassware for knocking back iced water and other thirst quenchers.

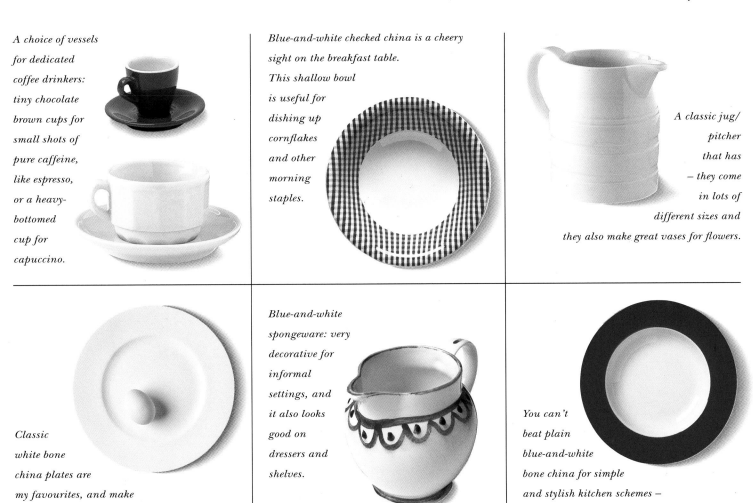

A choice of vessels for dedicated coffee drinkers: tiny chocolate brown cups for small shots of pure caffeine, like espresso, or a heavy-bottomed cup for capuccino.

Blue-and-white checked china is a cheery sight on the breakfast table. This shallow bowl is useful for dishing up cornflakes and other morning staples.

A classic jug/pitcher that has — they come in lots of different sizes and they also make great vases for flowers.

Classic white bone china plates are my favourites, and make the humblest meal look really appetizing.

Blue-and-white spongeware: very decorative for informal settings, and it also looks good on dressers and shelves.

You can't beat plain blue-and-white bone china for simple and stylish kitchen schemes — one of my all-time favourites.

Creamware looks brilliant in country cream painted kitchens, or dining rooms with decorating details in white and other neutrals.

Creamware china for refreshing brews, including a great big cup for warming milky breakfast coffees.

Perfectly formed bowl shapes — for serving everything from porridge and desserts to soups and salads.

PUTTING IT ALL
TOGETH

ER

Colour and comfort are key ingredients in putting rooms together. Bright, light, airy shades of white and cream create inviting spaces, as do stronger greens, lavenders and blues. Choose furniture that combines function with style, and stick to basic shapes. Think about texture to help bring life into your surroundings; draw from nature for inspiration.

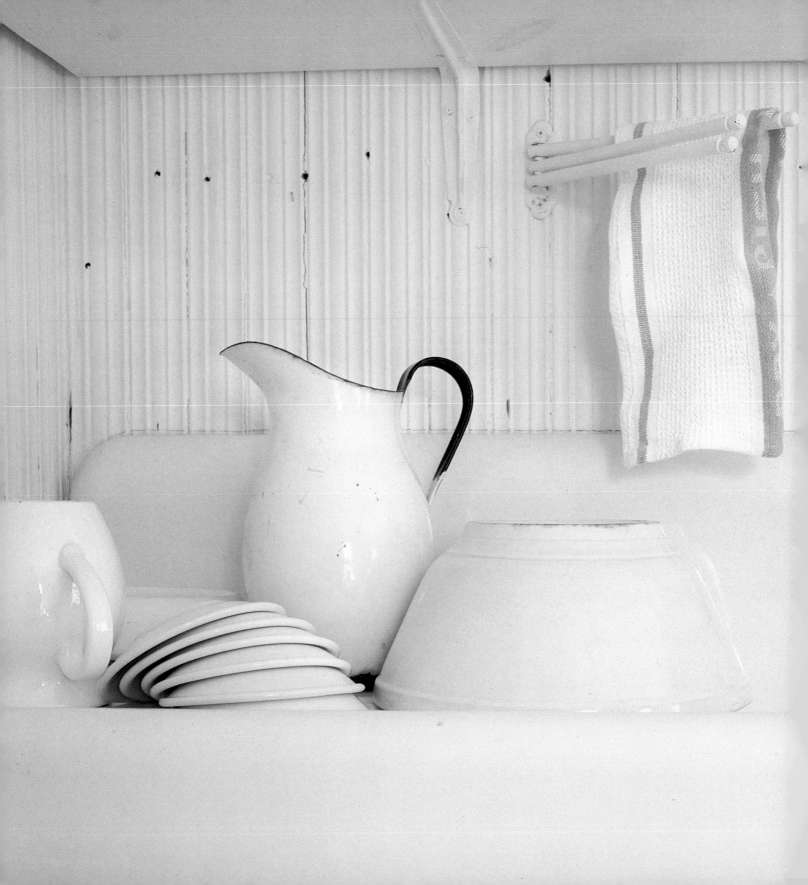

Culinary living

There are an awesome number of items that need to be squeezed into the average kitchen: boxes of breakfast cereals, pots, pans, dishwasher, fridge, sink – the list is endless. Storing and incorporating it all requires planning and thought. Cupboards, drawers, shelves and work surfaces should be considered both for functional and aesthetic appeal. Make surfaces durable and use basic materials like wood, marble, slate and stainless steel. Pare down your kitchen gear to the most basic essentials. Make the daily rituals of eating as pleasurable as is possible or practical. Eat off simple white plates, drink from good glasses, light candles, fill jars with flowers and spread a crisp white linen cloth for special occasions. Preparing food can be a therapeutic experience even if you are busy with work or family. Avoid food fashions (what is it this month – French, Italian or outer Mongolian?) and resist long-drawn-out recipes with impossible-to-find ingredients. Don't become a nervous wreck looking for exactly the right type of extra-virgin olive oil. Stick to food that you like and do well. It's far better to serve up an excellent cheese on toast than a second-rate and unremarkable attempt at something more flashy.

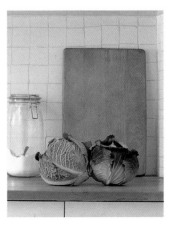

right *Wooden kitchen cupboards and drawers constructed from basic carcasses and painted in tough, matt creamy eggshell textures create understated and smart storage for kitchen kit.*

In the past, kitchens were purely rooms in which to prepare and cook food, while dining rooms were set apart as separate rooms dedicated to eating. To meet the demands of late 20th-century living, kitchens have evolved as spaces which fulfil all sorts of functions, so that eating and living are frequently combined. Different settings dictate different priorities. Rural kitchens need to cope with the toing and froing of muddy feet or paws and are the natural habitats of wonderful warming stoves such as Agas and Rayburns, which are both practical and stylish machines.

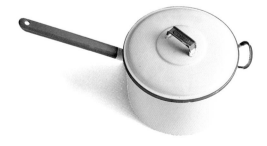

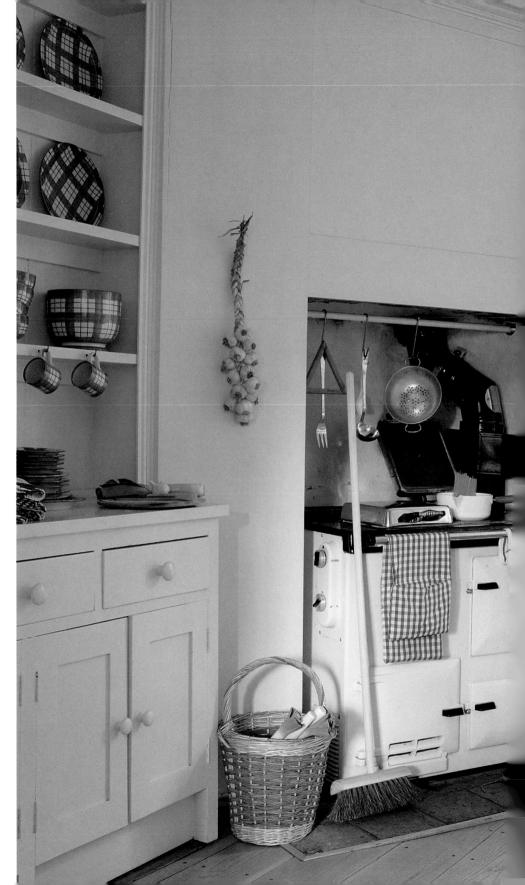

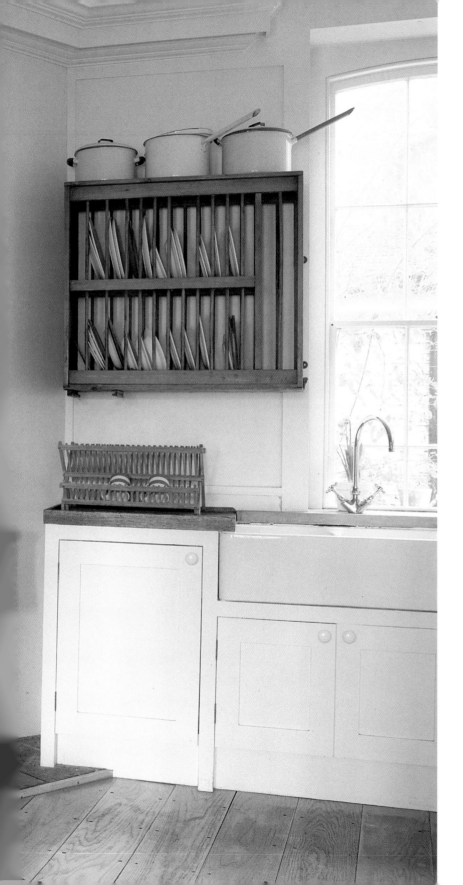

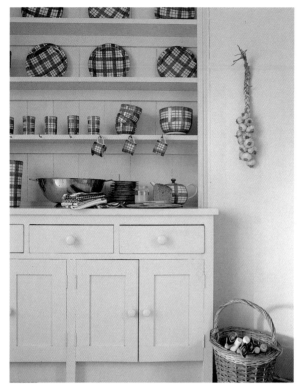

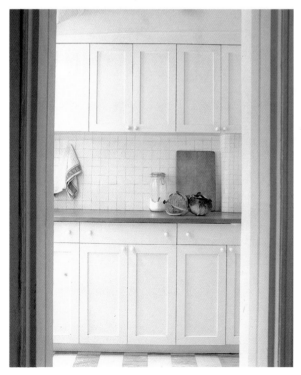

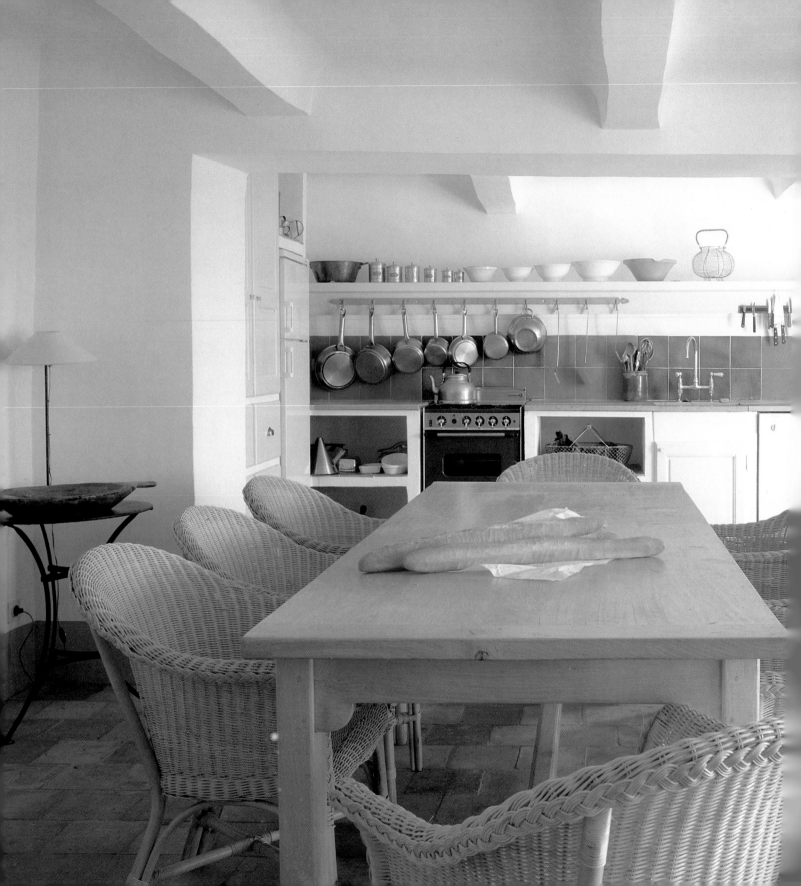

In town, there is more emphasis on the clever siting of labour-saving devices such as dishwashers, electric juicers, microwaves and so on, to help deal with the pressures of city life.

Most food preparation takes place on durable surfaces and there are various options. Oiled regularly and kept pristine with frequent scrubbing, worktops in maple or beech are the ultimate luxury, albeit a costly one. A cheaper solution is to buy lengths of beech block from large DIY outlets. Salvage yards are also a good source of reclaimed timber for work surfaces, for example I found a bargain teak draining board from a Victorian almshouse at a country salvage yard. Despite its association with glossy Hollywood-style bathrooms, marble is a robust, hygienic material and unpolished matt grey, white or creamy textures make practical, understated work surfaces. Marble is particularly affordable at source, for instance in southern France, Spain and Italy. For a really cheap kitchen facelift, laminated plywood is available in lengths from builders' merchants and comes in lots of different colours. The sink is a crucial part of the kitchen work surface and chunky, deep white ceramic Belfast sinks are ideal and can be picked up quite easily second-hand.

left *Clean uncluttered kitchens, with pots and pans neatly stowed away in cupboards or on shelves, are comfortable places where you can lay a big table and entertain your friends in style.*

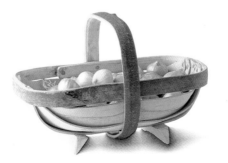

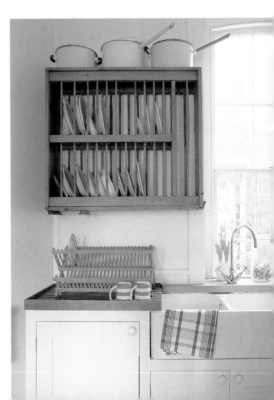

Painted storage

Create stylish storage on a budget with utilitarian basics such as painted tin cans, vegetable crates and terracotta flower pots.

TINS

Recycle used tin cans – baked beans and tomato cans are ideal – and paint them to create smart storage for kitchen utensils.

INSTRUCTIONS

1. Remove the lids with the type of tin/can opener that takes off the entire lid, leaving a clean edge on the can and no lip.

2. Wash the empty cans in hot soapy water to remove the labels. If any glue remains, gently sand with a fine sandpaper. Sand the top rim to take off the sharp edge.

3. Apply two coats of eggshell paint, inside and out.

CRATES

Find some wooden vegetable crates and jazz them up with paint to make kitchen storage. Paint them in various shades of country-kitchen creams or be inventive and experiment with bright blues, greens and yellows, as shown here. As an alternative to vegetable crates, you can attack any kind of box with a paint brush – oyster cartons, shoe boxes and even cereal packets can all be used to make colourful, almost instant storage.

INSTRUCTIONS

1. Wipe down the vegetable crates with a damp cloth and sand lightly to remove any splintered wood. Pull out any nails which are sticking out. and remove labels by scrubbing them with hot water or sanding them away.

2. Once the crates are prepared and dry, apply two coats of paint, sanding between coats.

FLOWER POTS

Introduce splashes of colour to a room with flower pots decorated in pinks, lavenders or any other strong shade. Experiment with motifs – checks, stripes and scallops are just three to consider.

INSTRUCTIONS

1. Before you begin, wash the flower pots, giving them a good scrub with a hard brush to remove all traces of soil and dirt.

2. Leave them to dry out thoroughly in a warm place; any moisture left in the clay will stain the painted finish.

3. Apply two coats of white emulsion/latex paint. When the paint is dry take a pencil and lightly draw your design directly onto the pots.

4. Paint over the pencil lines in a contrasting colour using a fine brush. Take care not to overload it with paint as you will have less control of your brush strokes. It is a good idea to blot the brush on some scrap paper first to remove excess paint and to steady your hand. If any pencil lines still show when you have finished, remove them with a clean, soft eraser after the paint has dried.

6. Place flowers in a glass jar of water and put in the pot. The painted pots are not weatherproof and should not be left outside in rain.

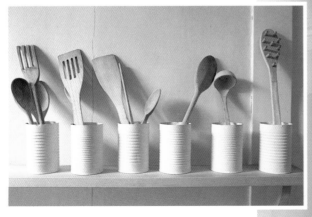

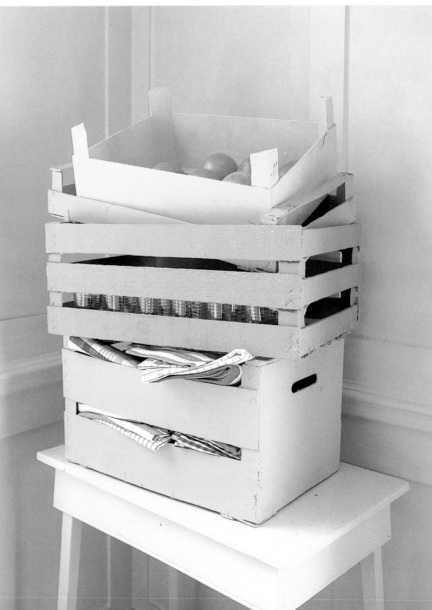

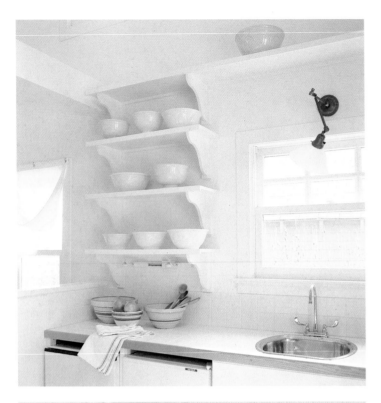

left *Open wooden shelving left in bare wood or painted in the same colour as the rest of the kitchen is a practical and decorative way to display china, kitchen tins and containers.*

Storage solutions are key to creating a well-organized kitchen. At the most basic level simple, open shelves in pine are incredibly useful vehicles for housing plates, glasses, culinary herbs and just about any other kitchen paraphernalia. Collections of tins and boxes in interesting shapes and colours make an attractive display. Screw cup hooks to the underside of pine shelving and you have instant hanging space for mugs, ladles, sieves and whisks. Not everyone is keen to have their kitchen contents on view, so cupboard doors hung on a basic carcass are the perfect camouflage for larder contents or a repertoire of pots and pans.

Wall-to-wall units and cupboards are practical but some custom-made schemes with fancy trims and detailing can be fantastically expensive. For a more individual look – and if you are strapped for cash anyway – combine a minimum of built-in elements such as a sink, cooker and worktop in a unit, together with free-standing features such as a second-hand dresser base jazzed up with paint, or an old metal factory trolley which is ideal for wheeling plates and dishes around. Other useful storage notions include a wall-mounted wooden plate drainer, or a tall, free-standing larder cupboard, ideal for filling with heavy items like tins, groceries and china.

right *A bright, cheerful kitchen with a utilitarian feel. Pride of place is given to a magnificent forties cooker that deals with cooking operations as efficiently as any contemporary model. Crisp blue-and-white checked lino floor tiles and a cotton tablecloth complete the homey, relaxed atmosphere.*

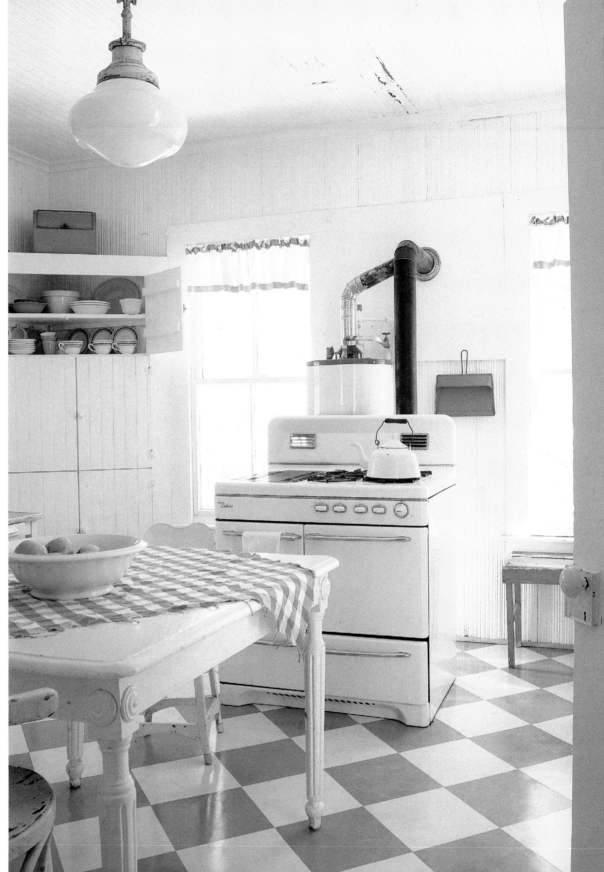

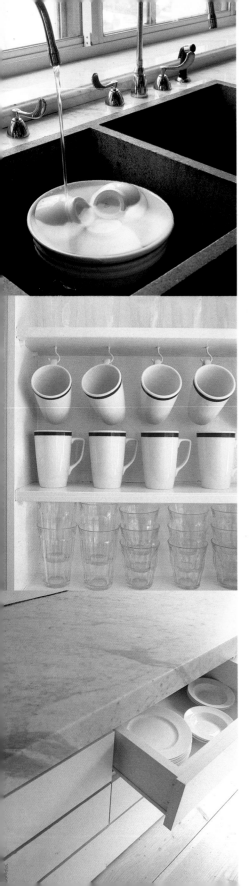

top left *Practical and functional: a wonderfully deep granite double sink that allows different washing operations to be carried out at the same time, a great idea for large families, or busy cooks who create a lot of washing up.*

centre left *Wooden shelving studded with cup hooks is a space-saving way of storing rows of smart blue-and-white mugs and basic drinking glasses.*

left *Although kitchen drawers are not an immediately obvious solution for storing china, in the absence of cupboards they work extremely well.*

right *In the streamlined and minimalist reinvention of a London terraced house, the area beneath the staircase has been artfully designed to contain storage behind a series of white lacquered flush-fitting cupboard doors.*

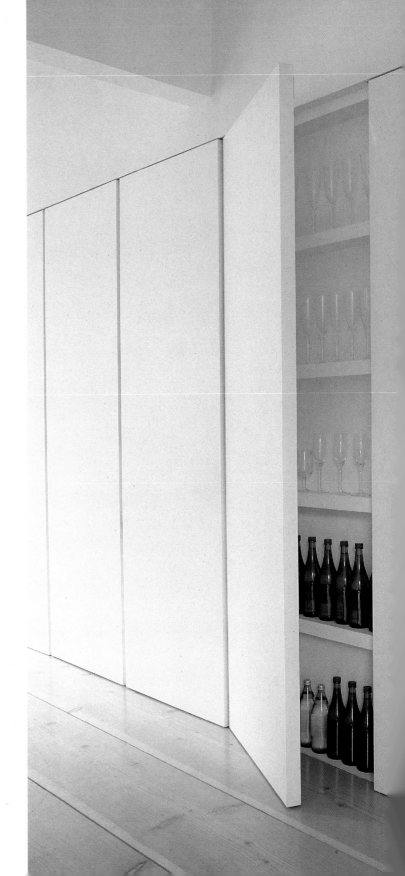

this page *Kitchen elements with a smooth, streamlined and contemporary edge are definitely no-go areas for clutter and chaos. Materials such as marble and zinc are practical worktop ideas, whilst pans in durable stainless steel look great.*

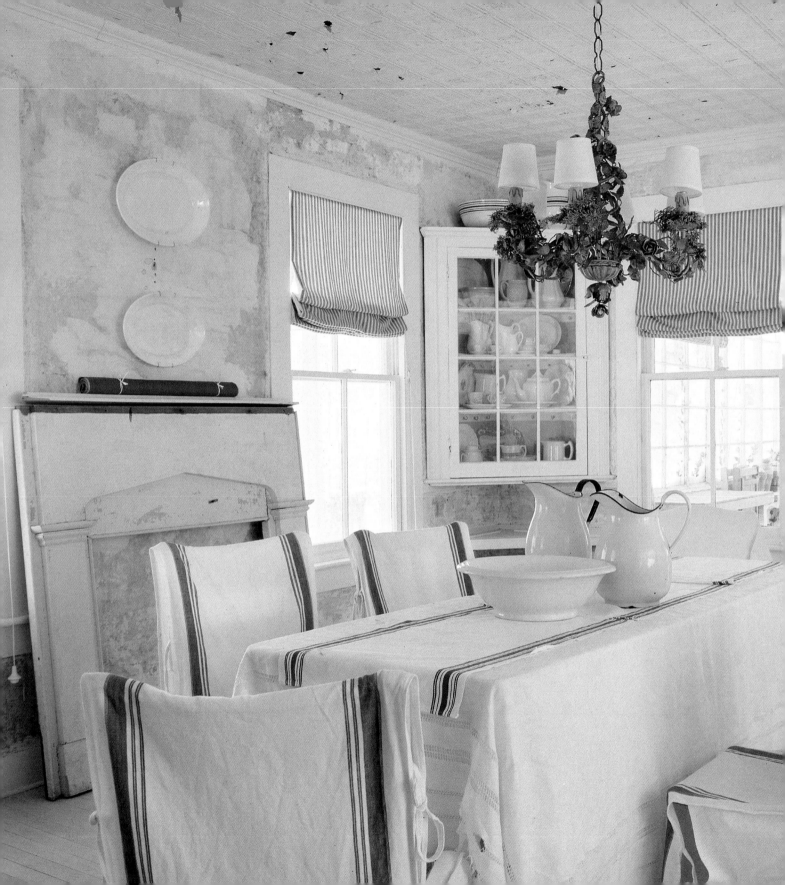

left **left** Blue-and-white *striped cotton roller towel, used for chair covers or for table runners as here, can be sourced from specialist companies who supply institutions.*
below *Crisp plain white cotton tablecloths work in any setting. A row of narcissi planted in big mixing bowls creates simple, colourful and scented decoration for parties and everyday use.*

Eating and drinking, however humble and low-key an affair, should be revelled in and made the most of. As well as deciding what to eat at any particular meal, what to eat it off and what sort of mood you want to convey are of equal importance. At the end of a gruelling day with three children there are few frills at my table, but it's still worth lighting candles or finding some ironed linen napkins to create a sense of occasion. Table settings needn't be elaborate affairs. Pleasing textures and well-made glass, china and cutlery are the crucial elements. On a day-to-day basis you might settle for a crisp check cloth with a jar of garden flowers, basic white plates and simple glass tumblers. When friends come it's worth pushing the boat out and laying a crisp, white linen cloth and napkins, together with candles, your best bone-handled cutlery and wine glasses.

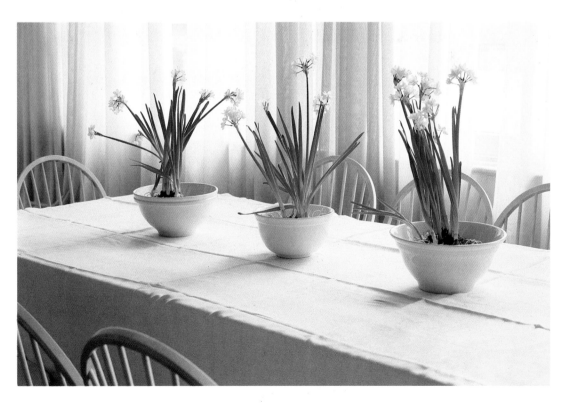

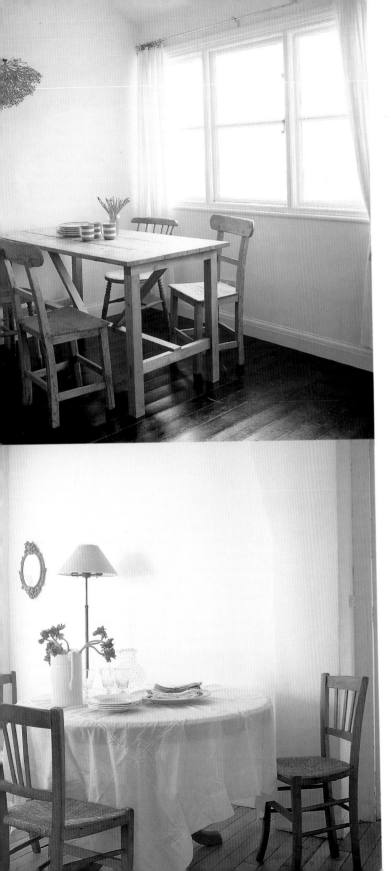

The sales are brilliant sources of discounted china and where I go to buy seconds of white Wedgwood bone china plates. Street markets and junk/thrift stores are useful for single pieces of antique glass. During a weekly hunt around my local market in London's East End, I pounced upon half a dozen late-Victorian heavy wine glasses, each one different, and use them to serve up everything from jellies/jellos to drinks. Department stores are good for table linen, together with an ever-growing number of mail-order companies. Alternatively, you could make your own tablecloths and napkins from specially wide linen from fabric wholesalers, or run up fabric by the yard or metre. If you're really stuck, simply use a plain white sheet. And if you have a children's party to organize, buy plain white disposable paper cloths available from most department stores.

One of the best things about assembling table settings is thinking of natural greenery and floral components for decoration. In the autumn, plates of nuts or leaves look striking and so do vases of branches studded with bright red berries. At Christmas time I spray apples with gold paint and put them in a big wooden bowl for decoration on the table, or hang them on string from a chandelier. I also scatter small branches of Christmas tree cuttings on the table and for some early seasonal colour and scent there are pots

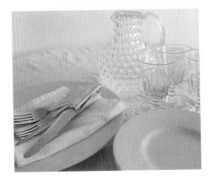

Wooden dining chairs come in a variety of shapes. Don't worry if yours aren't all the same design: a mix of styles, sourced from second-hand and junk/thrift stores, can look just as good as a fully matching set.

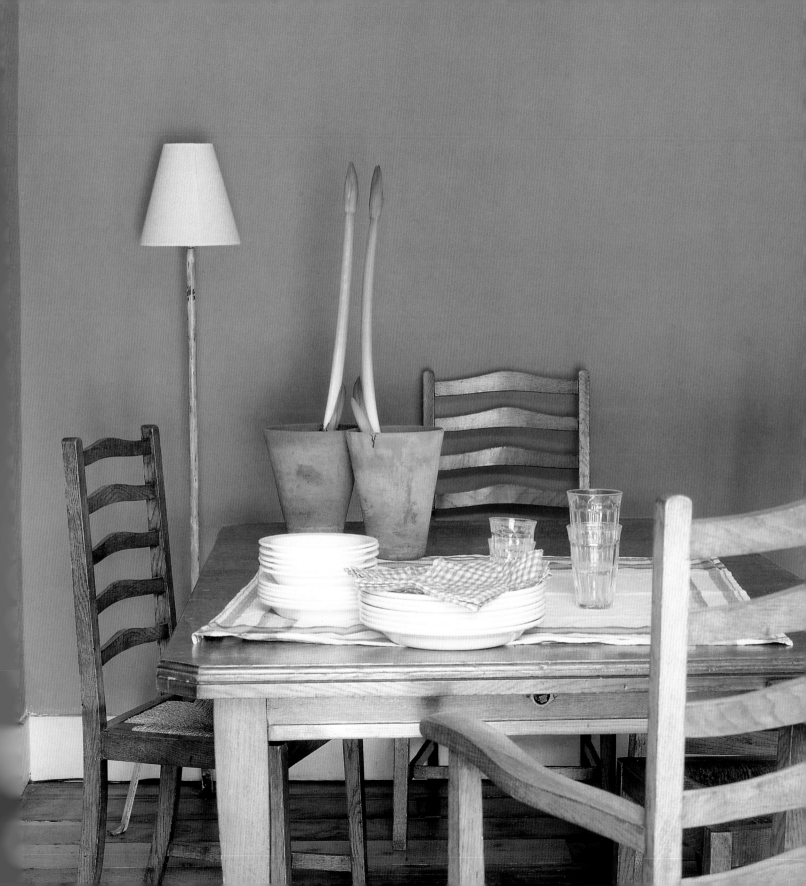

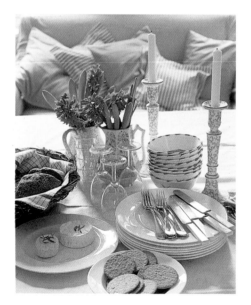

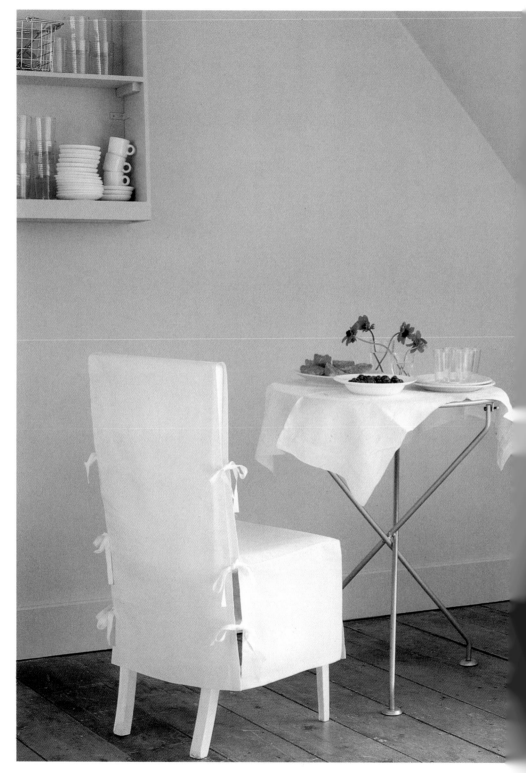

above *Plain white china plates, bowls and cups look great against any colour scheme, and always make food look appealing, however humble your offering. Specialist catering shops can often yield good buys.*

of flowering narcissi or hyacinths. In early spring I like to fill metal buckets with the bright green sticky buds of chestnut branches or pussy willow, but summer tables are the most fun to create: I pick nasturtiums and sweet peas from my back yard and bring home armfuls of cow parsley after a day out in the countryside. Even a few jugs/pitchers of fresh herbs, like rosemary, thyme, lavender or parsley make basic but beautiful decorations. Sometimes we've rented a cottage in Cornwall and there the summer hedgerows are thick with purple foxgloves which are stunning for table embellishments simply stuffed into tall, glass jars and vases.

On trips to Spain everyone eats outside in the evening sitting around trestle tables laid with grilled/broiled fish, meat, pasta, bread, wine and cheese. After the glut of wild spring blooms such as orchids, daisies, and lilies, it's harder to find flowers during the months of summer drought. A useful source is the local market wherel white tuberoses are sold, a few stems of which produce a glorious intoxicating scent as night falls. Otherwise the table is decorated with vases of silvery-grey olive cuttings. We get the barbecue going and cook up everything from sardines to slivers of (bell) pepper, courgette/zucchini and aubergine/eggplant.

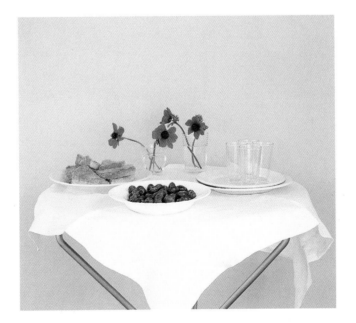

left *Soft lilac paint on the walls is a good foil for covers in calico and a plain white cloth. A lime green checked cotton curtain and single stems of purple anemones provide a colourful contrast in this fresh and inviting dining set-up for two.*

Making preserves

These recipes, savoury and sweet, have one thing in common: they are simple and satisfying to prepare, use fresh, natural ingredients, and are absolutely delicious.

STRAWBERRY JAM INGREDIENTS

1 kg (2 lb) strawberries, washed and patted dry, then hulled

1 kg (2 lb) sugar with pectin

juice of a lemon

PESTO INGREDIENTS

50 g (2 oz) basil leaves

50 g (2 oz) pine nuts

3 garlic cloves

175 ml (6 fl oz) olive oil

50 g (2 oz) grated Parmesan and

50 g (2 oz) grated pecorino (or double the amount of Parmesan)

LEMON CURD INGREDIENTS

grated rind and juice of 4 lemons

4 very fresh eggs

125 g (4 oz) butter, cut into small pieces

375 g (12 oz) caster sugar

STRAWBERRY JAM

Wonderful simply spread on toast with butter, strawberry jam can be stirred into natural/plain yoghurt for a simple dessert; layered between cakes, dolloped on scones with cream, or used as a base for tarts and pies.

METHOD

1. Put the strawberries in a preserving pan with the sugar and lemon juice. Heat gently until the sugar has dissolved, stirring frequently.

2. Bring to the boil and boil steadily for about four minutes or until setting point is reached (a spoonful on a cold plate will hold its shape and when cool will wrinkle when pushed gently with a finger).

3. Remove from the heat and skim off any scum with a metal slotted spoon. Leave to stand for 15–20 minutes to prevent the fruit rising in the jars.

4. Stir the jam gently then pot and cover with wax discs, wax side down, and cellophane rounds.

PESTO

This simple Italian sauce is fabulous with pasta. Stir in two tablespoons for every serving and top with more grated Parmesan. Use it to accompany grilled swordfish or tuna steaks, or as a filling for baked potatoes.

METHOD

Place all the ingredients, except the cheeses, in a blender and whizz to a rough paste. Then stir in the cheese. Serve immediately or store in covered jars in the refrigerator and use within three days.

LEMON CURD

Making curd is one of the most delicious ways of preserving fruit. Limes and oranges both make very good curd but the traditional favourite is lemon curd. Do not make huge quantities in any one batch as the mixture will heat through unevenly and be likely to curdle. Lemon curd is delicious by the spoonful straight from the pot. Less gluttonous

suggestions include spreading it on bread, using it as pancake filling or for lining the bases of fruit tarts and pies, or making traditional individual lemon curd tartlets. Or try serving it as a delectable dessert in tiny pots with home-made shortbread.

METHOD

1. Place all the ingredients in the top of a double saucepan or in a deep heatproof bowl standing over a pan of simmering water. Do not allow the base of the bowl to touch the boiling water.

2. Stir until the sugar has dissolved and continue heating gently, without boiling, for about 20 minutes or until the curd is thick enough to coat the back of a wooden spoon.

3. Strain the curd into jars and cover with wax discs, wax side down, and cellophane rounds. Serve immediately or store in the refrigerator and use within three days.

Substitute the lemons with limes or oranges for other fruit curds.

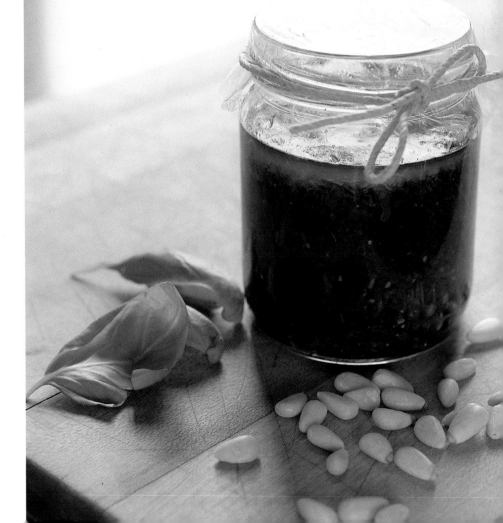

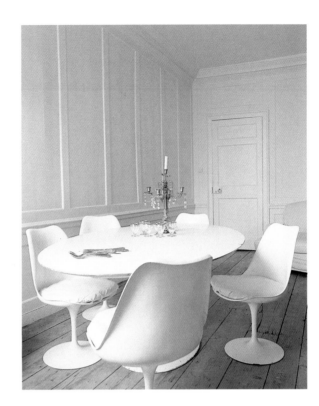

Table embellishments can be simple yet striking: **left** *Topiary shapes work well in terracotta flower pots. Try a leggy myrtle standard, like the one shown here, or other shapes in box/boxwood or bay.* **above** *A pretty candelabra, a lucky find in a Roman market, looks especially lovely at night.*

The seating arrangements of any dining area are dependent upon the space that's available. If it is limited, tables and chairs might need to be of the fold-up variety and stowed away when necessary. On the other hand, generously proportioned rooms can accommodate big wooden refectory tables, or oval and round shapes and deep comfortable seating. Don't worry about having sets of matching chairs as disparate shapes, especially junk wooden kitchen chairs, can look quite good together and if you want to create a sense of unity you can cover them in simple pull-on loose covers/slipcovers in calico, or some other durable and washable texture. (See pages 84-85 for some colourful examples in blue-and-white striped roller-towel cotton).

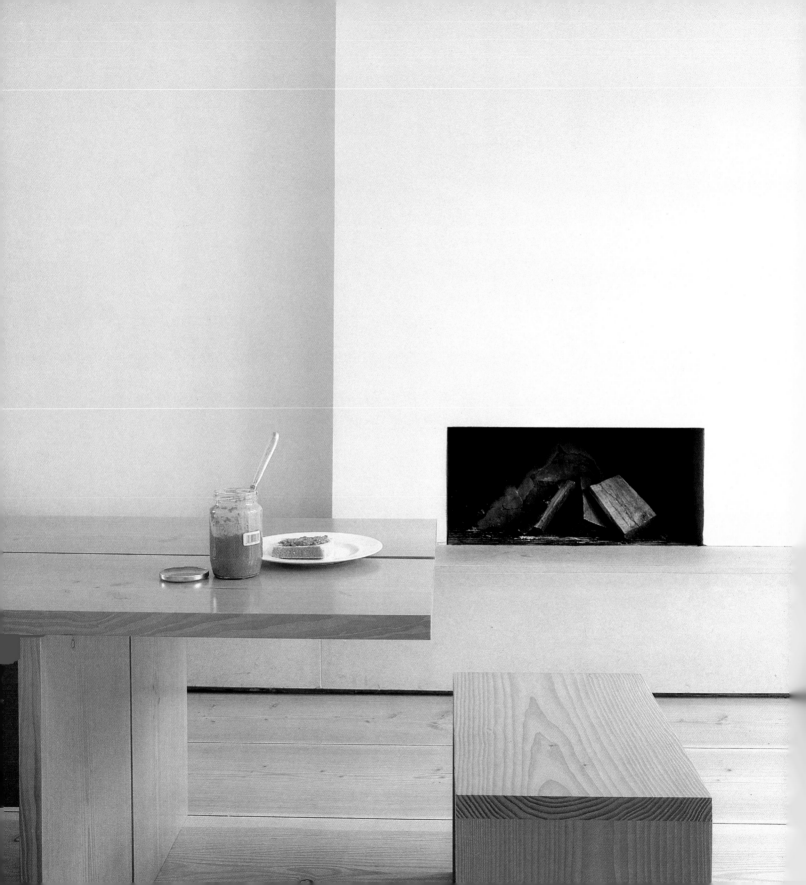

Choose a table to suit the style of the rest of the dining area. Rustic farmhouse shapes in wood look good almost anywhere and are practical and robust. Very contemporary streamlined models with zinc, stainless steel or laminated surfaces suit more modern settings. If furniture classics are your penchant, look to early 20th-century designs, such as simple ladderback oak chairs and solid oak tables, or more recent classics such as the sensually moulded white bucket-shaped Tulip chairs from the 1950s, shown on page 93. Since most people prefer suites of brand new dining furniture, excursions to markets and probing among junk/thrift stores can yield fantastic buys at bargain prices. If you need to make extra table space for a party you can make a very basic dining table from a piece of board or even an old door laid over a pair of trestles; simply disguise the makeshift base in a plain white sheet.

Other useful elements for dining areas include a side table or sideboard from which

left and above *Refectory style: a plain table and benches in solid Douglas fir pine are spare and minimal solutions for dining. Equally streamlined are the full-length limestone bench seating down one wall and the open fireplace.*

right *Low-backed wooden office chairs on wheels and a mahogany door laid on metal trestles are inventive ideas that are well suited to the wide-open contemporary living space in this converted London industrial building.*

to serve food or to display flowers or lighting. It's always handy to have supplies of plates, bowls and glasses close at hand, either stored on open shelving or in cupboards.

One of the highlights of winter is to be able to enjoy an open fire. If you are lucky enough to possess a working fireplace, gather some logs and kindling (or be practical and have them delivered) and give your guests the luxury of a warming blaze. Candlelight is the best and most romantic light to eat by. I buy creamy coloured church candles from a candlemaker at a nearby Greek Orthodox Church. If you don't possess particularly nice candlesticks, stick the candles on plain white plates or leave them free-standing for subtle illumination.

right *More colourful treatments for dining rooms include the yellow, green and blue scheme shown here. Pale cream walls in eggshell create a plain backdrop for splashes of more vibrant colours such as blue-and-white checked cotton Roman blinds/shades, sofa cushions in lime green and blue, and a simple metal chandelier in matt yellow paint. On the table, the plastic green checked cloth, available by the metre/yard from department stores, is smart and practical for everyday use. Flowering spring bulbs, bought cheaply by the tray from a local market, and planted in painted flower pots, provide scent and sunny detail.*

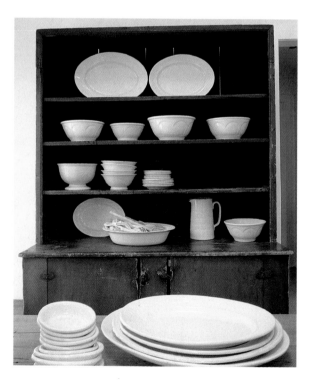

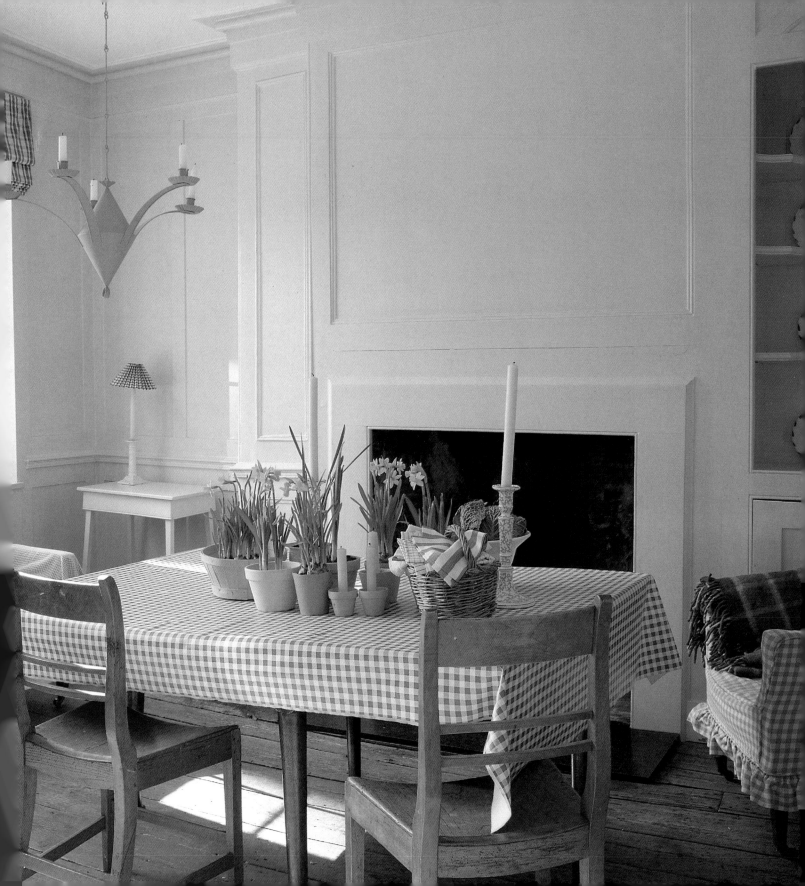

Relaxed living

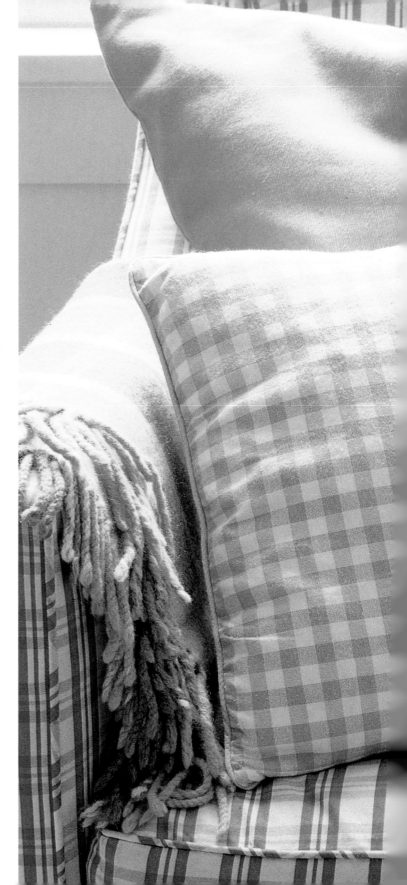

Even the most frenetic workaholics need time to sink into a comfortable chair, put their feet up and contemplate life. It's good to be nurtured by music, soft cushions or a blazing fire. Living rooms are tailored to meet the demands of their occupants — families with small children require battle-proof chairs and fabrics, while single individuals with no danger of sabotage by sticky hands might make a sumptuous wall-to-wall white scheme their priority. But whatever your family status, gender or age, comfort and texture are the most important factors for rooms in which you want to wind down. Use colours that soothe and are light enhancing — such as soft creams or bone whites — and keep paint textures matt. Buy really solid comfortable upholstery, and proper feather-filled cushions. Be selective with the fabric textures that you use. Seek out tough linens in beautiful creams and naturals, or strong woven cottons in ticking, checked and striped designs. Experiment with bright plain

colours — blues, greens, pinks and orange. Explore the variety of warm woollen fibres, for use as upholstery, soft throws or insulating curtains. Bring the room alive with natural elements: light scented candles or soak up the warmth of a blazing fire.

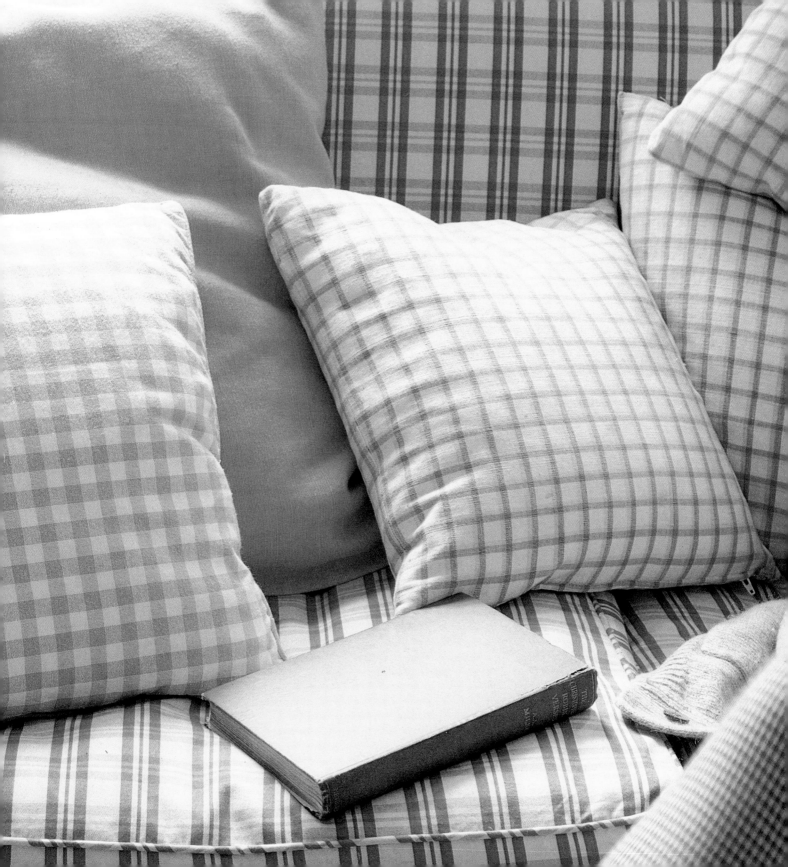

Living rooms should be comfortable and relaxed rooms where you can sprawl out on a sofa with a good book, listen to music, watch the television, or simply sit back and think. Colour, comfort, texture and warmth are important factors in putting together an agreeable space.

From curtains to loose covers/ slipcases, fabric colours can change a room as much as the impact of paint. Don't worry about slavishly matching the cushion cover, to the curtain lining, to the tie on your favourite slipcover. It is more interesting to try out similar but contrasting fabric shades. I remember a room I decorated to a spring theme where creamy yellow walls contrasted with bright

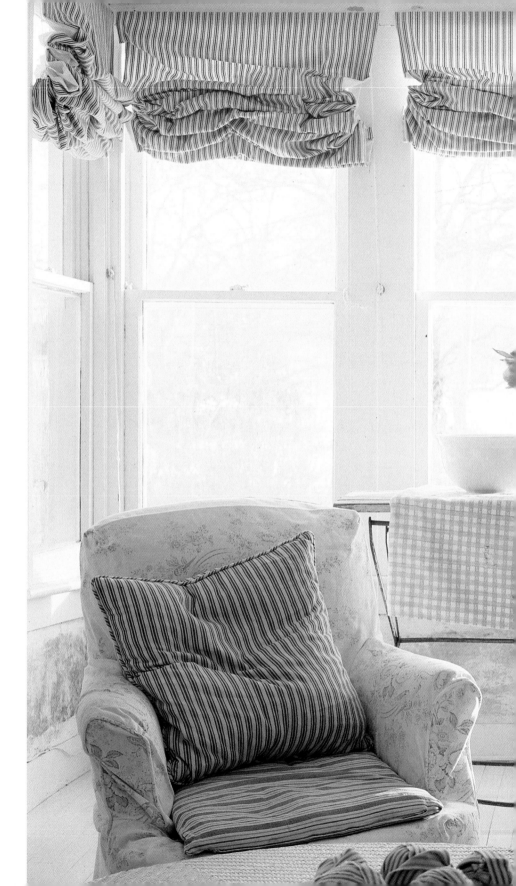

right *Blue-and-white is fresh with decorative details like crisp striped cushions and scrunchy Roman blinds/ shades, faded floral loose covers/slipcases, and lots of checked cotton accessories.*

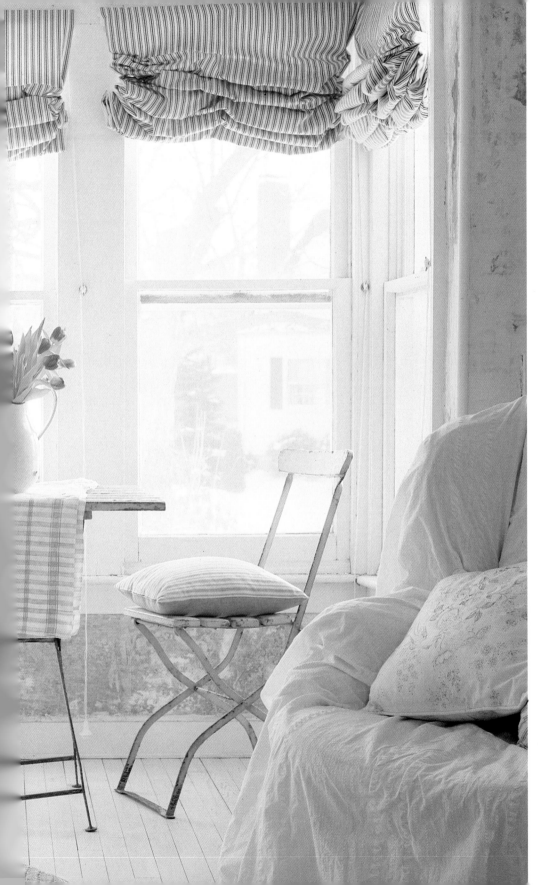

below *French metal daybeds can be found in salesrooms and antique shops and look great with striped cotton ticking bolsters or plain white cushions or throws. Paint them white or leave them bare.*

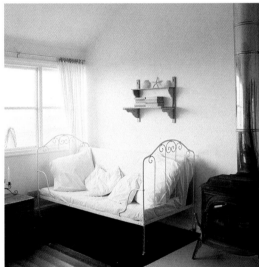

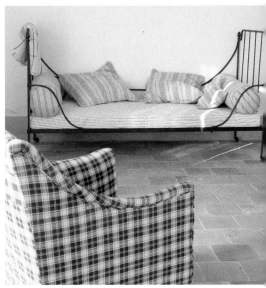

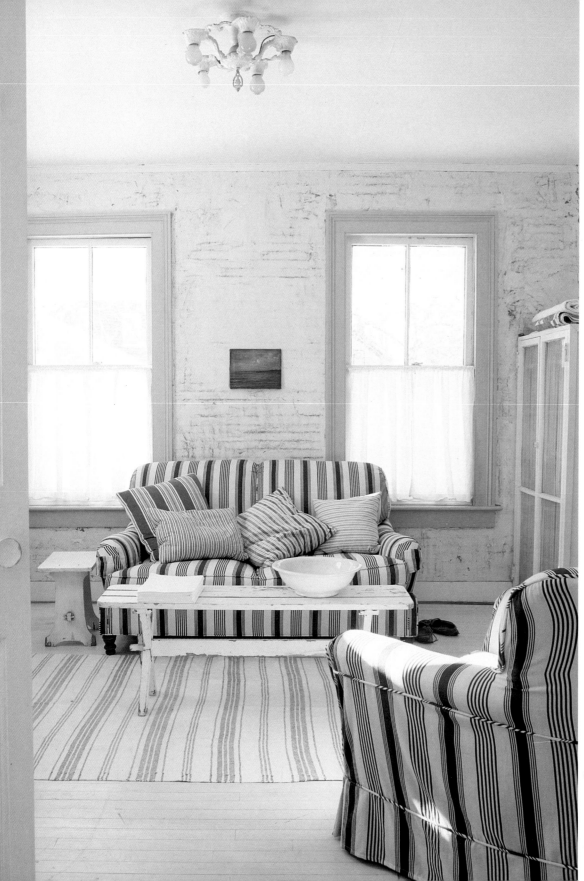

Blues, greens and greys
are useful colour tools.
left *Powder blue
paintwork looks sharp
against bold navy striped
slip covers and cushions
in assorted shades of
blue cotton stripe. White
brickwork walls and
whitened parquet
flooring emphasize the
airy feel.*
far right *A painted grey
skirting adds subtle
definition to plain white
walls in a light and
fresh Provençal sitting
room. Reclaimed
terracotta tiles laid in
an uneven pattern
add to the
vernacular effect.*
right *Warming not cold:
rich blue-green emulsion
paint makes a distinctive
foil for white woodwork, a
plain white dustsheet
throw and polished
wooden floorboards.*

green-and-white checked blinds/shades, together with loose covers/slipcovers in a dark cabbage-leaf colour and cushions in a lime green and thin blue-and-white striped cotton. The overall effect was bright, sunny and easy to live with.

Sitting rooms must be comfortable and this relies partly on well-made, sturdy upholstery. It is far more satisfactory to invest in a good-quality second-hand sofa, say, than something brand new, mass-produced and lightweight. I know an enterprising woman who sells everything from hand-me-down Knole sofas from stately homes to junk armchairs, all piled up in barns and outhouses in a farmhouse. If you invest in new upholstery test it out for comfort before

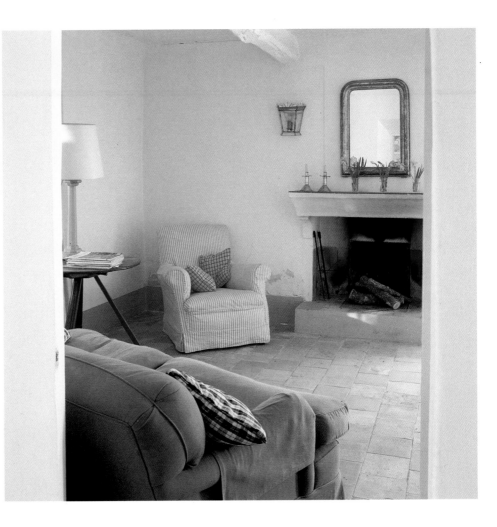

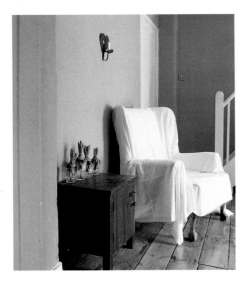

buying: sit on it for ten minutes, bounce up and down on the seat (you should be able to feel the underlying support); lean back (you should not feel any springs protruding from the framework); lift it to test the weight of the framework (it should not be too lightweight).

Upholstery fabric should be hard-wearing. Some of the best fabrics are linen and linen–cotton mixes. A few

years ago I found some wonderful earthy coloured linen reduced at a fabric outlet, on sale at 15 per cent of the usual price. I bought up enough to cover a Victorian chesterfield. Despite heavy wear and tear from parties, children, dogs and cats it is still looking respectable, only of course I am now itching to find another bargain. Loose or slip covers are practical for cleaning and a budget way of updating

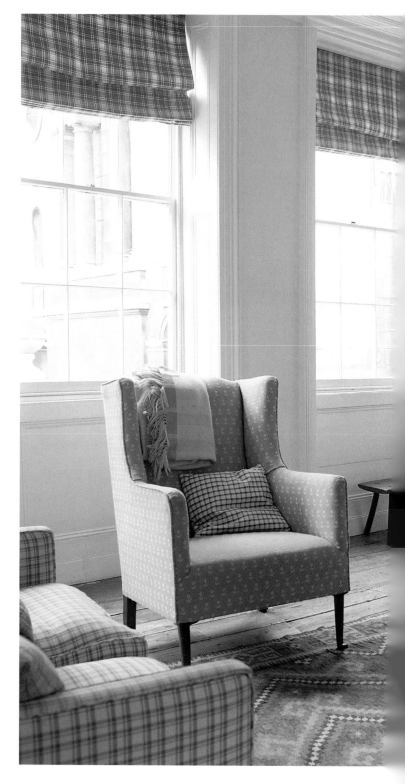

sofas and chairs. Loose covers/slipcovers can be made up with various details such as pleated or simple box skirts, self ties at the corners, or a row of buttons or a bow at the back. If you want a really instant update, cover up an unattractive sofa, perhaps in rented accommodation, with a white sheet or a simple check cotton throw. This is also a good idea for giving upholstery a change for the summer.

You can create a wonderful room with a great colour scheme and lots of decorative ideas, but if it's cold, it's miserable. The ultimate in warmth and atmosphere is a blazing log fire – and woods such as chestnut and apple give off delicious smoky scents. Ecologically sound but second-best is smokeless coal. Not everybody has access to wood, or the inclination to lay and maintain a real fire, so flame-effect fires are worth considering. Although they don't throw out as much heat as a real fire and inevitably look artificial, they are not a bad compromise. Underfloor heating schemes, common in Scandinavia and North America, involve hidden pipes connected to the central-heating system – a great way of dispensing with unsightly radiators.

Splashes of terracotta act as warming detail in the cream sitting room of a London Georgian town-house. Amongst furnishing and fabrics in blues, greens and yellows there is a kelim rug in faded earth and brick. Spread across the marble mantlepiece are old clay pots and a rosemary wreath. Other rich ingredients seen below include old wooden Spanish soup bowls filled with rag balls made of scraps of checked and striped cotton and an antique three-legged milking stool. Opposite, a fold-up butler's tray acts as a versatile display idea with a candlestick lamp and a jug of spring flowers.

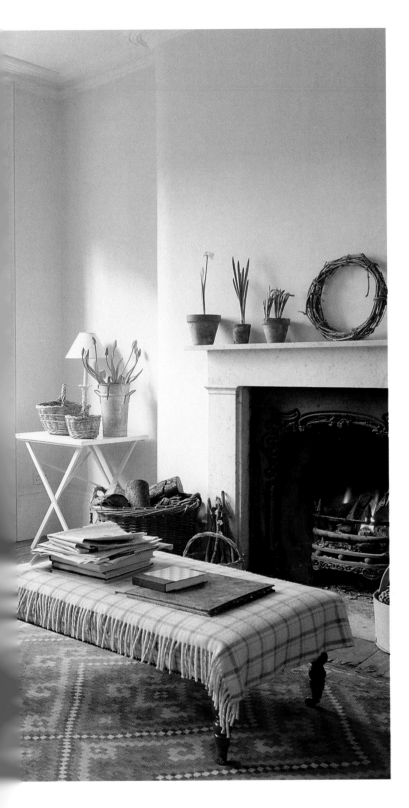

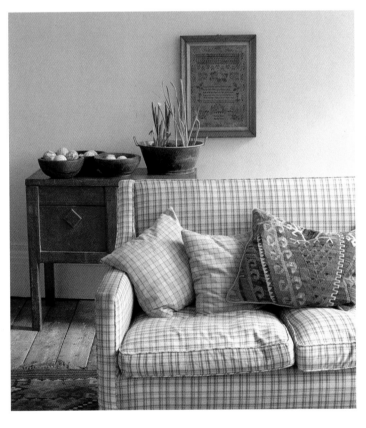

Roman blind/shade

Roman blinds/shades are a simple and stylish window treatment for any room around the house and do not require massive amounts of fabric. For durability make blinds/shades up in a tough fabric texture such as heavy canvas, linen or calico as in the creamy coloured example shown here, which as been self-lined to make it look smart from the outside.

MEASURING UP

1. Roman blinds/shades can either hang outside the window frame so that the entire window frame is covered or, as illustrated here, they can fit neatly into a recess.

2. Measure the width and length of the window in order to calculate the amount of fabric you need. Cut two pieces of fabric each 9 cm (3½ in) wider and 11.5 cm (4½ in) longer than the window.

MAKING UP

1. To fit a Roman blind/shade to the window it should be attached to a wooden batten, cut to fit the width of your window and hung from brackets fixed either side of the window frame.

2. I find it easier to take the blind/shade down to clean it if it is secured to the batten by Velcro. Using either a staple gun or tacks, secure the toothed side of the Velcro to the top edge of the batten.

3. Take the two pieces of fabric and, with right sides facing, pin, baste and machine stitch them together along the two long edges and one of the short edges, using a seam allowance of 1 cm (½ in). Turn right side out and press.

4. Cut two pieces of ringed tape to the same length as the blind/shade. The first ring should start 15 cm (6 in) from the top

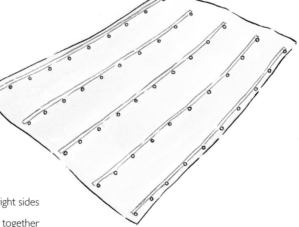

of the blind/shade. Pin these pieces of tape along each side of the blind/shade, close to the edge, then machine stitch in place. Space the remaining tape

evenly at approximately 30 cm (12 in) intervals. Check that the loops on all of the tapes are level across the width of the blind/shade and then cut the pieces to length and pin and machine stitch them in place.

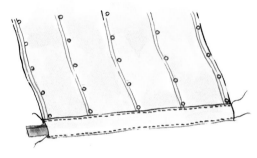

5. To finish the bottom edge, turn under 1 cm (½ in) and then 4 cm (1½ in), enclosing the ends of the tapes. Press and then machine stitch, taking care not to catch the loops whilst stitching. Machine stitch the hem close to the folded edge. Insert the lath into the casing to stiffen the blind/shade and to help it to hang well. Secure the ends with hand stitching.

6. Turn the top of the blind/shade over 1 cm (½ in) towards the tape. Pin, baste and machine stitch the other Velcro strip to this edge.

7. To calculate the amount of cord you need for each row of tape, measure twice the length of the blind/shade plus one width. Tie one length of cord to the bottom ring of each row of tape and then thread the cord up through every loop in the tape to the top ring.

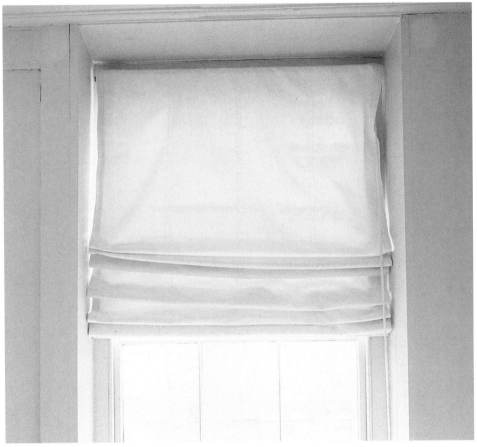

8. Fix an eyelet into the lower edge of the batten above each row of tape. Attach the blind/shade to the batten with the Velcro and run the cords through the eyelets so that they all meet at the far left. Trim the cords to the same length and knot.

9. Fix the batten to the top of the window. Screw a cleat to the window frame so that the cords can be secured when the blind/shade is pulled up.

this page *Neutral tones of white and cream create a peaceful feeling. Contemporary details include market finds such as a sixties basket chair and sunburst mirror, together with simple picture frames and streamlined lighting.*

far right *Harking back to fifties gum commercials, the owner of this cosy panelled sitting room in a traditional shingled house on Long Island aptly describes the subtly coloured paintwork as chewing-gum grey. Rough sisal matting, pine planking (resourcefully salvaged from packing crates) and neutrally coloured linen fabrics add to the fresh and understated effect.*

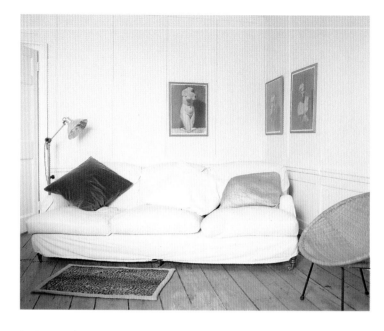

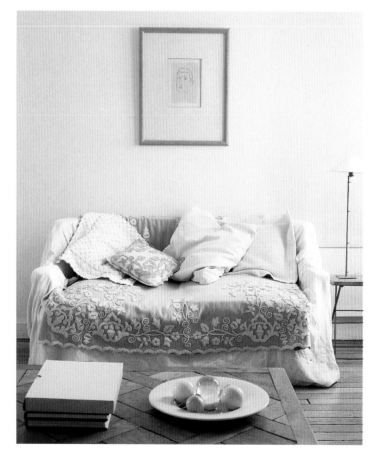

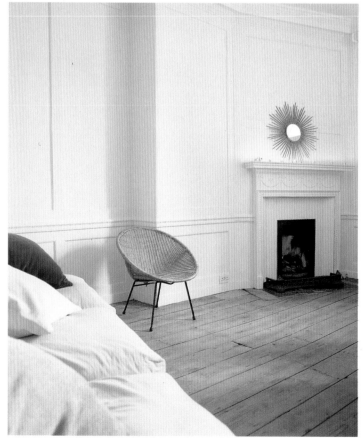

Cushions are important comfort factors. Buy proper feather or kapok-filled pads, as foam fillings are unsightly and lumpy. Pads squeezed into mean-sized covers don't look good, so make covers roomy and allow the cushion to 'breathe'. Simple piped cushions or flanged shapes are perennial classics. Bags with tie openings look good and are incredibly easy to run up on the sewing machine at home. You can make up cushions in just about any fabric – I like tough blue-and-white checked Indian cotton, striped ticking and light cotton in bright shades (which is good for a summery feel). You can also recycle covers from chopped-up old curtains, table cloths and off-cuts of fabric in your favourite colours or patterns. Anything faded and floral, especially blues and whites or soft pinks and lavenders will work well with checks, stripes and plains. If, say, you hanker after a beautiful floral cotton but can't afford the hefty price tag for a big soft furnishing project, then why not buy just half a metre/ yard, the average price of a pair of shoes, and make it up into a beautiful cushion for a favourite chair. It will last longer than the shoes!

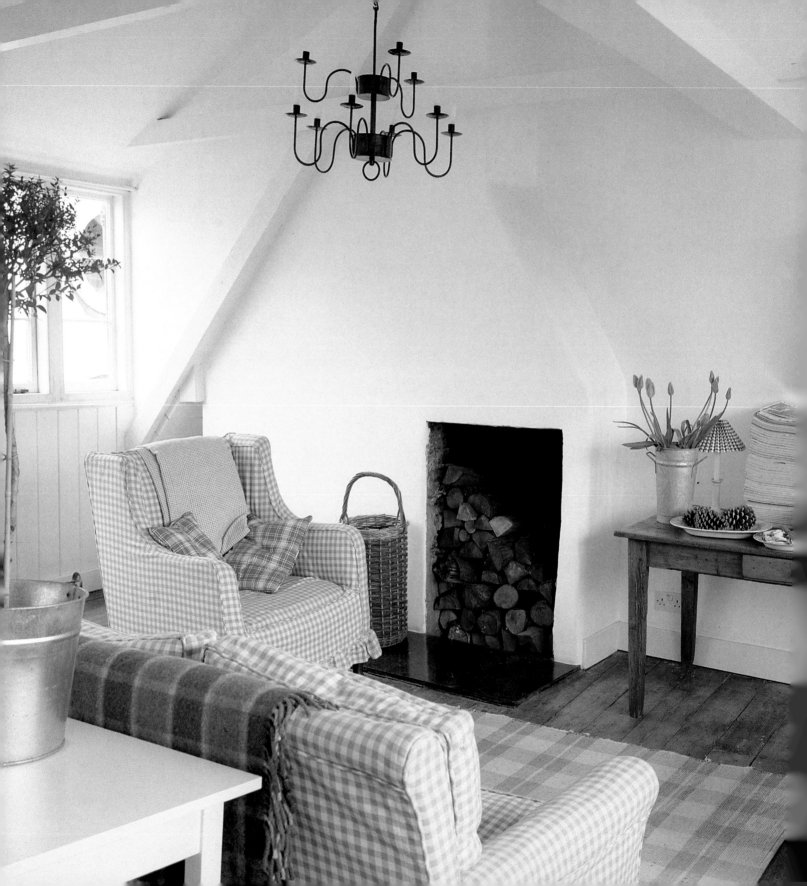

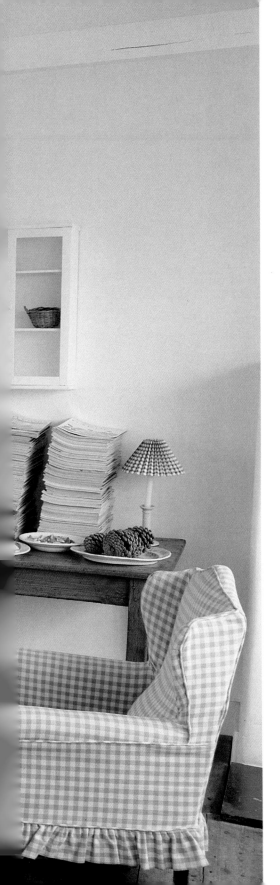

Deep-pile, wall-to-wall white carpet might be appropriate in a boudoir-like bedroom, but for everyday stylish living natural flooring textures such as coir, sisal, seagrass and cotton, or wool rugs in checks and stripes, are more liveable with in terms of cost and practicality. For insulation, layer rugs over one another. Buy mats that are bound with hessian or woven cotton borders as these look better and prevent fraying. Cotton rugs are cheap and many are designed to be thrown in the washing machine, but remember that very bright colours might run and so should be hand washed. Thick tartan/plaid wool rugs are a good investment.

far left *For a homespun feel with an updated edge this loft space has been decorated with pristine white walls, contemporary galvanized metal buckets and a primitive-style metal chandelier. Woven cotton bought in a sale has been used to make simple loose covers/ slipcovers for a battered old sofa and chairs.*
left *More homespun ideas: disparate furniture from a sale is unified with soft grey paint.*

Loose cover/slipcover for a sofa

If you have an old sofa at home that's looking a bit worse for wear, don't get rid of it. Old sofas are usually far more solidly built than new ones, so it's worth giving it a fresh start. Complete re-upholstering can be very expensive, but this idea is cheap and simple.

MATERIALS

9 m (30 ft) pre-washed white cotton drill, (150 cm) 60 in wide

pins

tape measure

tailor's chalk

ruler

sewing machine

CUTTING AND MARKING THE FABRIC

1. Remove the cushions and mark a line down the centre of the sofa with pins, front and back as shown. Measure the total distance and add 7.5 cm (3 in) for hems; cut a piece of fabric to this length for the all-in-one back, seat and front piece.

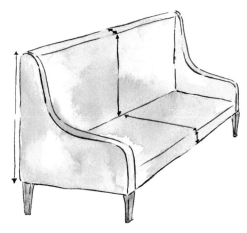

2. Fold the fabric in half lengthways with right sides together and mark the fold line with tailor's chalk. Place this fold along the pinned centre line on the sofa, letting 3.5 cm (1½ in) hang down below both the front and the back. Open out the cloth and smooth it into place to cover the sofa, pushing it tightly into the corners. Pin it to the sofa along the existing seam lines on the original cover.

3. On this sofa, a 9 cm (3½ in) wide band runs up and over the arm and down the back of each side. To cut out the correct amount of fabric for these bands, measure this total length and add 7.5 cm (3 in) for hems. The width should be 12.5 cm (5 in). Pin the strips onto the sofa arms and down the back along the side seam lines, allowing a 3 cm (1½ in) seam allowance to hang down at both the front and the back. Using your chalk, mark a line where the front and the top of the back sections of the sofa meet the bands. This will be your reference for matching up the pieces when you are making up the cover.

4. To cut the outside arm pieces fold the fabric in half and hold it against the side of the sofa, making sure the straight grain is vertical. Cut out the rough shape of the arm leaving a good 7.5 cm (3 in) seam allowance. Using the same method cut the inside arm shapes. Pin all four pieces right side down onto the sofa along the seam lines.

5. In between the side back and the back strip is a triangular gusset which allows the cover to slip easily on and off.

Cut out two triangular pieces of material. Each one should be 25 cm (10 in) at the widest point across the bottom. The height of the triangles should be equal to the height of the sofa back, plus 1.5 cm (¾ in) for the top seam allowance and 3 cm (1½ in) for the bottom hem. Join up these two points to form the triangles.

Mark three equidistant points down each side of the gussets for the ties. Put them to one side.

6. Mark the position of the seams with the tailor's chalk on all the sections following the pinned lines. Mark the junctions clearly with corresponding numbers so you know exactly which sections must be sewn together. Carefully remove the fabric and straighten the drawn seam lines with a ruler. Trim off all excess fabric leaving a uniform seam allowance of 1.5 cm (¾ in).

HOW TO MAKE THE COVER

1. To make the gusset ties, cut out two strips measuring 100 x 4 cm (40 x 1½ in). Divide each strip into six sections and cut again. For each tie turn under ½ cm (¼ in) along both the long and one short raw edge and press. Fold the ties in half lengthways with wrong sides together and machine stitch along the folded edges.

2. Attach the ties to the wrong side of the gusset at the points marked previously by machine stitching across their width.

3. Placing right sides together, machine stitch both inside arms to the sofa seat back and the seat.

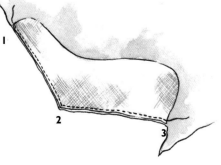

4. Machine stitch the bands to the inside arms and the main cover, right sides together, matching the marked seam lines and numbers.

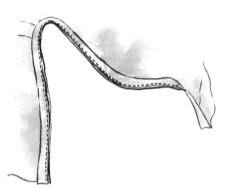

5. Next attach the outside arm sections to the band, with right sides facing, matching the seam lines and the corresponding numbers. Machine stitch the pieces together along the arm seam, but leave the back section open so that the gusset can be inserted.

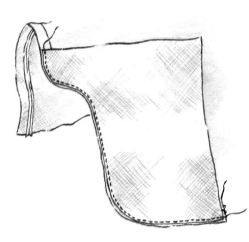

At this stage, your sofa cover should look like this. The shape is now recognizable, but the back is still loose as the side gussets and ties have yet to be inserted.

6. Insert each gusset between the outside arm piece and the back section of the band and, with right sides together, stitch them in place.

7. At this stage, place the cover on the sofa to check the fit and length. The gusset will allow for a certain amount of flexibility; make any adjustments if necessary. Remove the cover and trim the seam allowances. Hem the bottom by turning under ½ cm (¼ in) followed by a further 1 cm (½ in) and stitching all round.

TO MAKE UP THE CUSHIONS

1. For two 69 × 61 × 10 cm (27½ × 24½ × 4 in) cushions, first cut out four rectangles measuring 72 × 64 cm (29 × 26 in) for the seat.

2. For the sides cut two strips of fabric measuring 194 × 13 cm (78 × 5 in) and for the backs cut two strips 72 × 16 cm (29 × 7 in), each of which must then be cut in half along the length.

3. Make up some ties as for the gusset. Allow six for each cushion and mark their positions on the opening edges of the back sections. Press under ½ cm (¼ in), followed by 1 cm (½ in) on these edges. Place the short raw edge of the ties under this turning and stitch along the length of the back opening through all layers close to the edge.

4. For each cushion, place the two back pieces together with the hemmed edges meeting and, with right sides together, stitch the side strip to both ends of the back section, using a seam allowance of 1 cm (½ in).

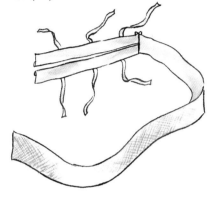

5. Mark the corner positions on each strip and turn them wrong side out; line up the top and bottom seat rectangles with these marks and pin, baste and machine stitch them in place with right sides together, using a 1 cm (½ in) seam allowance.

6. Trim the corners, turn the covers inside out, pull through the ties and insert the cushion pads.

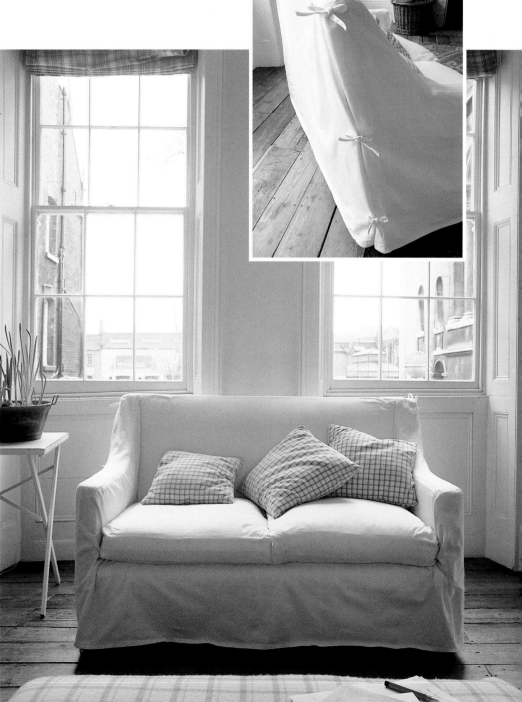

Textures help determine the style and look of a room. Country cottage living rooms need rustic injections of rough wool throws, wood floors, tough sisal mats and hand-woven log baskets. Streamlined contemporary settings need smooth touches, such as slipcovers in crisp white cotton, which help unify mismatched chairs and also complement pale wood floors. Modern materials such as zinc and aluminium for lighting and table surfaces also emphasize a more up-to-date look.

Curtains require substantial amounts of fabric but needn't break the bank. Stick to simple headings such as loops and ties. Choose strong cottons and linens. If you buy ten metres/yards or more from many fabric wholesalers

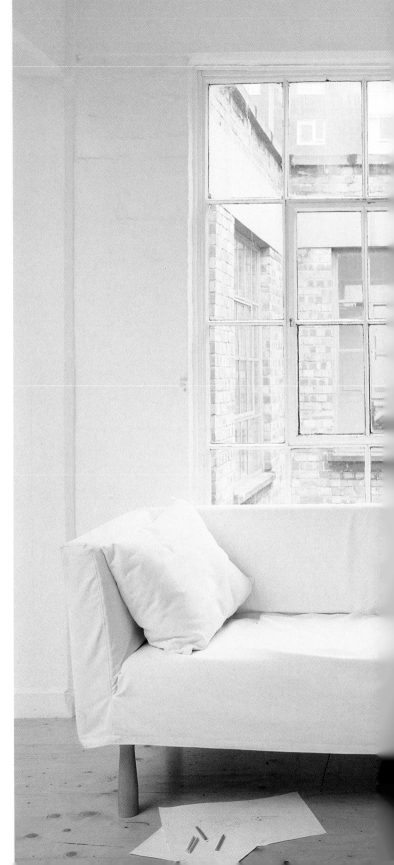

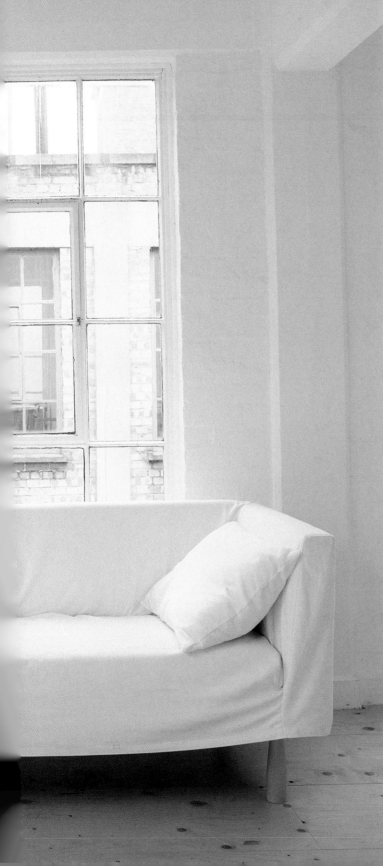

left *Comfortable yet functional living spaces with seating covered in robust ticking or calico.*
below *A small space set aside for a home study area successfully houses vital office elements, including a basic trestle table, a metal filing cabinet, cheap cardboard box files revamped with paint and a smart metal twenties-style desk light.*

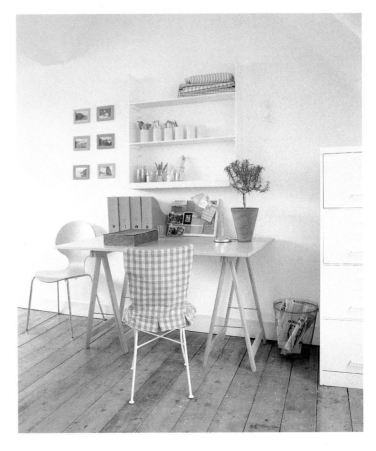

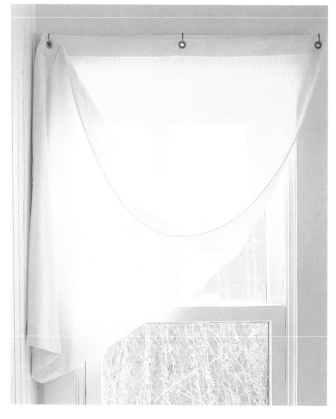

right Fresh and filmy: soft cream-coloured linen curtains with a decorative double-layered heading, recycled by the owner from a previous apartment. The wooden pole and rings are painted to create a unifying effect.

Simple shapes in plain fabrics create light and airy window treatments:
above *Light cotton curtains draped to the floor. They are simply tied onto a metal pole, bought by the length and bent over at the ends.*
right *Heavy canvas with eyelets can be hooked onto a window frame and pulled back as required.*

they will give you a substantial discount. Line curtains for a better hang and also to give protection from sunlight to prevent fading. Interlinings give greater insulation; bump is the thickest and looks like a blanket, while domette is a brushed cotton and the most commonly used. Roman or roller blinds/shades are useful for providing extra insulation with curtains, as well as protecting from the sun (see the project on pages 106–107). Blinds also suit just about any window shape. I like Roman blinds/shades and have examples in checked cotton and plain calico hanging at my Georgian sash windows; these are all hand washable in the bath. Unlined curtains in filmy textures such as muslin and organdie are cheap, stylish options. If you live in a climate with hot summers and cold winters, have sets of light curtains for summer and warmer pairs of thermal ones for winter, as you do for underwear. Paint curtain poles the same colour as walls for a unifying effect. Very cheap ideas for poles include wooden dowelling from timber yards cut to length and painted, and stretchy wire which is ideal for small drops, for example in cottage windows, and available from hardware stores.

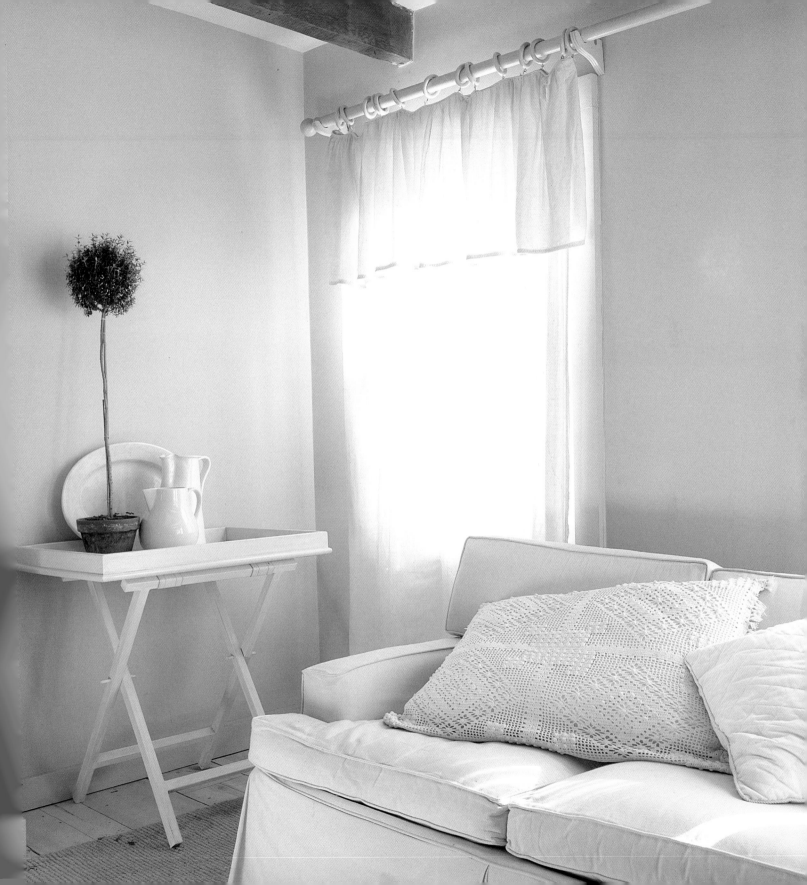

Pot pourri

The wood shavings and dried flowers in many store-bought pot pourris are no match for the simple scented examples you can make yourself. It is easy to dry garden flower petals, herbs and citrus fruit slices and peels. For scent, use drops of deliciously fragrant essential oils and contain the smell with a fixative such as orris root or cloves. Alternatively buy ready-made oil blends from herbal and pot pourri specialists or read books on the subject to create your own subtle tailor-made examples.

MATERIALS

china bowl for mixing
seal or lid for bowl
wooden spoon

SUMMER FLOWER POT POURRI INGREDIENTS

125 g (4 oz) lavender flowers and stems, pinks flower heads, delphinium petals, rose petals, hydrangea petals, and any other garden flower petals you can glean
15 g (½ oz) orris root powder
20 drops geranium oil

HERBY POT POURRI INGREDIENTS

50 g (2 oz) bay leaves
50 g (2 oz) rosemary cut into 15 cm (6 in) lengths
15 g (½ oz) whole cloves
20 drops rosemary oil

ORANGE AND LEMON POT POURRI INGREDIENTS

500 g (1 lb) oranges
500 g (1 lb) lemons
8 whole clementines
25 drops orange oil

SUMMER FLOWER POT POURRI

My mother makes this with as many petals and flower heads as she can collect from her garden in the summer. The faded colours give it an old-fashioned country garden effect.

INSTRUCTIONS

1. Dry the ingredients on sheets of newspaper in an airing cupboard or similar warm, dry space.

2. Using a china bowl and a wooden spoon, mix the dried ingredients with the orris root powder, taking care not to damage the flowers. Add the oil and mix again. Seal the bowl for four weeks to allow the fragrances to develop and then transfer the pot pourri to your favourite dishes and containers.

HERBY POT POURRI

I like the dark green colours of this aromatic mixture. It looks lovely in white bowls on a sideboard or kitchen dresser. Even dried, the bay leaves retain a little of their fresh scent, and the herby effect is enhanced with the addition of rosemary oil.

INSTRUCTIONS

1. Dry the herbs on a sheet of newspaper in an airing cupboard or similar warm, dry space.

2. Mix the herbs in the bowl with the wooden spoon. Add the rosemary oil and then mix again. Seal the bowl for at least four weeks to allow the oil to work and then transfer to your chosen containers.

ORANGE AND LEMON POT POURRI

Slices of dried citrus fruits scented with orange oil look and smell earthy and organic.

INSTRUCTIONS

1. Thinly peel the oranges and lemons and retain the strips of peel. Carefully slice the whole fruits into circles. Make incisions in the peel of the clementines, making sure that the whole fruit remains intact. Lay everything on sheets of newspaper in an airing cupboard or warm place until thoroughly dry.

2. Mix the fruit in the bowl with the wooden spoon. Add the orange oil. Mix again. Seal the bowl for at least four weeks and then transfer to containers; shallow bowls are best because the slices can then be arranged in layers.

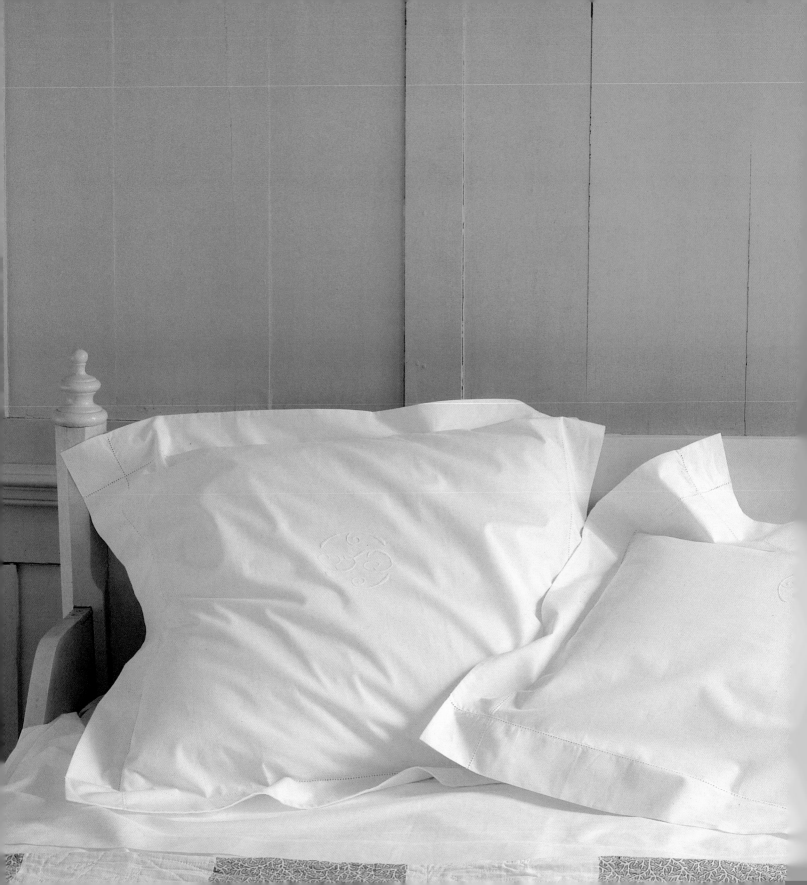

Sleeping in style

We do so much of it that sleep deserves to be a peaceful and luxuriating experience. On a cold winter's night it is bliss to curl up in crisp white bedlinen and warm woolly blankets. Conversely, in summer it's good to lie with the sparest of bedclothes, say just a fine cotton sheet, and an open window to catch a cooling night-time breeze. Bedrooms need to be quiet airy refuges away from domestic distractions. There should be lots of cupboards, boxes or ample wardrobe space to stow away clothing and clutter. Some of the best ideas include capacious built-in walk-in wardrobes with simple panelled doors. Old laundry baskets, big wooden boxes and even old shoe boxes covered in fabric and paint are also useful bedroom storage notions. Bedroom textures need to be soft and inviting, such as filmy muslin curtains, plain calico blinds and fine cotton pyjamas. Soft wool blankets in creams or blues are great for dressing beds. Then there are antique quilts with pretty floral sprigged designs, that look lovely folded or draped over a bedstead. Spend as much as you can afford on bedding — soft goosedown duvets or thick quilts and pillows are the ultimate luxury. It is also prudent to invest in a well-sprung mattress.

A bedroom is a sanctuary, away from work and other people; it is a place where you can tuck yourself up in between crisp sheets with a good book to read, a drink, and a bar of chocolate. Asleep or not, all of us spend so much time there that it should be the one room in the house where we can be indulgent. Bedroom textures should be luxurious, soft and warm. The stresses of the day fall away when you clamber into white cotton sheets, curl up under soft blankets and hug a comforting hot water bottle in cold weather. It pays to invest in the best bedding you can afford and take time choosing the right bed.

There are all sorts of bed shapes to suit the look you want to achieve. At a basic level there is a divan which can be dressed quite simply, useful in bedrooms that double up as daytime living rooms or studies.

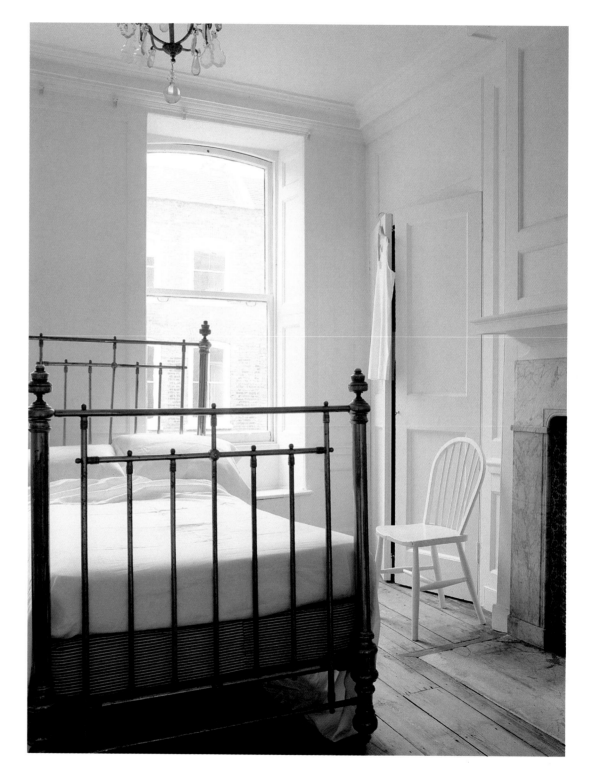

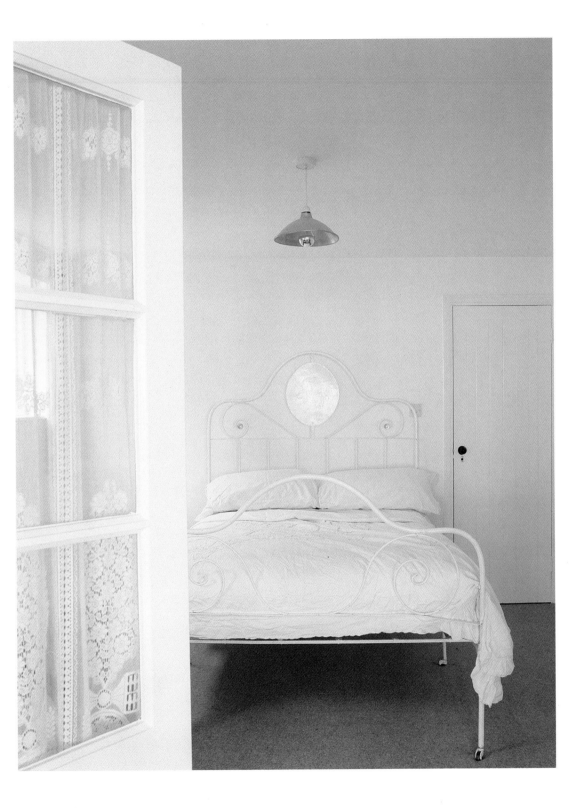

Comfort factors in bedrooms include freshly laundered sheets and warm creamy coloured wool blankets. Trawl markets and junk/thrift stores for old bedlinen; the quality is often better than modern textures. Really worth looking out for are old damask bed covers and fine embroidered linen pillowcases. Sleep peacefully in a traditional bedstead: classic brass always looks wonderful, and decorative ironwork looks great painted white. Create an oasis of calm with a clutter-free room.

125

Slipcover for a metal chair

A simple metal chair can be totally transformed with a lick of white paint and a tied slipcover. Here a fresh blue-and-white striped washable cotton is tailored to the shape of the chair so that it retains its gently curved outline.

HOW TO MAKE UP

1. First measure the three parts of the chair to be covered: the seat (A), the inside back (B) and the outside back (C). Transfer the dimensions of A, B and C onto pattern paper, adding a 1.25 cm (½ in) seam allowance all round. On pattern A mark the positions of the two rear chair legs with a cross. Take the outside back panel (C) and cut it in half vertically so splitting the pattern in two, then add a 1.25 cm (½ in) seam allowance to each new straight edge; this will form an opening at the back of the chair so that the cover can be easily slipped on and also removed. Using the paper patterns just made, cut out all four pieces in the striped fabric, making sure that you keep the direction of the stripes consistent (see below).

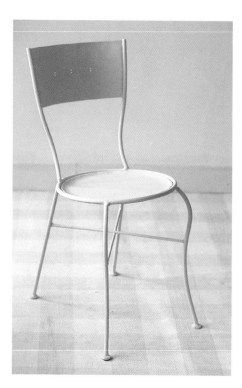

MATERIALS

metal chair
tape measure
pattern paper
pencil and pen
pins
scissors
striped cotton
needle
thread
sewing machine

2. For the frill, measure around the perimeter of the front of the chair seat from one rear leg to the other. Multiply this measurement by three.

3. Cut out a strip of fabric 15 cm (6 in) wide and stitch together strips to the required length, as measured in the previous step. Turn under the bottom edge and sides of the strip, pin, baste and machine stitch, leaving the top edge for gathering. With contrasting thread make gathers along the top edge so that the frill fits the perimeter of the front of the seat.

4. When the strip is gathered, align the arrow marked above with the arrow marked on pattern A. Pin, baste and machine stitch the gathered frill to the front perimeter of piece A, right sides facing.

5. To make the ties for fastening, cut out two strips of fabric, each 2.5 cm (1 in) wide and 17 cm (7 in) long. Fold each in half lengthways with right sides facing. Pin and machine stitch along a short and a long edge, turn right side out through the open end and hand sew the open end to a neat close. The finished tie should be about 1.25 cm (½ in) wide. Repeat for the second tie and press. In the same way make two shorter ties each 2.5 cm (1 in) wide.

6. Position one of the longer ties centrally over a cross marked on piece A, indicating the position of the rear chair legs. Sew firmly in place (see below). Repeat for the second longer tie.

7. Place two halves of C right sides together and stitch one third of the way down, forming a central seam. Turn in, pin and hand sew all the remaining raw edges. Place pieces B and C right sides facing. Pin, baste and machine stitch along both the sides and the top and then turn right side out.

8. To complete the frill, cut out a strip 15 cm (6 in) wide and three times the length of seat edge between the two rear legs. Cut the strip in half. Turn under the bottom and side edges, pin and machine stitch leaving the top edges for gathering.

9. Stitch the gathered frills, right sides together, to the bottom edges of piece C. Attach the remaining ties to the rear opening to fasten.

10. Pin, baste and machine stitch the bottom edge of panel B to the back edge of piece A, right sides facing. Press, slip over the chair and fasten the ties.

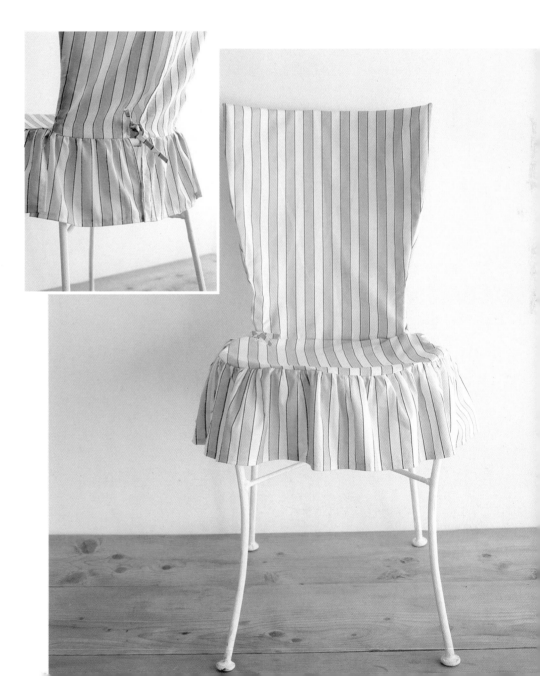

below *Grey paintwork and a simple painted bedside table, together with a subtlely checked blue woollen blanket and a glass of vibrant yellow spring daffodils, add colourful injections to the overall neutral effect created by the white walls and bedlinen in this restful Provençal farmhouse bedroom.*

right *Brilliant blues lend a oceanside air to a Long Island bedroom. Blue-and-white patchwork quilts, boldly striped cotton pillowcases, and white painted walls add to the bright and breezy feel, while a faded denim child's sailor suit hung on the wall brings a jaunty touch to the coastal theme.*

I prefer bright and airy bedrooms in whites and creams, in other words rooms that have a light ambience throughout the year. Darker, richer colours such as library green or study red may suit some individuals, but waking up to moody walls on dark mornings during a long winter may quickly become a gloomy prospect. Bedrooms need to be comfortable, optimistic places, with supplies of good reading matter, soft bedside lighting, some sort of seating, and maybe a jug of favourite scented flowers.

There is nothing to beat the simplicity of plain white bedlinen. It is smart and unassuming. When an injection of colour is desired then you can look to bold, contemporary designs, perhaps in tomato red, lime green, fuchsia pink or lemon yellow. These sorts of bedlinens work particularly well in southern climates with strong light. It seems that English country-house style with its fussy floral patterned sheets and pillowcases have had their day on the decoration scene (and not too soon). But at the mass-market end of things manufacturers persist in launching frilly, flowery designs that make beds look like the covers of chocolate boxes. However, florals in the bedroom can look really pretty, if used carefully and with restraint. Take as an example a simple lavender-coloured country bedroom theme, suitable say for a cottage bedroom. You can make up basic pillowcases in a delicate rose-bud print (note that dress fabrics often have more subtle floral designs than their furnishing counterparts) and combine with white sheets and pillowcases and a faded antique floral patchwork quilt. Stick to a plain cotton window treatment, paint the walls white and cover the floors in cheap, neutral cotton rugs. The whole effect is stylish and not in the least bit overdone or too pretty.

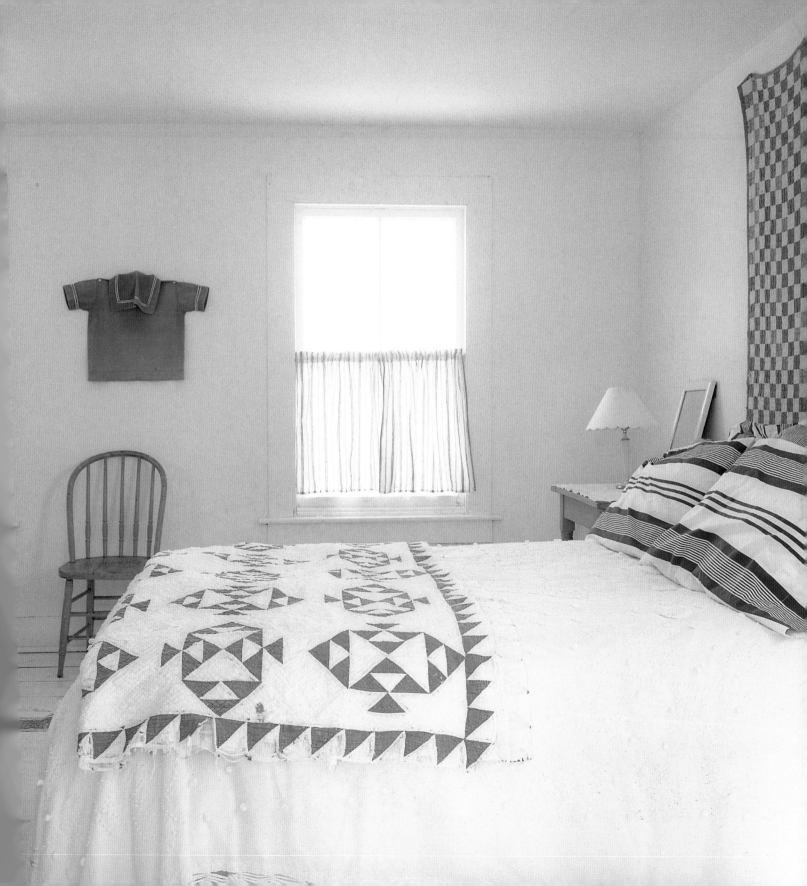

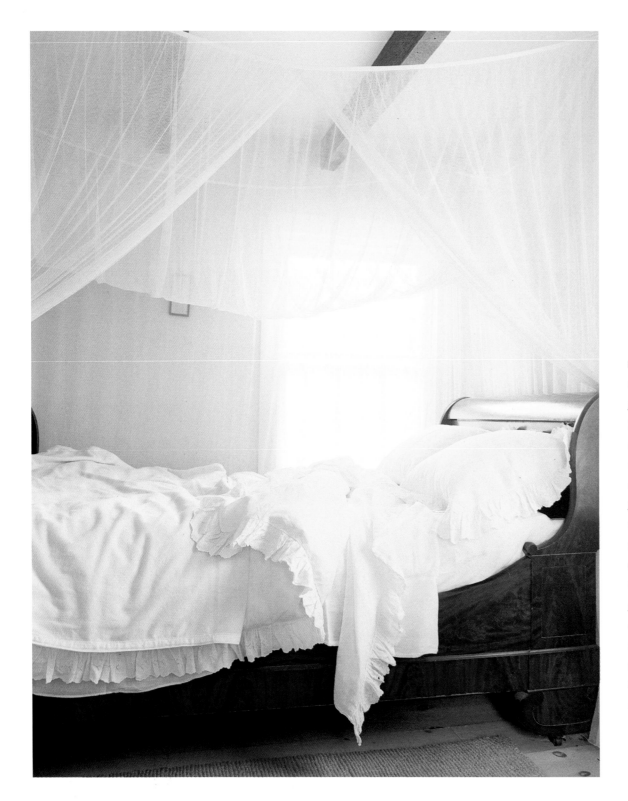

left *A romantic mahogany* bateau lit *is a great vehicle for layer upon layer of wonderful white antique bedlinen. A filmy mosquito net, functional as well as decorative, is generously swathed from the ceiling to complete the translucent effect.*

right *Distinctive in texture and colour, smooth polished parquet flooring and bentwood furniture are smart, dark contrasts to creamy walls and bedlinen in a Paris apartment.*

Forced to make my bed from an early age, I think that an orderly, uncluttered bedroom helps to set you up mentally for whatever difficulties and chaos you may come across during the day. Storage, of course, is a key issue. It is quite surprising how a few pieces of casually flung clothing, or perhaps a modest pile of discarded newspapers, is all it takes to create a bedroom scene that begins to look like a jumble/yard sale. A built-in run of shelves with doors along one wall is a very successful way of stowing away clothes, hats, shoes, bags, suitcases and other unavoidable clutter. Free-standing armoires and wardrobes are useful, but impractical if space is tight. If you are restricted to a limited budget then you can curtain off an alcove with calico, linen or even an old bedspread. Save for a couple of hours spent at the sewing machine,

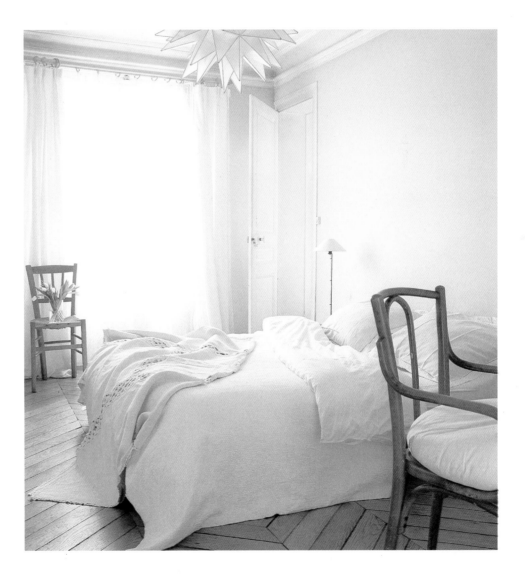

the results are almost instantaneous and very stylish. A large chest of drawers is always useful for swallowing up smaller items of clothing and spare bedlinen. Old trunks/chests, big boxy laundry baskets and modern-looking zinc boxes are also useful bedroom storage devices.

Bedsteads offer a variety of decorative possibilities. A Shaker-style painted wooden four-poster frame looks good with tie-on curtains, a muslin or linen pelmet, or left entirely bare. Good value examples are available in flat-pack kit form. Nineteenth-century French metal daybeds are excellent for bed-sitting rooms and look really smart with ticking bolsters and pillows; they are not difficult to find if you track down dealers who specialize in antique French decorative furniture. If you have children in the family then consider pine bunk beds. Available from most department stores or large furniture warehouses, they are very good value and can be dressed up with a coat of paint.

Those of us who enjoy the pleasures of a firm bed know high-quality bedding really does help towards getting a good night's sleep. The best type of mattress is sewn to size

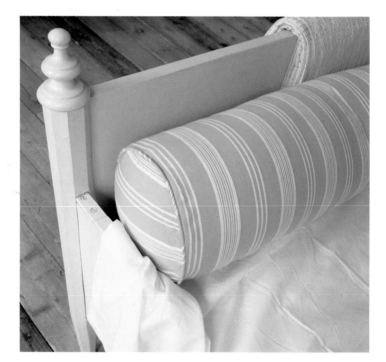

right *A country feel is evoked by matt-painted panelling, wood boards, a painted wooden bed, and simple fabrics and furnishings in a Georgian townhouse. An antique lavender patch-work quilt with a seaweed design and pink sprigged floral pillowcases, run up in lawn dress fabric, provide fresh detail.*

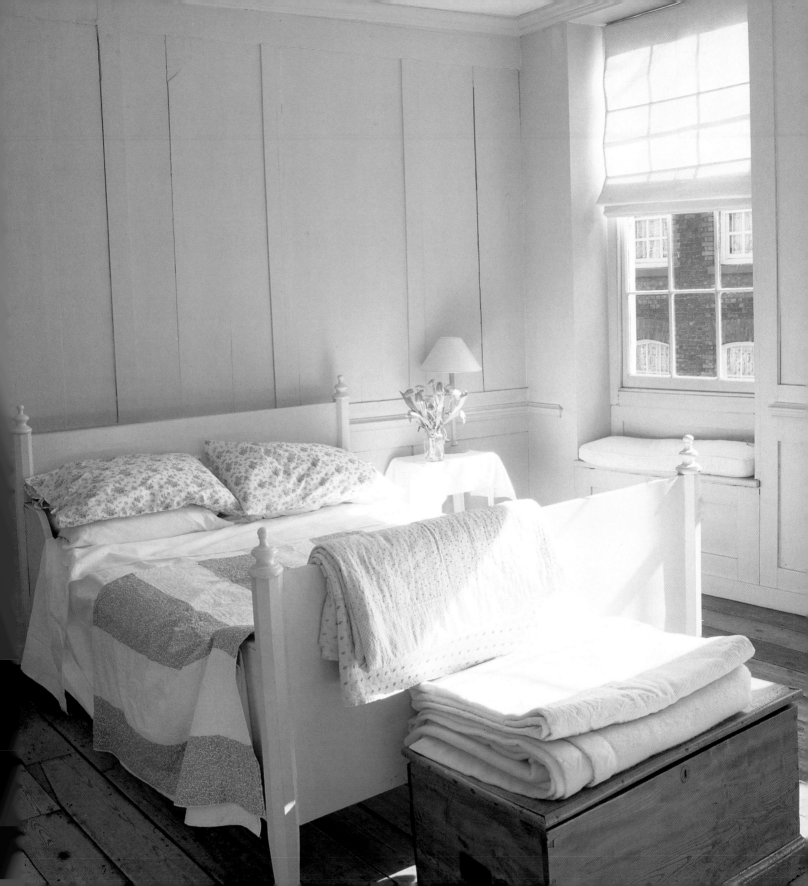

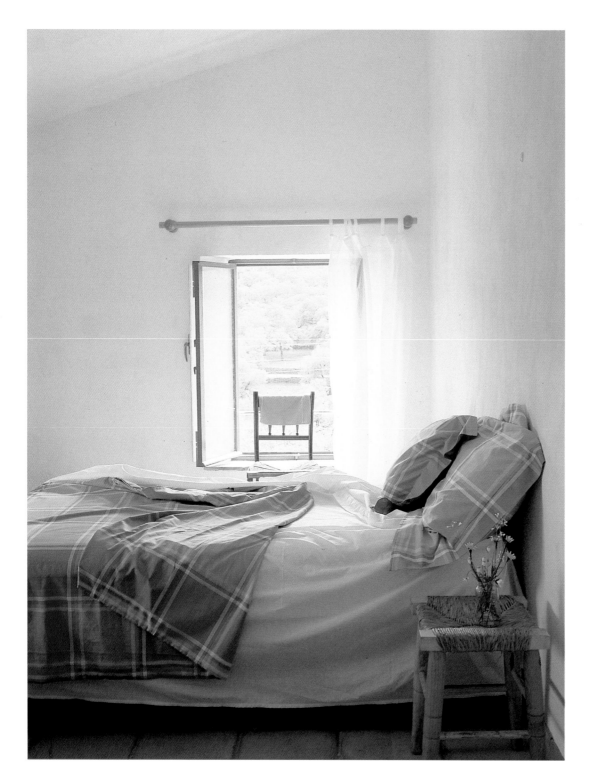

left *Hot shots: vivid splashes of bright colour work well in sunny, southern climates. Experiment with cool cotton bedlinen in bold blues, greens, yellows, pinks and orange. As temperatures soar, practical ideas for keeping cool are essential: windows flung wide let air flow through, light muslin curtains help to catch a breeze and stone floor tiles stay cool underfoot.*

with layers of white curled feather, together with fleece wool and white cotton felt all incorporated with solid box springs. Perfect pillows are combinations of duck down and feather, grey duck feather, or the ultimate luxury, white goose feather. And for people with allergies there are special hog and cattle hair versions available. It is well worth your while spending that little bit more when it comes to buying bedding, both for increased comfort and longevity.

My dream is to sleep in daily pressed and laundered linen sheets. Until this fantasy is realized I remain content with a box of assorted cotton linens at various stages of wear and tear. My softest sheets are in Egyptian cotton, bought years ago, and still going strong. I also love antique bedlinen and have various Victorian linen and cotton lace pillowcases, as well as the odd linen sheet handed down from elderly relatives, or bought in junk/thrift stores and markets. Although pure linen sheets are very costly, and need extra care and maintenance, they will last a lifetime. When buying linen it should feel clean, starched, crisp and tightly woven. Modern linens shed creases faster than traditional ones, reducing the sweat of ironing.

Duvets have become an almost universal item of bedding in Britain, but sheets and blankets have been making a comeback recently. The practical thing about layers of bed clothes is that you can simply peel back or pull on the layers to suit the temperature. In summer, for example, a cotton blanket and sheet are all that is necessary and if the temperature suddenly plummets then there is nothing to beat the addition of a traditional wool blanket with a satin ribbon binding.

below *Bunk beds are an economical and useful idea for children's bedrooms and are popular for their space-saving qualities as well as being fun to sleep in. Update and give a stylish look to plain pine bunks with pale eggshell paint as seen here.*

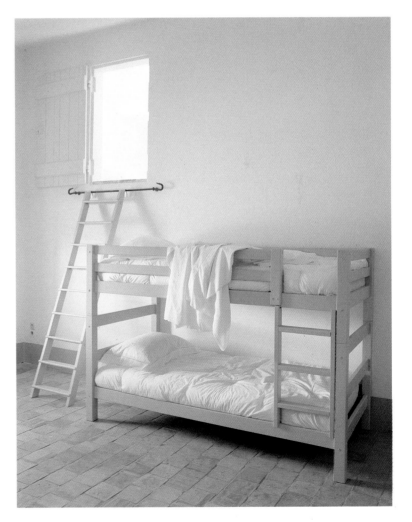

Clean living

To start the day, an invigorating shower, or simply a wash in a basin of hot water, wakes you up and triggers circulation. At other times, and especially at the end of the day, I can spend hours soaking in a tub of steaming hot water listening to the radio (sneaking off for a mid-afternoon session is also highly recommended for a rare treat). They may not be the best at conserving heat but smooth cast-iron baths are definitely the most agreeable to soak in. It's good to scent the water with fragrant oil or work up a creamy lather with soap. A bleached wooden bath rack is a useful vehicle for storing soaps and flannels and keeping reading material dry and readily to hand. Loofahs, sponges and brushes are also essential bathroom tools for keeping skin pristine and well scrubbed. To accompany daily washing rituals, use fluffy towels in white, seaside blues and bright spring green colours. Soft towelling bathrobes are also a delicious way of drying off – buy big sizes for wrapping

up well. The best showers soak you with a powerful delivery, and have finely tuned taps/faucets that deliver hot or cold water as you require it. Keep bathrooms well ventilated to clear steam, and invest in duckboards and bathmats to mop up pools of water.

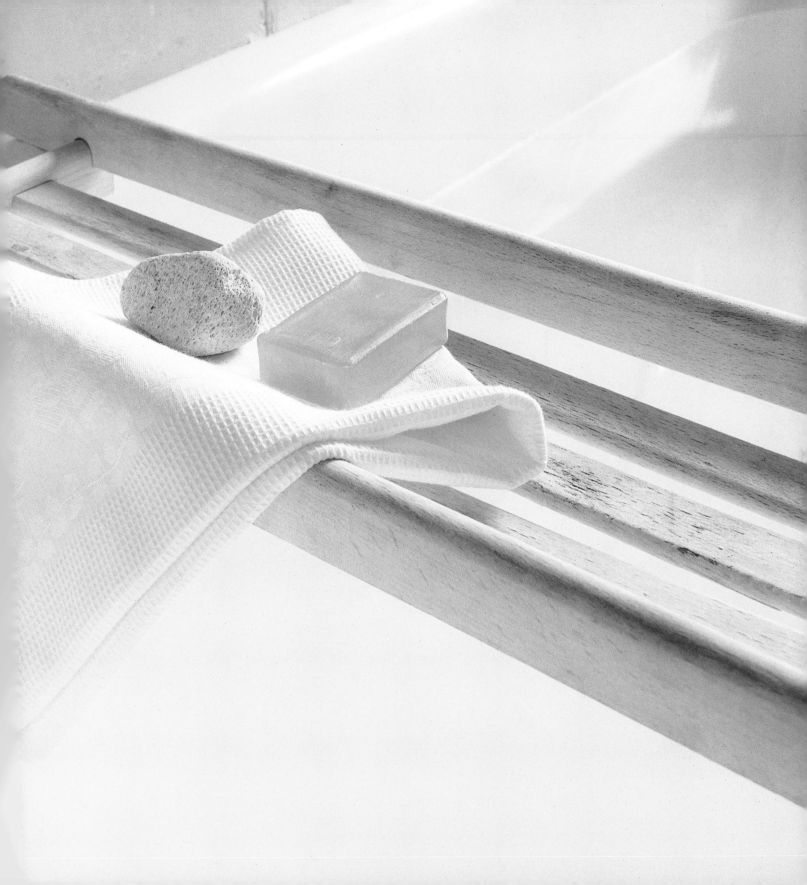

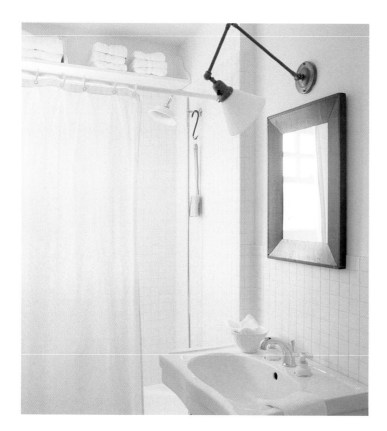

A bath, a shower, or even a quick face splash are instant revivers and help relieve the stresses of daily living. Like eating, washing can be a deliciously sensual ritual. It can vary from a short, sharp, invigorating cold outdoor shower on a hot summer's day to a more languid experience in mid-winter when a long, hot, steaming bath is the perfect antidote to dark days and icy temperatures. Copious supplies of hot water are at the top of my list of crucial bathroom ingredients – even the meanest, most poky, drab little bathroom can be acceptable if it delivers piping-hot water, and plenty of it. Smelly soaps and lotions are essential elements too. Among my favourites are delicately scented rosewater soap and rose geranium bath gel. If I'm in the mood for more pungent aromas, I choose stronger-scented spicy soaps with warming tones.

White bathrooms are bright, light and airy, as shown by the gleaming examples seen here. Walls and woodwork are in varying shades of white together with pristine clean ceramic tiles, baths and sinks. Deliciously tactile textures include big fluffy towels, soft sponges and tough cottons for laundry bags.

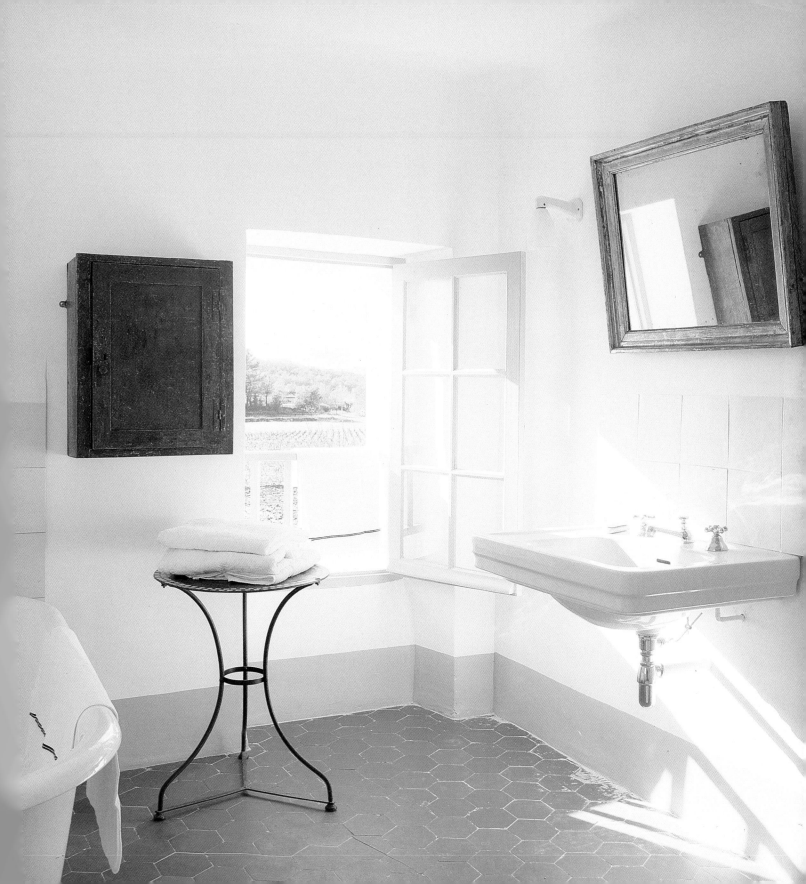

Bathroom wall cabinet

Give a basic pine bathroom cabinet a new look with oceanside-inspired greeny blue paint, and a utilitarian but stylish chicken wire front. You can apply the same treatment to any old cupboard picked up in a market or junk shop.

MATERIALS

wall cabinet
pin hammer
white spirit
steel wool
fine grade sandpaper
primer
undercoat
eggshell paint
2.5 cm (1 in) paint brush
chicken wire from a hardware store
wire cutters
staple gun or panel pins

HOW TO MAKE UP

1. Choose a cabinet that has a single central panel in the door. If it is an old cabinet make sure that the door construction is sound. Remove any beading holding the panel in place on the the inside of the door and then carefully knock out the panel by tapping around the edge with a pin hammer. Avoid damaging any beading around the front of the panel by knocking through from the front. If the cabinet has a mirror or glass in the door panel, remove the pins holding the glass in place and then very carefully push it out.

2. Prepare all surfaces before painting to ensure they are in the best possible condition. If the cabinet has been waxed, remove the wax coating with white spirit and steel wool, then clean with a rag. Always work in the direction of the grain. If it has been painted before and the paintwork is sound simply wash it down and sand it. If the old paint is chipped or flaking it is better to strip it off.

3. Apply a coat of primer, then one of undercoat, followed by two coats of eggshell. It is important to sand with a fine grade sandpaper between each coat to give a smooth surface for the next one.

Remember to paint all of the inside surfaces as well as they will be visible through the chicken wire; painting the shelves a contrasting colour, as here, is a smart idea.

4. Cut your chicken wire to size using wire cutters. Attach the wire to the reverse side of the cabinet door frame with a staple gun or panel pins bent over to catch the edges of the wire.

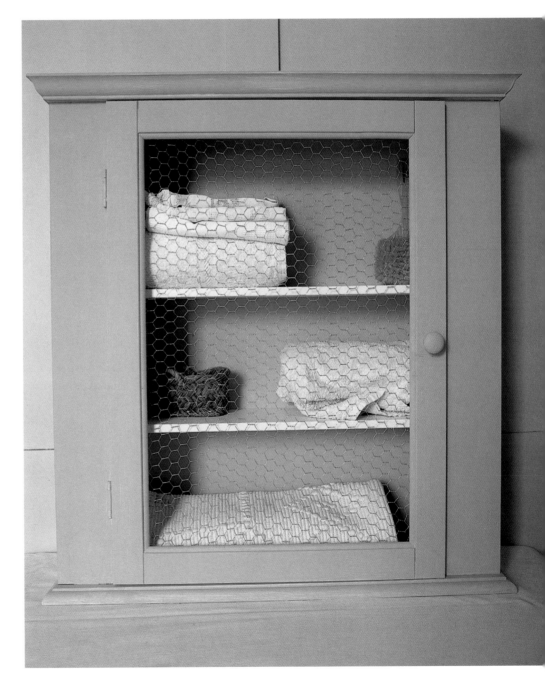

right *Real forties bath-rooms were cold clammy places with peeling linoleum floors and inter-mittent hot water issued from unpredictable gas boilers. The sea green and white Long Island bath-room here might be retro in feeling, but is very modern in its comforting supplies of heat and hot water. Simple and func-tional, it houses a sturdy cast-iron bath on ball-and-claw feet, a plain wooden mirrored bath cabinet and a painted stool for resting a bath-time drink. Seek out ideas for recreating this relaxed, utilitarian look by rummaging around in junk/thrift stores for big white clinical enamel jugs (the sort that hospitals used for washing babies), old formica-topped tables, metal buckets and medicine cabinets, or old versions of the wooden bathmat below.*

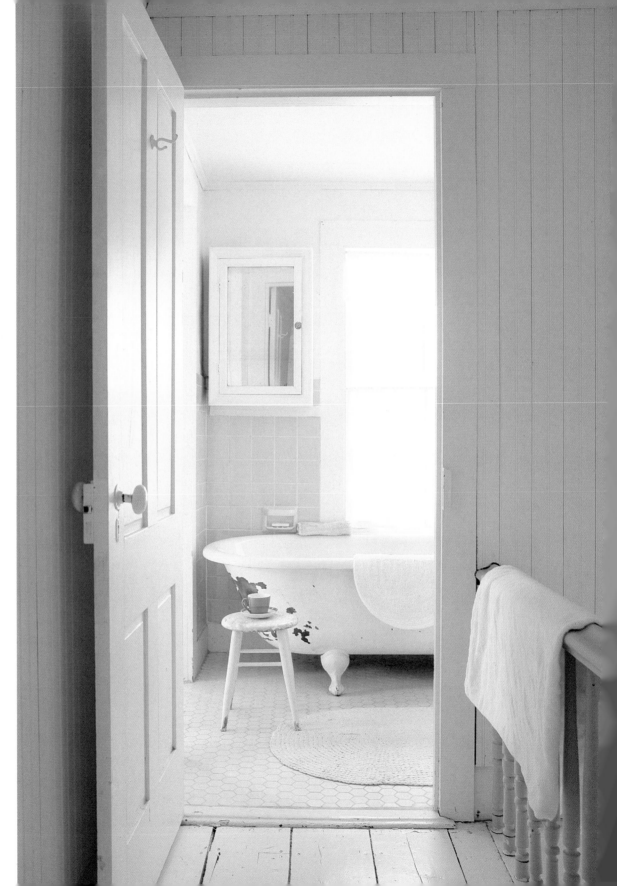

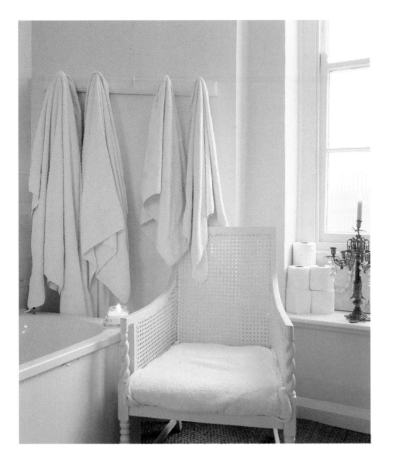

Indispensible for drying off big white cotton bath sheets and white rag-rug Portuguese bath mats is my thirties-style heated chrome towel rail/rod. To finish off the ablutions it's good to wrap up in a soft, white waffle cotton dressing gown – they're rather expensive, but well worth it for a daily dose of luxury.

Choosing a bath is a question of taste as well as practical considerations. Traditional-style, free-standing cast-iron baths with ball and claw feet are deep and look good but they do need sturdy floors to support their own weight, the considerable weight of a bathful of water, plus the weight of the bather. In contrast, modern acrylic baths are light, warm to the touch and come in lots of shapes.

above *More luxurious yet eminently achievable bathroom ideas include a tinkly glass candelabra for bathing by candle-light, and a comfy chair with soft towelling seat-ing. Practical bathroom storage ideas include woven cane laundry baskets and junk objects like old metal school shoe lockers or tin boxes used to house soaps, lotions and other paraphernalia.*

Drawstring bag

A basic bag shape can be made up in tough cotton and used to store everything from sewing materials to towels. The pattern shown here can be adapted to make roomy laundry bags, or sized down to make a trio of practical storage bags for the bathroom. If you want to be really organized you can label utility calico storage bags with indelible fabric pens.

MATERIALS

90 cm (37 in) heavy cotton, 115 cm (45 in) wide

tape measure

pins

scissors

needle

thread

safety pins

sewing machine

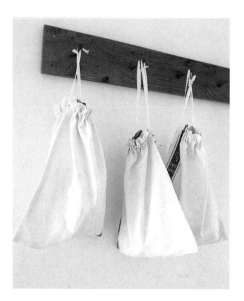

HOW TO MAKE UP

1. For the bag, cut out one piece of fabric measuring 92 × 42 cm (37 × 17 in). Fold the fabric in half, with right sides together, and pin, baste and machine stitch one of the long sides for 36 cm (14 in), using a seam allowance of 1 cm (½ in). Leave a 2 cm (¾ in) gap and then continue sewing to the end of the seam.

If you want to make a double tie repeat this process on the other long side. For a single tie follow these instructions for one long side only and machine a continuous line of stitching up the other long side. Press the seams open.

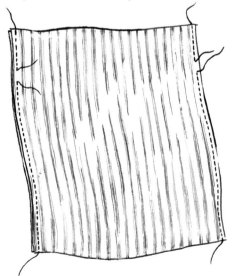

2. To make the casement that will contain the ties, fold over the top raw edge 1 cm (½ in) all round and press the fold in place. Then fold over a further 5 cm (2 in) evenly all round, lining up the side seams. Press and pin in position.

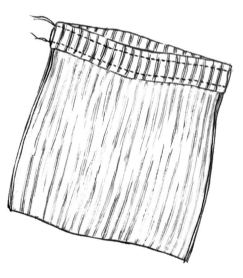

Machine stitch all round the top of the bag 1.5 cm (¾ in) from the folded edge. Make a second row of stitching around the bag 3 cm (1¼ in) below the first row. Make sure the line of stitches runs through the folded edge on the underside. Turn the bag right side out and press.

3. To make the ties, cut two strips of fabric 3 × 110 cm (1½ × 44 in). Turn under ½ cm (¼ in) on all four raw edges on each strip. Fold the strips in half lengthways and, with wrong sides facing, pin, baste and machine stitch along the open ends and side, close to the edge.

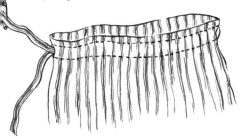

4. Attach a safety pin to one end of a tie and guide the tie through one of the casement holes, completing the full circle.

Repeat for the second tie, starting and finishing at the opposite hole. Remove the safety pins, knot the ties and pull the ends to draw.

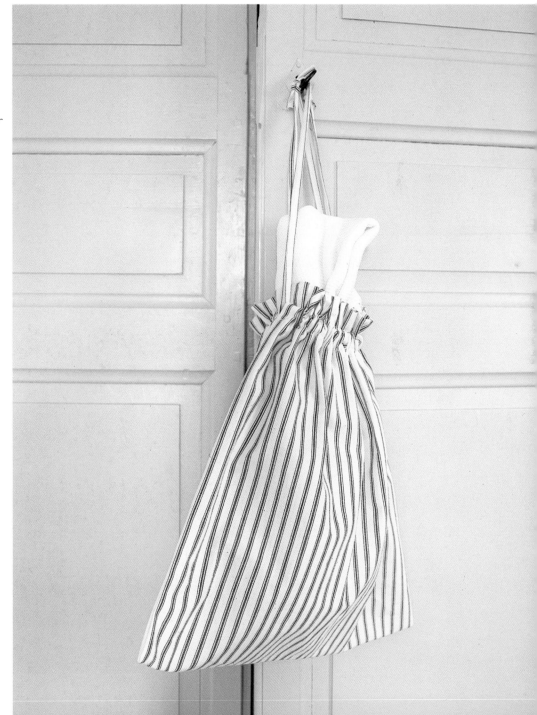

far right *Get the look and create your own Georgian-inspired bath-room with matt eggshell paint, an old-fashioned bath on a raised platform and big weathered brass taps/faucets. Hide ele-ments of contemporary life behind plain panelled cupboards. Seal wooden floors in matt varnish or use thick cotton bathmats to soak up water from dripping bodies.*

Enamelled steel baths are strong and hardwearing (and for this reason favoured by hotels and hospitals) but, like modern acrylic baths, they need the support of a frame. For stylish details either box in the bath with plain white tiles, or make a surround of tongue-and-groove wood panels which can be painted or waxed for protection.

Bathroom textures and surfaces need to be hardwearing and easy to maintain. Cleaning the bathroom

this page *Old ceramic jugs, weathered wooden shelves with cut-out pat-terns, cheap painted peg rails and seashell prints are key elements for a traditional feel.*

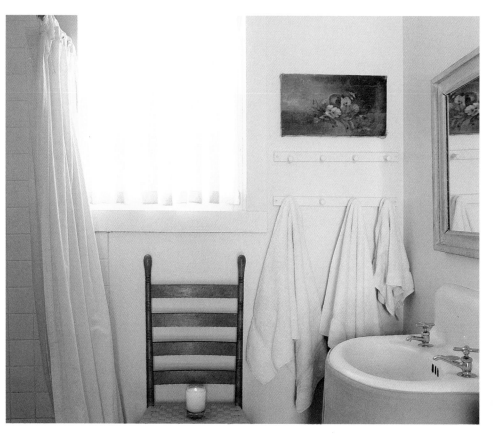

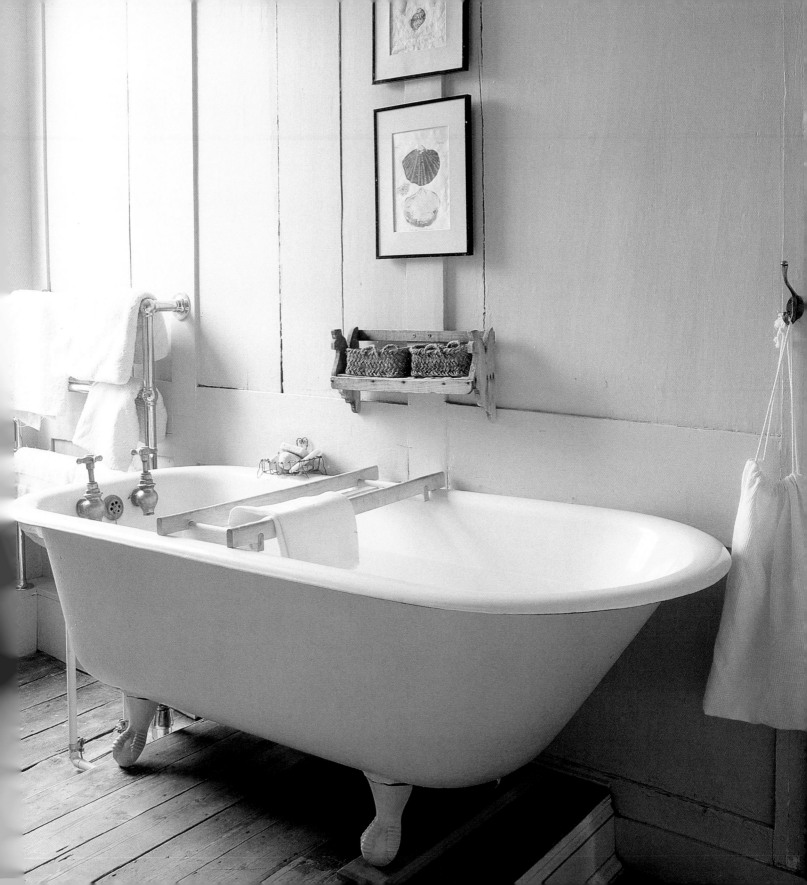

right *Daily ablutions are an uplifting experience in this bright and cheery sea green and blue theme. Solid functional fittings that were happily left intact for the owner included a splendid old ceramic sink on a stand with classic taps/faucets and visible fittings.*

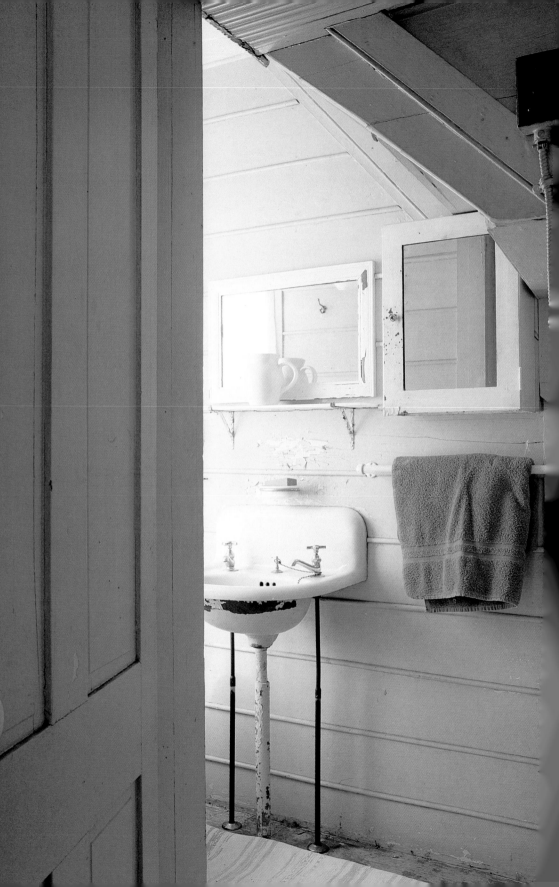

The average bathroom showroom stocks a pretty paltry selection of taps/faucets and unremarkable shapes often cost a lot. Here are some inspiring ideas.
above *A single stainless steel spout with a concealed tap/faucet mechanism.*
above right *Brass taps/faucets from a builder's yard.*
right *Chunky Victorian pillar taps/faucets found in a London salvage yard.*

becomes much less of a chore if you wipe down baths, washbasins and showers daily with soapy water while they are still warm, then rinse and dry; this helps prevent a build-up of dirt. Try not to use abrasive cleaners which can damage many surfaces and glazes; choose softer sponges or cloths instead.

Ceramic sinks, basins, lavatories and shower trays are widely available, and good value. Ceramic tiles for floors and walls provide a good splash-proof environment. Wooden floors are acceptable if well sealed, as is terra-cotta, or even linoleum, provided it is properly laid to stop water seeping underneath and causing damp. Avoid carpet

this page *Introduce colour to bathrooms with bright towels and marine-blue and lime-green robes or deep blue glass bottles for lotions and potions.*
far right *Swimming-pool inspired tiny blue mosaic tiles are an inventive idea for a walk-in shower space. Equally resourceful are basic stainless steel kitchen mixer taps/faucets reinvented as shower taps/faucets and spouts.*

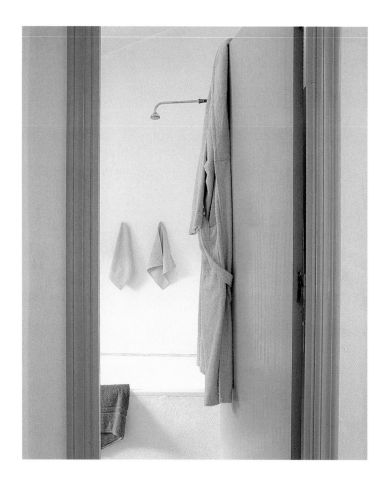

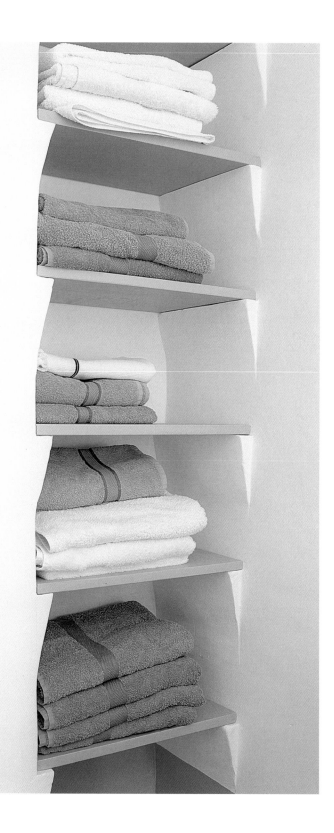

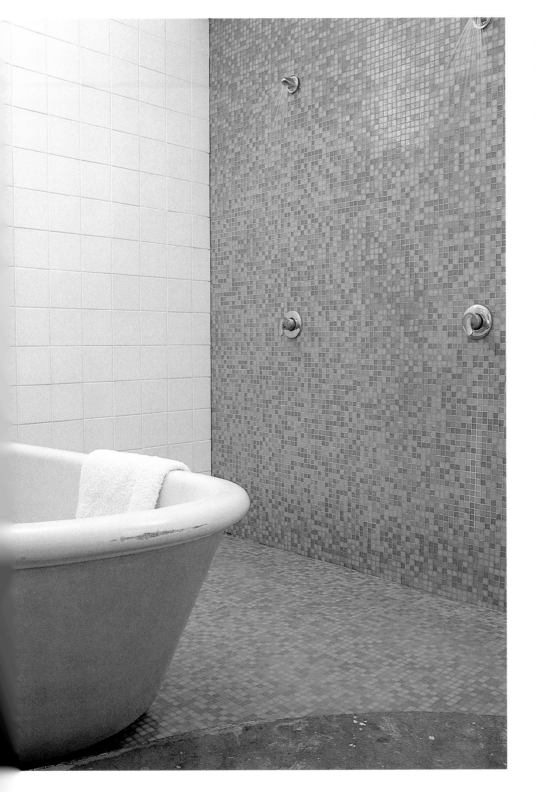

as sooner or later it will get wet, and begin to turn mouldy and smelly.

When planning a shower it is essential to check that you have enough water pressure to produce a powerful downpour. You might need a pump that automatically boosts the flow. Showers can be simple affairs – from a hand set fitted to the bath taps/faucets with a protective screen or curtain, to a state-of-the-art walk-in room with a power shower.

There are numerous ways of storing bathroom equipment. Built-in cupboards are useful and one which houses a boiler will make practical airing-cupboard space for keeping hot, dry towels to hand. Boxes and baskets are good for stowing away dirty linen, spare towels or bathroom brushes and sponges. Versatile peg racks in wood and metal are ideal for hanging up sponge bags and flannels.

PURE STYLE

GARDEN

PURE STYLE GARDEN IS

also about experiencing the obvious, simple pleasures in life (the very elements that many of us neglect in the hurly-burly of daily living) like eating home-grown herbs or tomatoes, cutting your own roses for the table, or the sheer peace of sitting outside on a warm starry night. It looks at being self-sufficient, with ideas for creating a utilitarian vegetable patch for growing your own healthy produce – an increasing trend among people who are tired of consuming tasteless vacuum-packed fruit and vegetables from supermarkets. *Pure Style Outside* focuses on the decorative aspects of open-air living and the elements required to make your outside area more like a room, and it is full of inspiring ideas for good-value durable fabrics, simple outdoor furniture and accessories, and basic but good-looking tableware. It is also about eating, with suggestions for delicious outdoor food, using plain good-quality ingredients, from pasta with home-made tomato sauce, to grilled vegetables and delicious treats for dessert. Lastly, *Pure Style Outside* shows you how to appreciate the sensuous qualities of the natural elements that make an outside space a living, breathing place – water, light and shade, scent and texture – whether it is the cool, refreshing atmosphere of a wet garden after rain or the feel of lush grass underfoot.

ELEMEN

TS

Bring life to your outside space with organic textures and colour. Take a simple but practical approach and invest in basic old-fashioned tools that do the job properly. Take inspiration from vernacular styles for decorative and functional detailing. Choose colourful flowers that are easy to grow, and use fabrics and furniture to make your outside area a luxurious place.

Colour

Colours change endlessly according to the seasons, the weather and the time of day. Strong sunlight on white walls dazzles the eyes with a harshness that makes us reach for a pair of sunglasses, whereas a dull day actually intensifies colours so they appear to leap out of the greyness. Consider colour in every aspect of outside living: plants, architectural details, furniture, fabrics and food. There is beauty in the simplest elements: a climbing white rose; green peas and beans growing in a vegetable patch; and a shady table laid with a crisp white cloth and bowls of green salad. Simple colour schemes for plants look distinctive, such as rows of brilliant-yellow sunflowers; a white wall covered with tumbling tendrils of sky-blue morning glory; or a window box painted pale green and planted with hedges of dwarf lavender. Enhance a sense of greenery by painting doors and windows in garden greens. Take note of vernacular styles, such as the colours of blinds and shutters in Mediterranean villages, or the shades of green paint that decorate sheds and fences on farms. Make your outside space more of a room with colourful cushions and awnings: try classic shades of white or blue, or bold combinations like vivid orange and pink.

White

The simplicity of white makes it a purist's dream colour and a versatile tool: white flowers can be used as a foil for greenery and white garden accessories look crisp. Although I am tempted to grow flowers in all my favourite colours, I stick to mainly white as ultimately it is the look most soothing to the urban eye. Each spring I look forward to the sweet-smelling white flowers that bloom on the climbing *Rosa* 'Madame Alfred Carrière', an old-fashioned rose that thrives in its shady environment. White *Clematis montana* produces hundreds of star-like flowers that spread in May along the railings of my roof terrace. Perfect for shady spots is the less-rampant *C.* 'Henryi', which produces huge white flowers during the summer and has even bloomed in a warm December.

Whitewash

Stone

Canvas

Pebble

Spiky foxgloves are good for height and attract bees, but most are biennial. For smart, almost instant window-box material I buy pots of white asters, available from nurseries at the beginning of summer. Bright whitewashed walls are the vernacular style on sun-drenched Mediterranean patios and the look is easy to create with white-exterior paint. I use white emulsion/latex paint to transform everything from flowerpots to trellis; when it looks worn I simply repaint it, although old chairs and tables with blistered, peeling paint can look charming. Hardly practical, but white cushions and cloths look wonderful outside and create an airy, summery feel. I use old sheets for tablecloths and prewashed canvas for cushions and awnings, so at least the whole lot can be revived in the wash.

Blue

Blue, the colour of the sea and sky, and flowers like blue-bells/bonnets, agapanthus and delphiniums, combines well with pink, white or yellow. As a single colour it looks dramatic: a wall covered with jewel-like morning glory blooms, a fence bordered with cornflowers/bachelor's buttons, or a bank of papery irises. Sheds and window boxes look jaunty painted in the bright shades seen in all oceanside towns. Look to Aegean villages for inspiration and create a rich sea blue for tubs and flowerpots by mixing a few drops of blue universal stainer into a can of white emulsion/latex paint. A whitewashed patio looks great with blue and white cotton cushions and tablecloths, while bright-blue plastic cloths and plates look cheery.

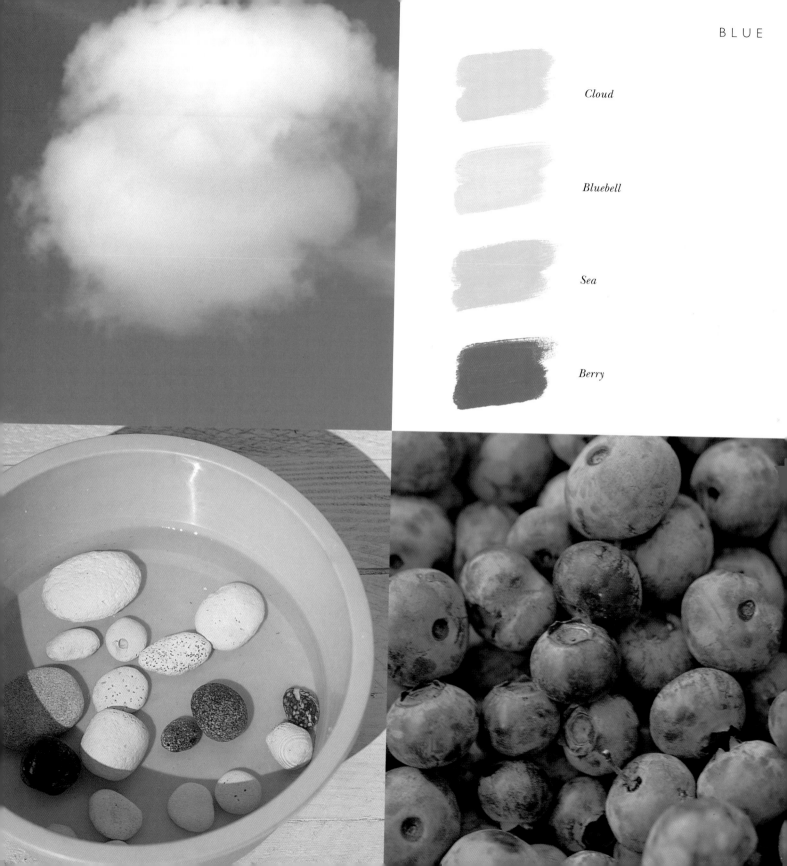

Cloud

Bluebell

Sea

Berry

Green

The array of greens in a vegetable patch illustrates the vast spectrum of shades: purplish green cabbages, lime-green lettuces and glossy peas packed in their pods. However commonplace, there is beauty in silvery green lavender, shiny rosemary, lime-green alchemilla and even a stretch of lush lawn. In spring, young leaves are luminous and bright with a yellow hue, and as the season progresses they darken to richer shades of green. Potting-shed greens, which blend unobtrusively with their surroundings, are the

Bean

Fig

Mint

Shed

shades devised by generations of gardeners who have painted fences, sheds, doors and seats in basic colours. Even if foliage is sparse, you can create an illusion of greenery by painting a bench, table, chair or door in anything from rich olive to paler leafy tones. Sea green or mint are more modern and have a Mediterranean feel; they are shades that look smart against galvanized metal buckets and pink- and lavender-coloured flowers. Green- and-white striped canvas is useful for deck chairs and awnings, and is the sort of utilitarian material that is still found in traditional fabric outlets.

Pink

Pink is a classic garden colour, and photographs of glorious pink and lavender borders of delphiniums, foxgloves, roses, sweet peas and peonies are what we hanker after and pour over in glossy garden books – the images would be complete with ourselves in appropriate gardening attire (a big floppy straw sun hat, with secateurs/shears and an old basket). Nature has so exquisitely matched pink with green: think of spiky lavender heads on trim silvery green stems, or fuchsia foxglove bells on lime-green stalks. I love to see trellis with pink rambling roses, or a garden wall flanked by towering pink hollyhocks. Fluffy purplish allium balls are good for creating

height, and clusters of pinks are pretty and old-fashioned for edging borders. Pink is a fabulous colour for summer table settings. I have a cloth and chair covers in an old Laura Ashley cotton Provençal print which look particularly vibrant. Pink-and-orange checked napkins enliven a plain white cloth, and deep-fuchsia place mats look great with lime-green napkins and vases of pink roses and alchemilla. To complete the effect, serve pink desserts like raspberry jelly/gelatin embedded with fruit or strawberry ice-cream.

Hollyhock

Sweet pea

Allium

Pansy

Orange

Earth

Tomato

Pumpkin

Flowerpot

vegetable garden look pleasing and deter caterpillars and snails, and pots of tall orange lilies look good on a balcony or terrace. Orange and pink are an exciting combination – try modern hybrid orange roses with old-fashioned pinks and cerises, and there are rich orange and pink varieties in the dahlia family, until recently considered rather kitsch. Dahlias are beautiful, but need

Garish and regimented municipal-park displays have made orange flowers unpopular with sensitive gardeners, and although splashes of orange would be unwelcome in a classic pink, lavender and white country-garden border, it is a wonderful, daring hot colour that can add vibrancy and life to an outside space. Borders of marigolds in a

flavour and decoration. There is something inviting and luxuriant about the neat avenues of trees laden with jewel-like oranges in southern Europe. A bowl of oranges with their leaves still attached makes a wonderful table decoration, and white jugs/pitchers stuffed with marigolds create vibrant splashes of colour.

to be grown in an orderly fashion, say, as part of a vegetable plot, and the cut flowers look wonderful in a simple jam jar. I vowed not to have any orange in my almost-white garden, but couldn't resist packs of nasturtium seeds. They are foolproof to plant in pots and trail up a tent of sticks producing endless orange, yellow and scarlet flowers, which can be added to salads for nutty

Yellow

Candle

Honeysuckle

Nasturtium

Hay

Reassuring bursts of yellow daffodils, narcissi and tulips punctuate city gardens and the countryside in spring, confirming that all the colour hasn't drained away during the winter. I like to plant pots and window boxes outside the kitchen with dwarf daffodils and narcissi, which have a wonderful heady scent. As a child I used to plant daffodil bulbs and keep them in a cupboard until spring; it was sheer magic to watch the shoots grow and produce a mass of yellow trumpets. I also have a fascination for sunflowers and cannot believe they can grow quite so tall and produce such giant glowing heads in so few weeks. Try planting rows of sunflowers to make a natural border or to create shelter from the wind. Other yellow favourites include honeysuckle, which is easy to grow from cuttings and has a scent that intensifies during the evening, and pale hollyhocks flanking a front door. For the outside table, yellow and green make a stylish combination. Grill/broil courgettes/zucchini and decorate them with edible courgette/zucchini flowers – wildly expensive in smart farmer's markets but free if you grow your own. For dessert, I serve yellow peaches in butter-yellow pottery bowls.

Surfaces

Organic, natural and synthetic surfaces combine to make the garden a living, breathing space. Nature creates an ever-changing textural picture: consider dry, sun-baked terracotta and the same surface after a heavy storm, darkened and glistening with puddles. Many surfaces improve with age and exposure to the elements, such as sun-blistered peeling paint on an old garden table, the bleached silvery grey of a weathered oak chair, or an irregular hand-thrown terracotta pot, crumbling with moss and age. For boundaries there are diverse materials such as old red brickwork, New England-style featherboarding, and simple wood-and-wire or stick fencing. For underfoot, old red-brick pavers can be laid in a herringbone pattern to edge borders or make practical pathways in a vegetable plot. Smooth square terracotta tiles look distinctive laid in a regular checquerboard pattern, and a line of old worn York flagstones creates a simple, useful path. Alternatively, there are cobbles, gravel and luxurious

soft lawn. Water is a sensuous, cooling surface, and merely filling up an old sink or bucket lined with pebbles and shells creates a simple makeshift pool. Textural fabrics for outdoor use include cotton canvas for awnings and woven cane or rattan for seating.

Texture

Contrasting textures in the garden are surprising and exciting, with tactile elements like rough weatherboarding, blistering paint, balls of hairy string/twine – useful for a multitude of gardening jobs – and brooms with twiggy bristles. The feel of a rough weathered flowerpot or a bleached wooden basket together with the smooth coolness of metal tools make any garden task a sensuous experience. After pounding city streets, treat tired feet to a soft and springy lawn, or a

carpet of heady scented thyme or camomile. It is satisfying to march down a crunchy gravel path or sunbathe on worn, lichen-encrusted flagstones, while teak decking, a good material for a pool-side area or terrace, feels smooth to the touch. No-nonsense coarse canvas is a natural, practical fabric for seat covers and awnings, and acts as a foil to indulgent feather-filled cushions and soft throws for luxurious siestas. There are also the textures of a dry garden, which contrast with those of damp soil and dripping plants, newly watered or after a storm, when leaves are bent double by drops of water.

Deciding what lies underfoot in your garden space is important in both practical and visual terms. The court-yard at the back of my house in London is laid with old brick pavers that were found ten years ago in a Cambridgeshire salvage yard. They are a rich red terracotta, which has weathered enough to look as if they were laid when the house was built

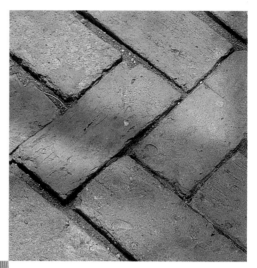

Underfoot

sense of order and lead the eye in exciting and sometimes unexpected directions. A diminutive flower and vegetable garden that I know in America's Catskill Mountains is criss-crossed by a series of swept hard-earth path-ways, an idea transplanted from the southern states where the owner grew up. An enclosed herb and vegetable

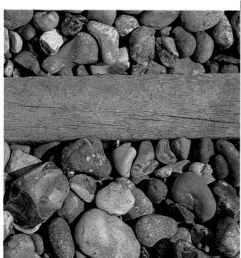

nearly 300 years ago. A weekly sweep with a stiff-bristled broom is enough to keep the area pristine, and after very wet spells I hose it down with a mild bleach solution to keep slippery moss at bay. Old creamy yellow flag-stones were another option that I considered, but they were more costly to transport and to lay per square metre/yard. Garden paths create a

barefoot in the cool of the evening. They can be obtained quite cheaply from builder's merchants in France, Spain and Italy, or from local suppliers who import them. If you have time, it is also worth looking out for tiles salvaged from old farmhouses. The irregularity of rough, uneven cobbled surfaces is appealing, and I am inspired by the decorative marble-chip patios,

garden in Connecticut is more formally bisected by uneven brick avenues, while a London vegetable plot belonging to a friend of mine is divided by irregularly shaped slabs of stone. Smooth terracotta tiles laid in simple geometric checquerboard patterns are perfect for patios in a hot climate as they retain heat and are delicious to walk on

boardwalks at the beach and is a useful surface for roof gardens or small terraces where heavier materials are not suitable. For a greener, softer surface, the obvious choice is a lawn. More unusual are flagstones with herbs like camomile or thyme planted between the cracks, which emanate a delicious scent when crushed underfoot.

pavements and alleyways found in many Spanish villages. Other aggregates, such as gravel, create textural, crunchy paths that are practical and reasonably maintenance-free. Specialized suppliers will provide everything from white marble cobblestones and green marble pebbles, to beach pebbles, cockleshells and terracotta shingle. Teak or pine decking has a seaside look inspired by

Boundaries

The earliest gardens were contained for practical reasons – for privacy, to exclude vermin and simply to enclose a cultivated area of ground. As well as protecting plants from frost, gardens surrounded by walls of red brick feel secretive and romantic. Visit old walled gardens in grounds of historic houses, for inspiration for designing your own enclosed area. Also, gather ideas from vernacular styles for fences and walls when choosing a boundary for your garden or vegetable patch: New England linear picket fencing is charming and can be found in garden centres on both sides of the Atlantic, and flat plank fencing, seen worldwide, can be painted white, garden green, or left unfinished to weather and bleach. Improvised fences of sticks or pieces of curved wattle look rustic and decorative in small vegetable gardens, while a row of espaliered fruit trees or pleached limes and neatly clipped box/boxwood hedges create natural, green boundaries. To create decorative borders for beds, try rows of smooth, round pebbles, lengths of bent or woven wattle, or scalloped Victorian terracotta tiles. Another

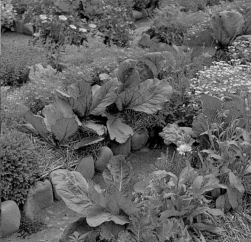

boundary that should not be over-looked is the facade of the house. Even if the only outside space you have is a window box, think about the colour and texture of the wall around it. A white-painted box planted with white daisies and set against white featherboarding evokes a simple New England cottage, while whitewashed

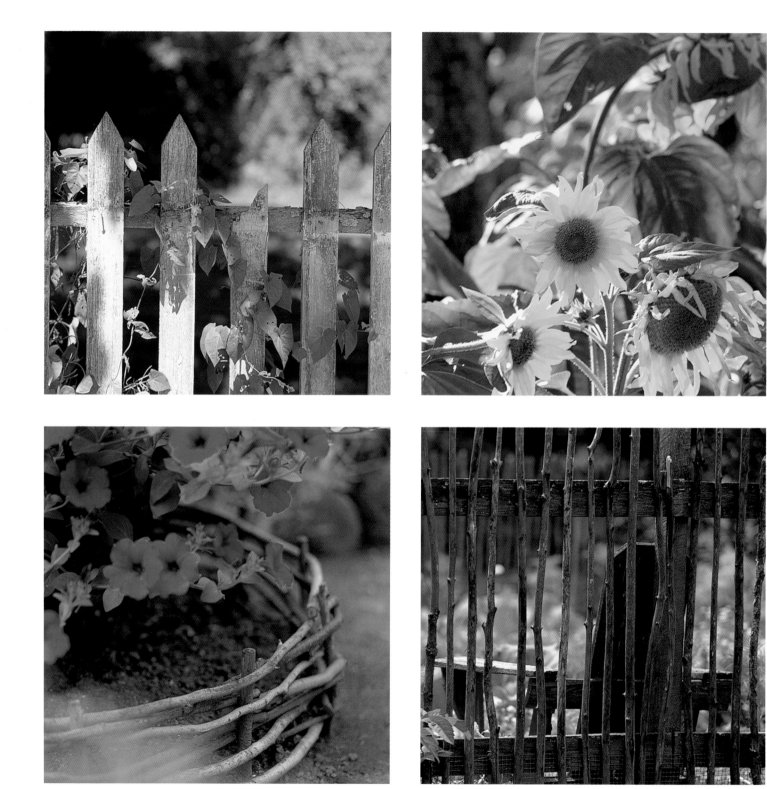

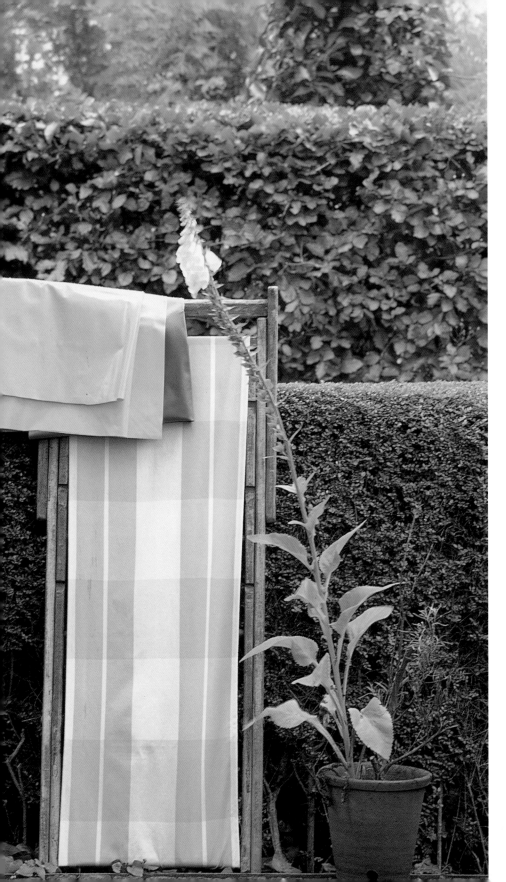

walls create a Mediterranean feel and are ideal for small patios as they reflect light and enhance the sense of space. Climbing roses and honeysuckle look pretty trained up the facade of a brick house. Alternatively, the flat features of modern precast brick walling can be alleviated with paint. The rich barn red that wooden cabins and sheds are painted all over North America and Scandinavia makes a strong backdrop for plants and outdoor furniture. I mixed up a greenish blue shade for a stretch of new wall, and this also makes a perfect ground for plants or topiary box/boxwood trees in metal buckets.

Utilitarian gardener

Efficient gardeners are methodical and rigorous about their duties. They rely on good, basic tools and, above all, have a passion for growing things. Sheds, lean-tos and other covered areas are utilitarian spaces in which to store all their garden paraphernalia, whether it is a supply of firewood or an array of pots and garden tools. Resourceful individuals cobble together sheets of corrugated metal, salvaged wood and doors to create makeshift shelters. Then there are glass greenhouses for nurturing delicate seedlings, overwintering cuttings and growing frost-intolerant fruits and vegetables. The British are very fond of sheds, which lurk at the bottom of many suburban gardens and are stuffed with everything from Wellington/rubber boots, pea sticks/stakes, seed trays and tools, to old-fashioned insecticide pumps. Another essential is a compost bin, filled with grass cuttings, leaves and other potential mulch. Even a city dweller with little outside space can reserve a corner for organizing gardening gear. Make sure the area is watertight and perhaps construct a lean-to shelter. Paint crates for storing pots, use a side table as a potting bench, build shelves for tools, or screw in hooks for string and raffia. A window-box gardener might find that a canvas bag does the job.

Potting shed

On a train journey to any large British city you see patchworks of allotment/ community gardens, the plots often sandwiched between bus depots and electricity pylons/poles. The gardeners who hold the leases are a mixture of knowledgeable old-timers, who remember the self-sufficiency practised by everyone during the Second World War, and a younger generation of gardeners who want their children to know that vegetables come from the earth, rather than from Cellophane packs. Everyone has a shed, no matter how makeshift or eccentric, and a look inside any might reveal deck chairs; old plastic bottles to up-end on sticks to make improvised scarecrows; string; raffia; yoghurt pots for seedlings; and an array of tools. Vegetable patches and mixed gardens need year-round attention, from spring when bulbs begin flowering and the soil is hoed and fertilized in preparation for planting, through summer when fruits and vegetables ripen, weeds are battled with and watering is a constant activity, to autumn when plants are cut back and produce is harvested. These gardens require soil that is fertile, well

185

drained, well tilled and weed free. Light and crumbly soil allows air to enter, which sustains the organisms that make up healthy earth, so if soil is hard when dry, and sticky when wet, dig in as much organic material as you can to lighten it. Inexpensive meters for testing the acidity of soil are available – a pH of 6.5 is ideal for general purposes. With increased popularity in organic growing methods and less reliance on chemical pesticides and fertilizers, many gardeners are keen to make their own compost/humus and grow plants such as marigolds, which are said to destroy snails and caterpillars. Yet it is rather impractical not to resort to manufactured fertilizers if you have restricted growing space. I buy bone meal and apply a weekly dose of Miracle Grow/all-purpose fetilizer to help my roses, delphiniums, foxgloves, clematis, herbs, lettuces and tomatoes. I also collect bags of well-rotted horse manure from a nearby city farm, which I apply in copious quantities in early summer and autumn. If you have space, a compost heap is essential, with ingredients such as tea bags, eggshells, vegetable and fruit peelings, manure and grass cuttings. Keep it moist with water and turn the heap occasionally to aerate it.

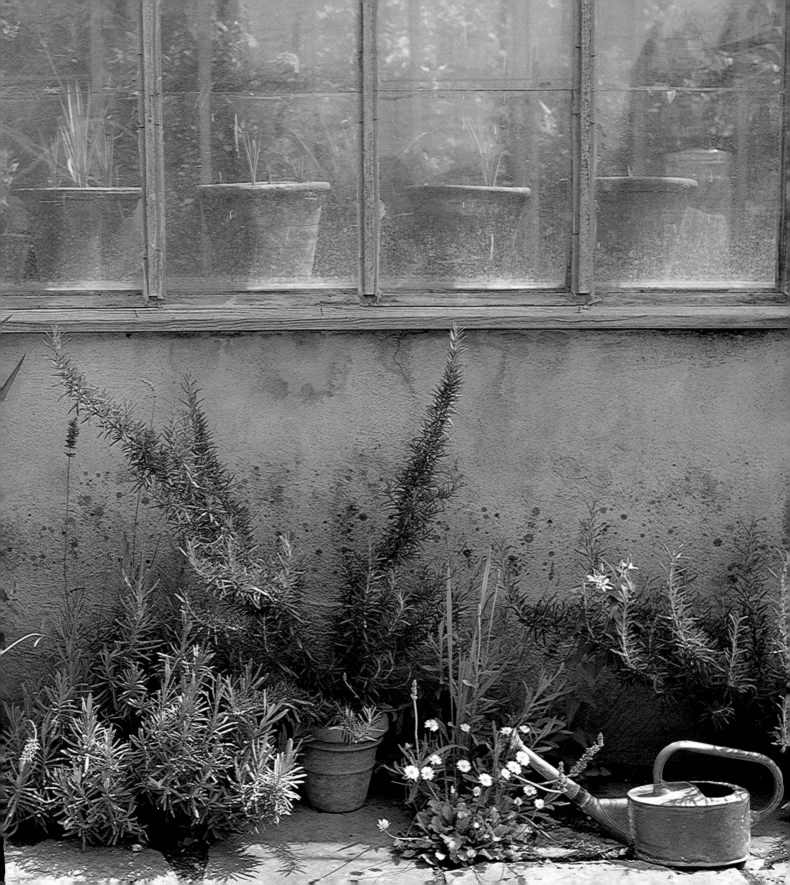

Structures

There is a fashion for growing anything from nasturtiums and tomatoes to beans and sweet peas up tentlike frames made from stakes or twigs. The effect, inspired by old-fashioned growing methods, is easy to achieve, decorative, and a practical way of training plants. Single sticks of wood set in compact rows are another functional but charming way of training beans and other climbers that do not produce heavy fruits, and 'hedges' of thin twiggy sticks are great for training sweet peas. For really simple but effective structures, buy lengths of chicken wire from hardware shops. Alternatively, simple wooden square trellis, available from any good garden centre, looks really smart painted a shade of garden green: I used it for training clematis over a rather ugly stretch of brick wall on my roof garden. Arbours, arches and pergolas create shady areas in which to relax, and are also decorative ways of supporting climbing roses and other brilliant blooms. Simple metal rose arches can be obtained from garden centres or mail-order catalogues, and the rather unsightly finish that many come in can

be concealed with tough enamel paint. Pergolas made of sticks are particularly romantic and easy to construct, but coat the ends that sit in the earth with an anti-rot preparation. A shady vine pergola is like a little outside room, and can be made by training a grapevine or another vigorous climber over a wooden or wire-and-metal structure.

Tools

Wooden-handled garden shears for trimming
hedges and cutting back shrubs.

*A set of all-metal trowel, dibber/dibble and
fork – essential tools for potting plants and
seedlings – are practical and easy to clean.*

*Keep a besom broom for sweeping up leaves
and twigs, and a supply of cane pea sticks
to build wigwams to train climbing plants.*

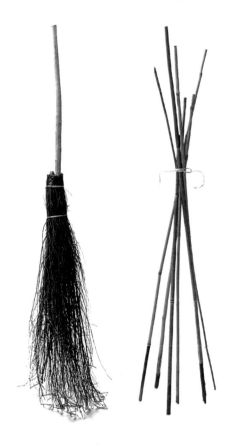

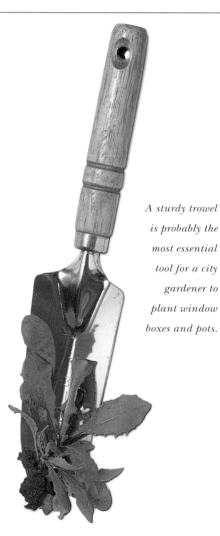

*A sturdy trowel
is probably the
most essential
tool for a city
gardener to
plant window
boxes and pots.*

I have a few indispensable tools for my
gardening, which live in the old coal
cellar – my version of a potting shed.
Most of my gardening is carried out in
pots and window boxes, and my water-
ing can is used twice a day in hot
weather to satisfy the thirst of the
potted plants. The essential fork, trowel
and dibber/dibble are kept tucked into
a pot, and secateurs/shears and a pair

*This plastic apron is
practical gardening
attire, together with
a pair of tough
gloves like these
vinyl-coated ones.*

*Curvy and compact, traditional wooden
baskets are shaped perfectly for carrying tools,
plants and other gardening gear.*

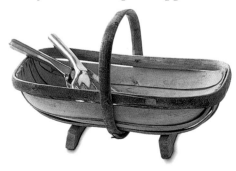

Bright-green refuse sacks are a jollier alternative to the ubiquitous black bin bags.

A big plastic holdall/tote is inexpensive and can be used to carry items, such as picnic gear and logs from the wood shed.

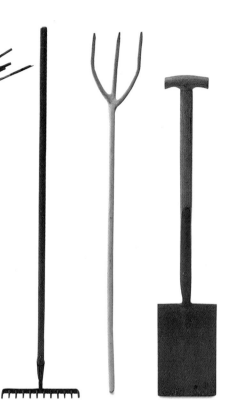

I have several metal watering cans and this galvanized example is good because its boxy proportions make it easy to carry and pour.

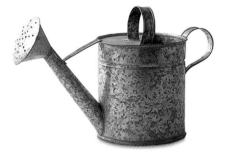

of tough gloves are always at hand for pruning. There are also canes/stakes, wire and string for training new growth, and hats, old shirts and gumboots/rubber boots. I also keep cans of emulsion/latex for painting trellis, pots and furniture, and plastic bottles of diluted liquid detergent to rid the roses of greenfly/aphids and more potent insecticide to deal with blackfly.

A rake for leaves, a traditional pitchfork and a solid spade/shovel with a wooden handle are all useful implements for the gardener.

Raffia and string are invaluable for all sorts of jobs, from tying tomato plants to canes/stakes, to hanging up bundles of bulbs to dry.

Plant labels need not be boring to look at. Metal or wooden garden tags are much more stylish than plastic ones – and they are not expensive.

Gumboots/rubber boots are the most sensible footwear for gardening jobs on soggy wet days – this pair is lined with leather.

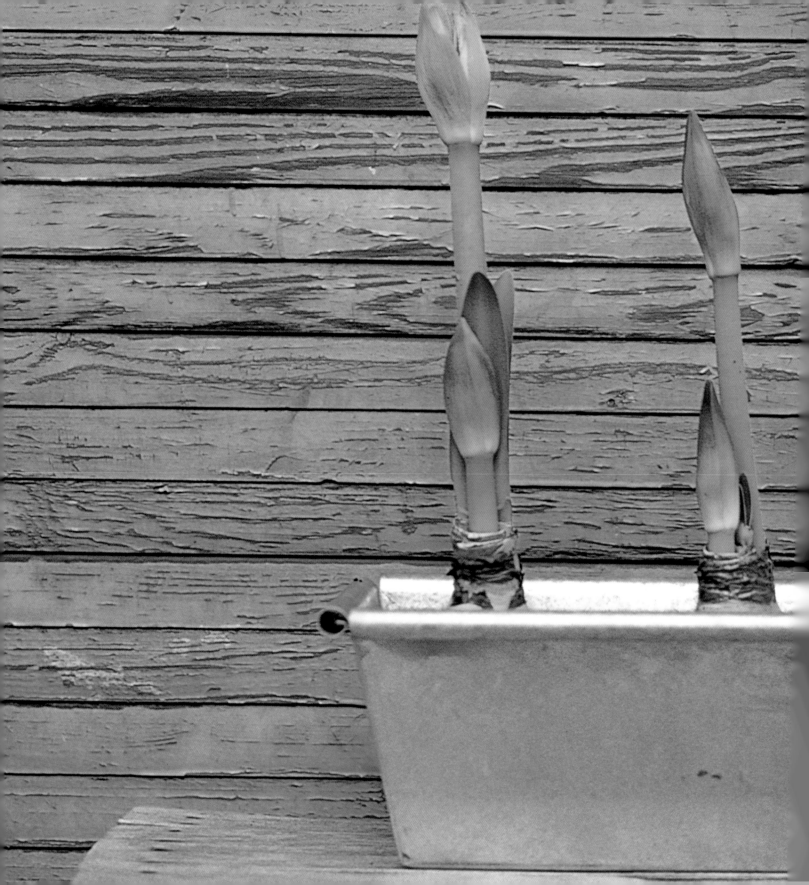

Containers

Almost anything will do as a plant container: plastic bowls, old sinks, terracotta pots, wooden tubs and galvanized metal buckets are just some examples. Containers make focal points within a garden and can be moved whenever you feel like it. Try a pair of tubs with standard box/boxwood or bay trees on either side of a door, or mass together terracotta pots filled with herbs. Create a miniature garden on a windowsill or balcony with window boxes containing anything from little lavender hedges to trailing nasturtiums, vegetables or herbs. Wooden seed trays, picket-fence window boxes and twiggy troughs are all useful for displaying pots of herbs, spring bulbs and summer bedding plants. For added colour I paint pots in shades of green, blue or white. Good drainage is the key to success, and normal-size pots with a central hole need only a few stones in the bottom before being filled with soil. For a well-balanced potting medium, use soil that is light, friable, easily drained and nourishing. Mix heavy

soil with sharp sand, and light soil with rich loam. Add granulated peat to help retain moisture, and fertilizer to provide nourishment. With the addition of compost or potting soil and regular feeding, potted plants will remain healthy in the same soil for years.

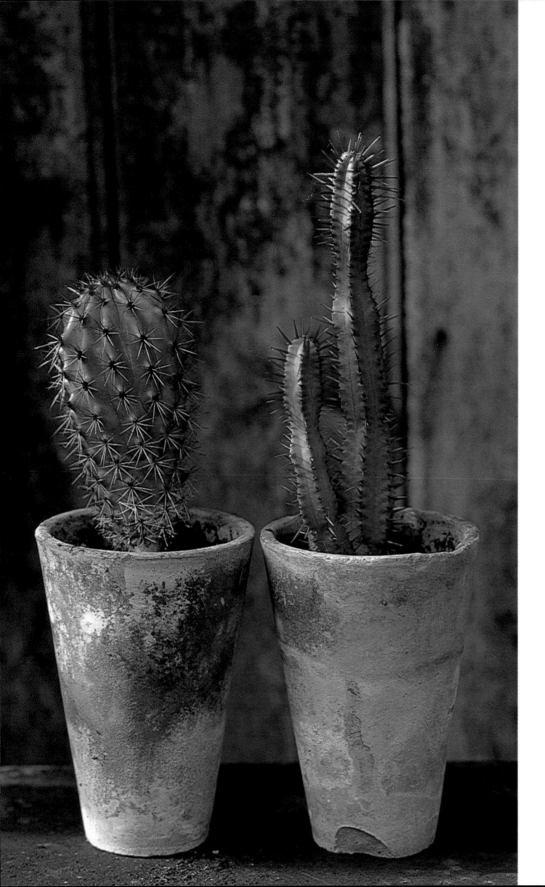

Terracotta

Shapes range from traditional flower-pots to giant Ali-Baba urns. Good garden specialists import wonderful textural terracotta pots from Spain, Italy, France, and Morocco. Salvage and reclamation yards are good sources of old hand-thrown flowerpots – I have five beautiful worn examples that came from the glasshouses of a country mansion. Machine-made terracotta pots look uniform and lack the texture and irregularities of hand-thrown examples. To add instant character to cheap pots from garden centres I mix up a wash of white emulsion/latex paint coloured with green, blue or terracotta paint. Pots left out in the elements weather quite quickly, but you can accelerate the process by smearing them with yoghurt to encourage green moss to grow. I use giant terracotta pots in all shapes for planting clematis, trailing tomatoes, honeysuckle and lavender, and rectangular containers placed against a wall for growing taller things like foxgloves and delphiniums. Create a windowsill or balcony kitchen garden with herbs planted in individual pots: rosemary, parsley, mint, marjoram, rocket, sage, thyme and basil (provided

Ideal for a rooftop or balcony vegetable garden is a long tom/tall flowerpot painted in vibrant lime-green emulsion/latex paint with a tent of pea sticks/plant stakes and raffia to support a cherry tomato plant.

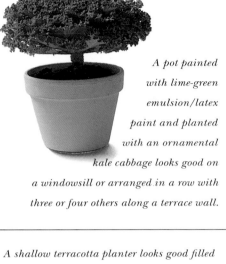

A pot painted with lime-green emulsion/latex paint and planted with an ornamental kale cabbage looks good on a windowsill or arranged in a row with three or four others along a terrace wall.

Old terracotta bowls look decorative planted with herbs or bedding plants like pansies, but make sure there is a hole for drainage.

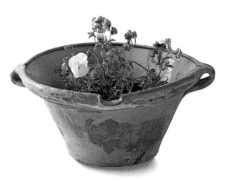

A shallow terracotta planter looks good filled with several low-growing plants such as mind-your-own-business/baby's tears.

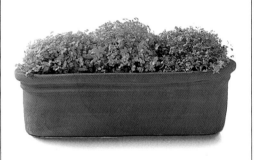

A 19th-century-style terracotta rhubarb forcer with a removable lid can either be planted with tiny trailing flowers or left empty as a decorative feature.

it is sunny, warm and sheltered) grow well with a strict daily watering regime. Or use terracotta pots for vegetables: I have grown lettuces, trailing tomatoes and dwarf cherry tomatoes with success. For a structured look, round box balls/ball-shaped boxwood plants look architectural in square terracotta pots, while little box/boxwoods or bay standards suit pots with a round shape.

left to right

Pansies planted in a wall pot painted with a wash of white and terracotta emulsion/latex; two tom/tall terracotta pots planted with an amaryllis and a topiary box tree.

Ornamental curly kale cabbages in a simple
galvanized metal container make an unusual
decoration for the table or windowsill.

An old powder-blue enamelled camping dish
is an idea for planting violas and other
tiny flowering plants.

A basic metal tin is ideal for growing wheat
grass – the latest organic wonder root, which
can be liquidized to make a nourishing drink.

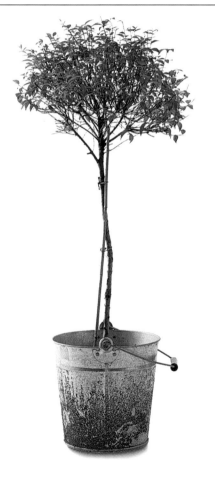

The silvery green leaves and rough texture
of aromatic lavender work well with metal
containers like this florist's display bucket.

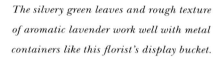

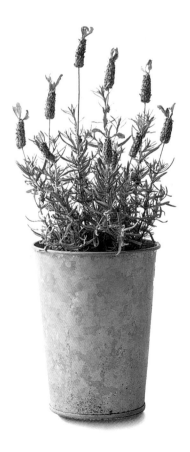

A weathered bucket is a pratical, yet pleasing,
container for a box/boxwood standard.

A shapely bay standard in a metal bucket can
be placed on a table to create a sense of height.

Metal

Functional and simple metal kit for the garden, such as galvanized metal watering cans and bins, and corrugated-iron shacks and sheds have a rough, honest appeal and create a foil to the softness of plants and flowers. Metal plant containers – whether they are buckets, troughs, bowls or old cans – have a tough, utilitarian feel, and their modern look makes a refreshing change from traditional stone or terracotta containers. The silvery grey colour of the metal works well with greenery, and the textured galvanized surfaces look good contrasted with silvery grey-green lavender leaves or shiny dark-green rosemary bushes. Simple architectural shapes such as topiary box/boxwood or bay look smart and stylish in metal buckets, which can be bought inexpensively from hardware shops. You can even recycle baked-bean or tomato tins and make them into vases for cut flowers or, with small holes punched in the bottom for drainage, containers for herbs. The Spanish are particularly fond of using giant olive-oil tins or oil drums to plant everything from geraniums to hollyhocks.

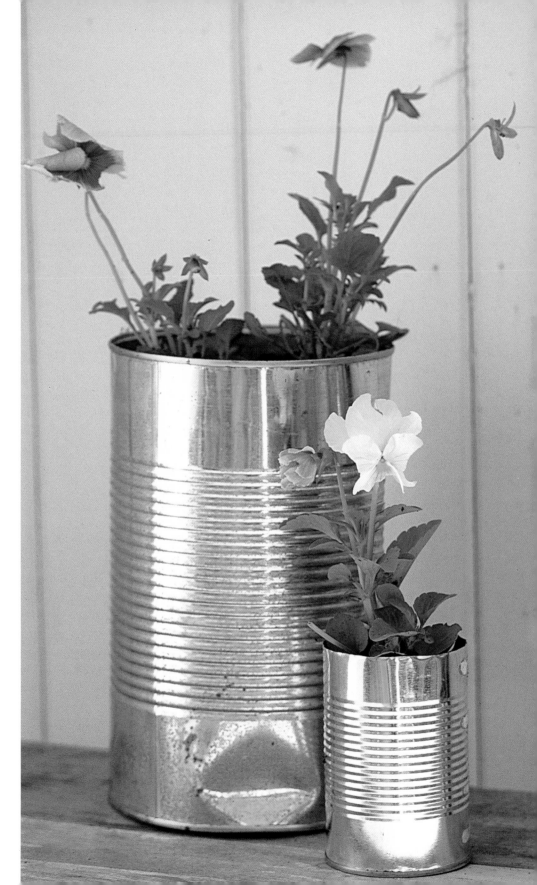

Sky-blue and sea-green plastic pots are an alternative to traditional terracotta. Use as a table decoration or display five or six on a sill.

Based on the design of egg boxes, these functional cardboard seed trays are available from any good garden centre.

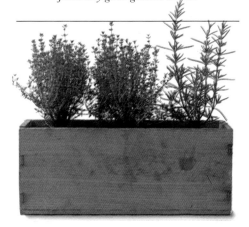

For a plain, natural effect, fill an unpainted junk box with silvery thyme and rosemary.

Plain white plastic cups, which can be bought very cheaply from any supermarket, make useful and simple pots for planting young plants and seedlings.

A window box with picket-fence detail, filled with pots of herbs, is ideal for a kitchen garden.

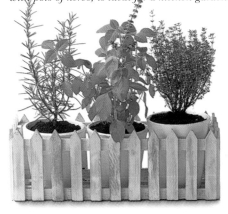

Basic and traditional wooden seed trays are a practical and innovative way of displaying pots of flowers or herbs.

An old wooden box has been brightened with coats of white emulsion/latex paint to make a simple window box for flowers or herbs.

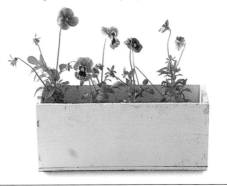

Wood and plastic

For a rustic look, a basic rectangular window box in strong hardwood like cedar can be left to weather a lovely silvery grey or painted to unify with doors, walls and furniture. It is such fun to pick your own juicy tomatoes and to have a few herbs at hand for giving delicious flavour to suppers of fish, new potatoes and salad. A simple window-box kitchen garden could have herbs like chives and parsley at the back and trailing cherry tomatoes at the front. Or, for a simple, uniform scheme, plant white or blue hyacinths, hedges of dwarf lavender, nasturtiums or white asters. Wooden slatted tubs, barrel shaped or square, can be filled with anything from wild flowers and herbs to topiary box/boxwood trees or giant sunflowers. Wooden seed trays, filled with pots of herbs, look good displayed on outdoor tables. Steer clear of plastic pots and window boxes in soulless colours and shapes. Be inventive and adapt brightly coloured sink bowls and buckets, in vivid greens and blues, for a more contemporary look.

An ugly standard plastic window box has been transformed with two coats of powder-blue emulsion/latex paint, and then planted with ornamental kale cabbages for a contemporary look.

199

Flowers and plants

It is exciting to grow your own flowers, herbs, vegetables and fruits – and you don't have to be an expert. It is equally pleasing to nurture a window box or grow a tub of rocket from seed as it is to plan a large-scale garden. Colour is the most important criterion for me when it comes to choosing flowers and plants. My favourites remind me of childhood summers: white climbing roses; fat purple alliums; white and pinky-purple clematis; pink foxgloves; deep-blue and lavender delphiniums; blowsy pink peonies; and gaudy orange, pink, white and red dahlias. I am an impatient gardener who wants the picture on the seed packet to be realized overnight. Although it is satisfying to take a cutting of a plant like honeysuckle, stick it in the earth and actually see it start to shoot a few days later, with the constraints of domestic hurly-burly, it is more sensible to invest in young plants from garden centres. When it comes to home-grown produce, it is possible to grow things in confined spaces: I had a good crop of tomatoes this summer from five plants in pots on the roof garden, plus nasturtiums and rocket grown from seed. There are also pots of herbs like basil, mint, thyme and rosemary, just some essentials to have at hand for flavouring every-thing from fish to salads.

Flowers

I am not a serious gardener because colour is my main priority when choosing flowers. I am not concerned with planting fashionable varieties and I probably make dreadful gardening gaffs simply because I want the colours to look right together. I am sure it is not *de rigueur* to mix tomatoes, nasturtiums and white clematis — a group I had on my roof terrace — but against the dreary urban roof-scape of concrete and brick, the bursts of vibrant orange, yellow, scarlet and white on a backdrop of greenery looked cheery. My dream is for a totally white garden (much like my ideal white minimalist interior), scented, romantic and flowering all

year. To achieve the former I need a lot more gardening expertise than I am prepared to gain, and with three children the interior vision is not meant to be – at least for a few years. Therefore, I am content to be less exacting about colour in the garden and to experiment and make mistakes. I stick loosely to a palette of individual colours that also marry well with each other: white, pink, lavender, and hot oranges and yellows. I find that blocks of single colours tend to be more

opposite, clockwise from top left *Pretty blue border geraniums; leggy delphiniums to add height; delicate white violas; foxgloves – easy to grow, but most are biennial; agapanthus, with ball-like flowers on slim green stems.*
above *Not all poppies are red; more delicate shades include white, lavender and blue.*
right *Passion flowers are vigorous climbers.*

dramatic and less confusing to the eye, like a wall smothered with white roses, tubs of green topiary box standards, or a path edged with pinks. For height and drama I love foxgloves, especially white ones. Having disdained this woodland plant for years as a self-seeding weed, gardeners now compete to produce varieties for flower shows in the most subtle shades of pink, white and lavender. The tag that came with my appropriately named 'Albino' describes the majestic spikes of tubular white flowers that bloom during June and July, and, of course, the warning that foxgloves are toxic if eaten. I managed to grow them in large pots on the roof with quite satisfactory results. One day I will plant pots of white agapanthus, whose graceful stems support lacy

heads – another good plant for height that grows well in sunny spots. Delphiniums seem ridiculously easy for amateurs like me to grow and their tall spikes with a froth of blue and mauve flowers exist quite happily in potting composts enriched regularly with bone meal and plant food. Climbing white roses and pot-grown rambling clematis are other favourites that are good for camouflaging unsightly objects. Passion flower is a pretty climber that grows well in sheltered positions. The blooms only last a day or so, but are produced so freely that there is a constant display from June

opposite, clockwise from top left *Peonies look beautiful even after heavy rain; voluptuous, rain-soaked summer roses; morning glory's trumpet-like flowers live less than 24 hours.*

clockwise from top left *Poppies look wonderful in wild, uncut grass; border geraniums add a touch of delicacy; woodland foxgloves look at home in both country and urban gardens.*

to September, often followed by edible bright-orange fruit. Morning glory is another eager half-hardy annual that produces myriad trumpet-shaped flowers, in sky blue, magenta or deep pink, from June to September. The flowers last only part of a day, normally closing during early afternoon, but, shaded from the midday sun, they may last until evening. A traditional cottage -garden flower with late-summer blooms, often used to edge a path or potato patch, the perennial dahlia is ideally suited to making a brash colour statement. With many varieties and combinations of white, crimson, pink, yellow and purple – some with two colours in one stem – dahlias are making a comeback. Zinnias are another showy flower in gorgeous pink and orange, with broad and flat, rolled, or even frilled petals. They flower in late summer and give life to a border. While carnations are deemed kitsch, the common garden pink, which is in the same family, is a pretty, feathery border flower that is easy to grow.

opposite *Dahlias make bold colour statements.*
clockwise from top left *A fuchsia dog rose; a feathery petalled dahlia; home-grown nasturtiums; pretty cottage-garden pinks; a vibrant zinnia; poppies growing in long grass.*

Herbs

Herbs look beautiful and taste good: camomile or thyme are fragrant planted between flagstones; mint, thyme and parsley make good cottage-garden borders; and rosemary or bay can be clipped into architectural shapes. Even if you are restricted to a windowsill or balcony it is possible to grow in containers most of the herbs needed for cooking. Tomato salads and sauces without basil would be dull, and I generally keep a plant in the warmest, most sheltered spot for the duration of summer, and freeze sprigs for use in winter. Sage grows quite happily on the roof terrace and is reasonably hardy. I love the strongly scented leaves chopped sparingly into sauces and salads. Part of the pleasure of growing rosemary is cutting the spikes, which releases the heavenly sharp scent. Used sparingly, rosemary is delicious with pork, chicken and roasted vegetables. Mint has an irresistible smell and flavour, and grows like wildfire. I use tiny sprigs to decorate ice-cream and to add flavour to new potatoes. It is a pleasure to pinch the scented leaves of lemon balm, which you can add to wine punches and salads.

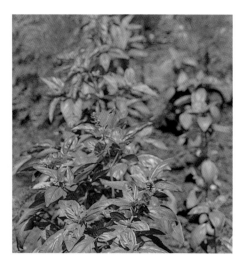

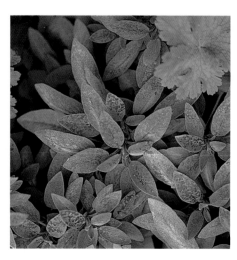

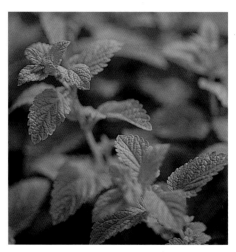

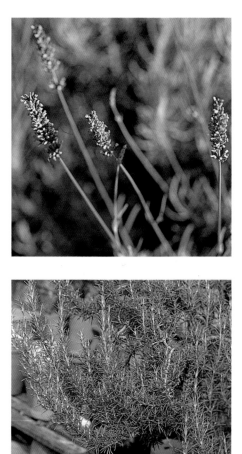

clockwise from top left *Basil, delicious in salads and sauces, thrives in sheltered spots but is destroyed by the first hint of frost; lavender looks and smells wonderful and can be used to flavour biscuits/cookies; drought-resistant rosemary is deliciously aromatic, but needs to be used sparingly in the kitchen; lemon balm grows vigorously and is delicious in punches; sage keeps its leaves throughout the winter and tastes good in stuffings and stews.*
opposite *Parsely is a versatile herb and is particularly good for flavouring salads.*

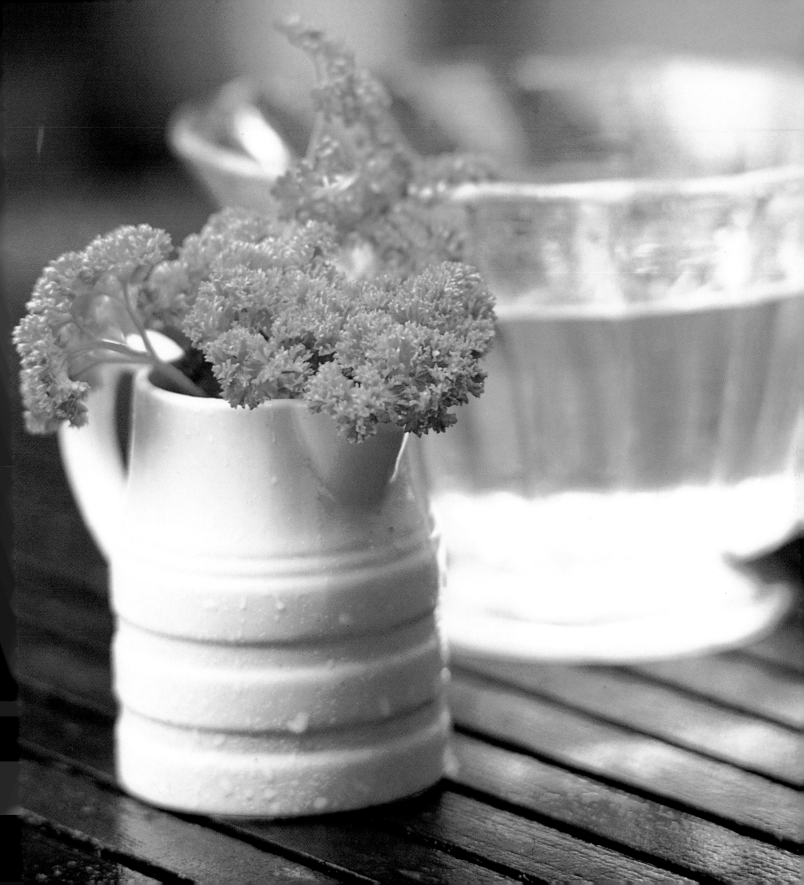

Edible flowers

Edible flowers add colour and taste to salads, desserts and cakes. Crystallizing rose petals is a magical way of dressing up cupcakes or buns. Wash your favourite petals from the garden, dip them in a mixture of egg white and sugar, then leave them to dry. Try crystallizing viola, pansy, geranium and lavender flowers, too. Bonnet-like pansy flowers make shortbreads into edible works of art, and bright-orange marigold petals look pretty on top of iced cakes. Bright-blue borage flowers, traditionally used in ice-cold Pimm's and lemonade, look pretty on a salad of courgette/zucchini and cucumber. Both dandelion and nasturtium flowers and leaves make vibrant additions to green salads, and yellow courgette/zucchini flowers are tasty if you dip them in a light batter and deep-fry them for a few minutes, and they look good raw in salads.

opposite, top to bottom
Pansies, borage and crystallized rose petals are pretty decorations for cookies, salads and cakes.
far right *Fresh herbs and flowers.*

right *Grilled/broiled courgettes/ zucchini decorated with their flowers (also* **below right***).*
below *Nasturtium flowers and leaves taste nutty in salads.*

Produce

I have always had a fascination for seed packets and the magnificent specimens that are promised in the illustrations. Even though we lived in London with little room for a vegetable patch, my parents grew courgettes/zucchini, tomatoes and raspberries covered in bridal-like veiling to keep off the birds. We had two big plum trees, one a Victoria that bent double and eventually collapsed with its yield of fat, juicy plums. My mother was endlessly making jam and there always came a point when my sister and I never wanted to see a plum again. My family and I are learning to grow things using the knowledge of the villagers near our house in Spain. We have learnt how to plant, stake and care for tomatoes, how to dip ridges for potatoes, how to take the seeds out of sunflowers and even how to thresh chick-peas. To cope with a glut of tomatoes, we skin and bottle them to store away for use in the winter in salads and stews. Even though the slugs and some kind of wilt threatened, we cut and ate our own magnificent cabbages which, lightly

steamed with butter, even the under-eights ate without dissent. At home in England, apple trees provide fruit for cooking and eating, and there are plenty of strawberries and raspberries for delicious jams. I have even been successful on my roof terrace this summer with a trailing variety of tomato that grew up a tent of sticks and produced tasty rosy-red specimens. I have also had luck with rocket/arugula, which grows with ease from seed and is a delicious nutty and slightly bitter addition to salads. Wild food is fun to gather: blackberries come to mind immediately, and they make delicious jam and pies. Sloes, found in country hedges, are bitter raw, but they can be added to gin and left to steep for a few months to make a pink, sweet brew in time for Christmas.

Fabrics and furniture

Toughness and durability are essential qualities for outdoor fabrics and furniture. All-purpose cotton canvas works well for simple chair covers and shady awnings, while cream calico – cheap, durable and washable – is ideal for making tablecloths, loose covers/slipcases and cushions. Another favourite understated fabric is blue-and-white ticking, a robust cotton twill closely woven in narrow stripes. Traditionally used for pillows and mattresses, it looks good in any setting, whether as cushions on a hot whitewashed patio, or as simple chair covers in a leafy garden. Plasticized cotton or PVC/vinyl are useful for waterproof tablecloths and come by the metre/ yard in checks and bold colours from department stores. You don't have to invest in extra sets of furniture for outside: indoor foldable chairs can be whisked out when the sun shines, as can a lightweight table. If you prefer permanent outdoor furniture, hardwoods should be oiled regularly or coated with tough exterior paint. The alternative is the aged,

weathered effect: peeling paint, algae-encrusted wood or rusty metal – organic textures that look at home with outside elements. There are plenty of outlets for junk furniture that can be left outside, but expensive pieces should be brought inside once summer is over.

217

Fabrics

Fabrics need to be tough and hard-wearing for outside use. The best textures include canvas, linen and washable plastic. Department stores or haberdasheries/fabric stores are great sources of stripy deck-chair canvas, plasticized cottons for cloths and basic cotton calico/muslin. For stylish colours – bright blue, green, pink and orange – head off to interior design shops that update their collections as regularly as fashion houses. Heavy cotton canvas is one of the most adaptable fabrics and can be used to make sturdy loose covers/slipcovers for garden chairs. It is important to wash natural-fibre fabrics before cutting and sewing, so that you can renovate them in the wash without disastrous shrinking. I like to buy tough blue and white plain or striped cotton canvas to make awnings for my yard. The ends are hemmed and the corners punched with metal eyelets. The awning is secured to hooks on the wall with nylon rope that can be adjusted. White and cream fabrics look fabulous, especially in a white-painted outside space. Imagine that you are creating the outside version of a simple, minimalist interior. White cotton loose covers/slipcovers can disguise ill-matching chairs, and a white sheet flung over a table looks stylish and provides a plain background for food. Scatter cushions should be filled with feathers and bench squabs/pads should be of good-quality foam and have removable covers secured with Velcro, buttons or ties. Fabrics in vibrant seaside blues, apple greens and rosy pinks add colour and enhance surrounding flowers and greenery. Pink and orange cloths and napkins look bright and contemporary, while blue-and-white ticking looks smart in any setting and makes understated covers for cushions, bolsters and chairs.

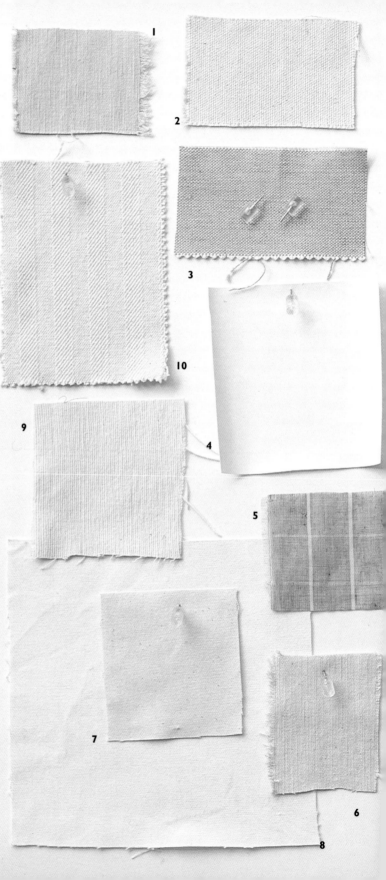

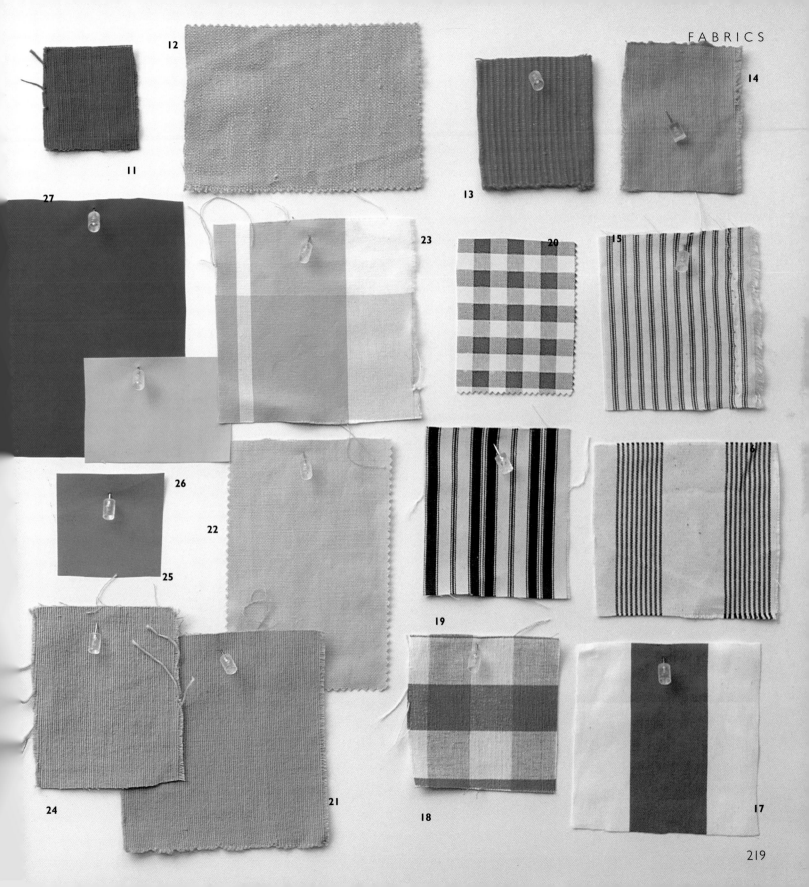

11

12

13

14

27

23

20

15

26

22

25

16

19

24

21

18

17

Furniture

Simple wooden benches of teak or another tough hardwood look good left in their natural state, or they can be painted with exterior paint, like this one in bright blue.

This contemporary rocking version of a traditional deck chair folds away for easy storage. It has a lightweight aluminium frame and a tough green Textilene cover.

Cheap, practical, but totally charmless, moulded plastic garden furniture has spread like a rash through parks, hotels and gardens. Here are some simple, decorative alternatives for seats and tables that combine form and function without breaking the bank. Anything that folds is useful, so it can be brought inside when the elements become inclement. My favourites are small

Solid wooden garden tables are one of the most practical outdoor items and can be put to use at any time of year, with painted surfaces that weather well for an organic look.

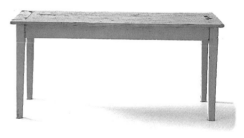

Picked up in a junk/thrift store, this old metal table with flaking paint looks good in the garden all year, and can be used to display pots of spring bulbs, or laid for summer meals.

A small folding table makes a dining table for one, and two or three can be put together to accommodate more people.

A folding director's chair, with a yellow checked cotton seat and back, is painted a sludgy grey that blends with garden greenery.

A flat-pack pine potting bench has been updated with coats of sea-blue emulsion. Use it to store flowerpots, seed trays and tools, or as a side table for serving food.

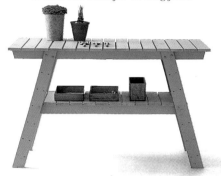

A traditional deck chair in a tough blue-and-white checked cotton cover looks crisp and cheerful in any outdoor setting.

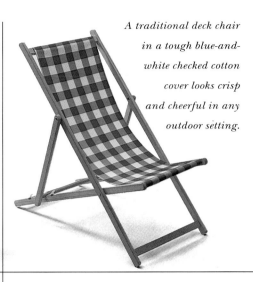

A cheap wood-and-fibreboard folding table can be carried outside for seating large groups; it can be smartened up with a cloth in white cotton or bright lime-green PVC/vinyl.

Lightweight folding cricket chairs are smart for outdoor dining. They come in lots of colours from sea blue to white, and old ones are often nicely worn and have rough, blistered paint.

folding slatted wooden tables spruced up with a lick of white emulsion/latex paint each season. There are streamlined, contemporary folding chairs and loungers with lightweight aluminium frames and tough synthetic covers. Outside furniture can be very basic: a plain white cloth on a practical folding decorating table becomes stylish with some jars of cut flowers and candles.

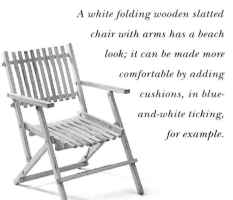

A white folding wooden slatted chair with arms has a beach look; it can be made more comfortable by adding cushions, in blue-and-white ticking, for example.

This sun-lounger is made of aluminium with a Textilene all-weather fabric cover. Ideal for camping, or for stretching out on a sun deck, beside a pool, or in the back garden.

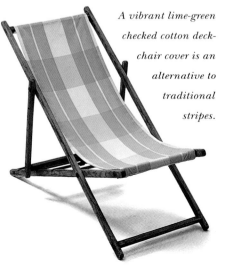

A vibrant lime-green checked cotton deck-chair cover is an alternative to traditional stripes.

Accessories

Setting up your outside space is no different from furnishing a room inside. The furniture will largely determine the look, so decide whether to buy smart pieces that need to be stored inside during winter or to look around in junk/thrift stores for old metal or wooden tables, benches and chairs that can be left outside to weather and provide exterior detail all year round. A simple solution for outside eating is to buy a hardboard tabletop with separate trestles and folding chairs, which can be dressed up with natural fabrics like cotton, calico/muslin, canvas and ticking. There is enormous scope for creating stylish outside table settings. Forget the days when we were expected to lay dinner tables with immaculate sets of cutlery and cut-glass crystal. At the most basic level, unbreakable plastic cups, bowls and plates are useful for children and picnics, while simple white catering/cafeteria china, with enamelled tin bowls and jugs/pitchers, creates a plain look that can be embellished with jugs of colourful flowers, candles and napkins in brightly coloured checks.

I love to mix odd glasses and jugs found in markets and junk/thrift stores. Whatever you choose, the only rule is to try to create informal settings that look wonderful, yet are simply achieved.

Lighting

Without doubt, the most sensuous outside lighting is candlelight at an alfresco supper or the flickering flames of a campfire. The only really pretty electric lights are strings of white lights, like those used on Christmas trees, which look magical strung in rows across a garden or patio. Cream candles are my favourite lights for outside and I have a store of empty jars that make really cheap but attractive containers. I also like glass storm/hurricane lamps and find that a line of three or four along the table creates pools of soft light. Candles can be displayed in basic metal lanterns from hardware shops, which are practical because they can be hung on hooks on the wall. For simple, cheap outdoor lighting buy bags of nightlights/votive candles in metal holders. They look stylish in flickering groups of two dozen or so in the centre of a table or in lines along windowsills, or placed in niches in old walls. Nightlights/votives can burn in a soft breeze but on windy evenings I put them in jars or pots.

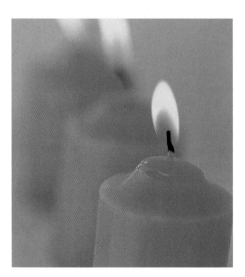

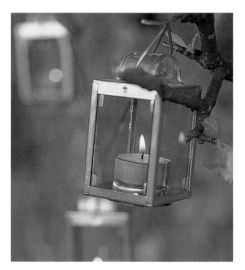

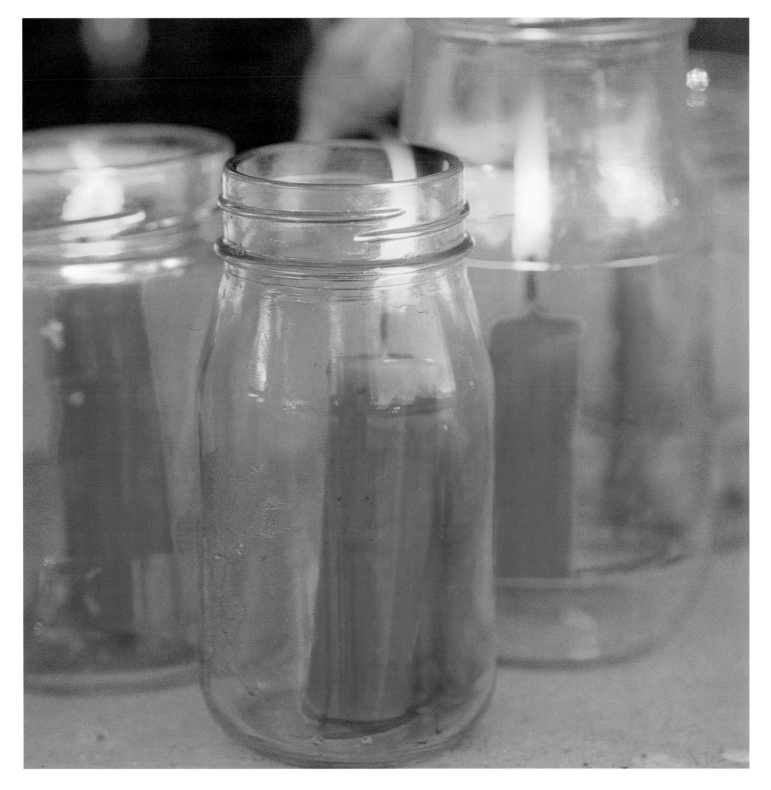

Utensils

A tough white plastic salad bowl is practical for use in the garden and kitchen, and lightweight enough to take on picnics.

A plain wooden tray is ideal for carrying food, drinks and utensils out into the garden. This one has been given a face-lift with blue emulsion.

Dome-shaped food nets conjure up images of old-fashioned country dairies and are efficient at keeping bugs off meat and cheese.

I use simple, basic, functional equipment and utensils for outdoor eating. Invaluable favourites include tough, unbreakable plastic bowls, plates and mugs, which can be bought really cheaply from hardware and chain stores. Tough glassware is not only practical, but looks very smart and is also widely available. For picnics and eating on the move, I am very

If outdoor meals involve children, delicate cups and glasses are likely to end up in smithereens. Play safe with plastic mugs and sturdy Duralex glassware that comes in lots of smart shapes and even bounces when dropped.

Reminiscent of those used in school cafeterias, a simple glass water jug/ pitcher looks good on an outside table, and is very cheap and easy to find in hardware shops.

A basic rectangular plastic lunch box, which can be slipped into a bag or backpack quite conveniently, is always useful for picnics or for carrying sandwiches to school or work.

Enamelled tin plates and mugs are great camping basics and also look good at the table. You can find this utilitarian tableware in hardware and camping shops.

Department stores are good sources of cheap and cheerful, brightly coloured plastic tableware, such as these vibrant orange examples that are ideal for picnics and informal outside meals at home.

A traditional barbecue is good for cook-ups at home or on the beach. Although tiny, it will produce sufficient heat to cook four lamb cutlets with garlic, with enough heat left over to roast bananas in their skins.

Napkins and place mats in bright solid colours or checks look best against plain cloths or bare wooden tabletops, and are cheerful even on the dullest summer's day.

Keep bottles cool with an insulated bottle cooler. This metal one is useful for smaller bottles or for butter and other fast-melting food.

fond of my tiny metal barbecue, which gives out enough heat to cook a veritable feast of sausages, or delicious fresh fish, vegetables, and even bananas and marshmallows. Brewing up cups of steaming coffee on a Primus/butane stove with a camping kettle is also a great way of keeping warm when picnicking on a sharp and clear winter's day.

A simple galvanized metal jug gives a robust, utilitarian look to outdoor table settings and is perfect for serving glasses of ice-cold water, or for holding a bunch of freshly cut flowers.

For a truly luxurious picnic, take bottles of drinking water to brew reviving cups of fresh coffee and tea, using an old-fashioned camping kettle heated over an open fire or gas camping stove.

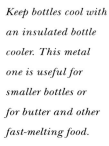

Plain white china is the best neutral backdrop for food, and is the perfect choice for stylish yet simple table settings.

227

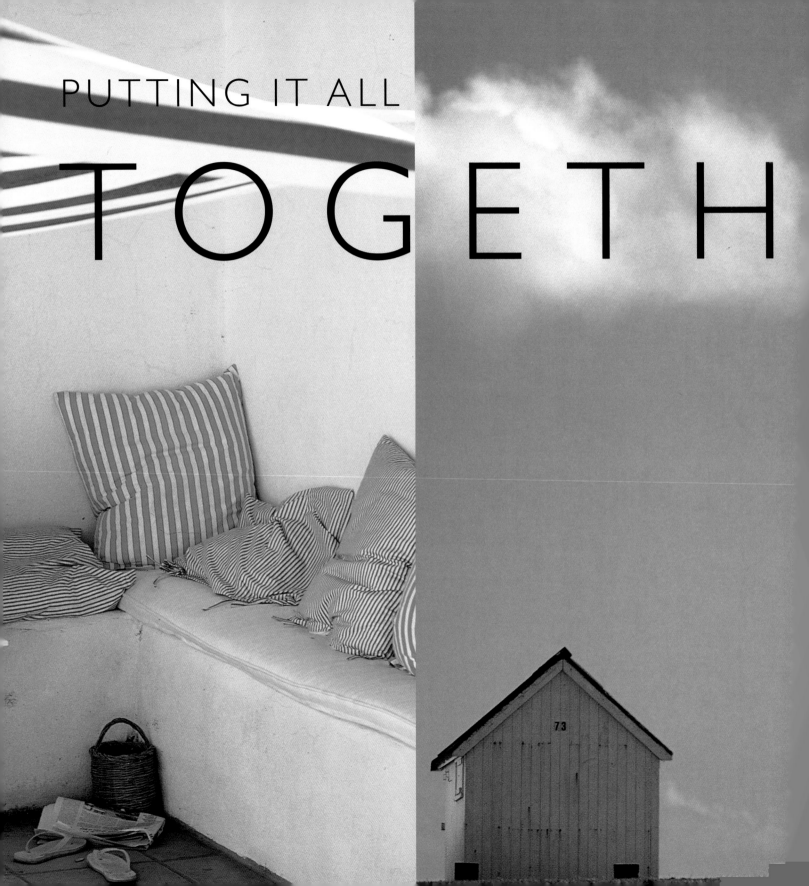

PUTTING IT ALL

TOGETH

ER

Create a simple, colourful, textural outside retreat, where you can unwind on a heap of soft cushions, or soak up the heady scent of a climbing rose. Get in touch with the elements and plant a vegetable patch to grow your own nourishing produce. Bring your dining room outside for delicious, informal meals, or stretch out on a blanket on the grass for a picnic.

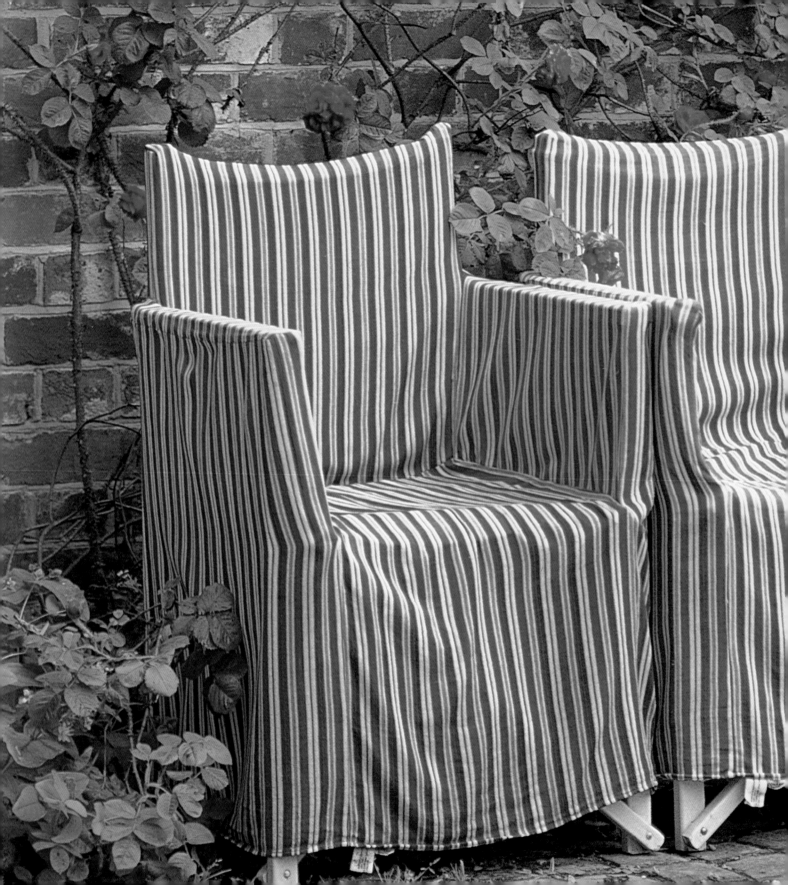

Outside retreats

Many of us, especially urban dwellers, are hemmed in for much of the working day and hardly experience fresh air, let alone the sensations of a crisp and frosty morning or the brilliance of a red sunset. Deprived of natural sensations and smells, we humans get depressed, lethargic and irritable, but our sense of wellbeing increases dramatically when we go outside. Whether it is a terrace, patio, vegetable patch, or even a windowsill with a brimming window box, having an outside space to tend to and enjoy creates a diversion from the irritants of daily life — bills, unwanted phone calls, dirty dishes and so on. Making a room outside — somewhere to eat, drink, sit, contemplate, garden, or play — is no different from decorating and furnishing spaces inside our homes. Outside as well as in, it is important to decide what sort of overall look and feel you wish to create and to be resourceful with your available space. The crucial design aspects still apply, such as what colour to paint walls, what kind of floor-

ing and fabric to choose, and what sort of furniture will work. It is also about creating a little bit of magic to give you a wonderful retreat in which to sit with a book on warm summer evenings or eat croissants and drink steaming coffee in the crisp morning air.

opposite and right

An elegant shady Long Island porch is painted white and blue and furnished simply with old wicker tables and chairs, with soft feather cushions covered in faded blue-and-white striped ticking.

below left and right

Porch style in the barn-red cabins of America's Catskill Mountains makes the most of a selection of simple junk furniture.

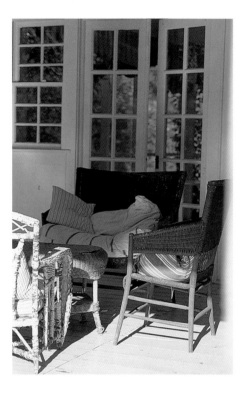

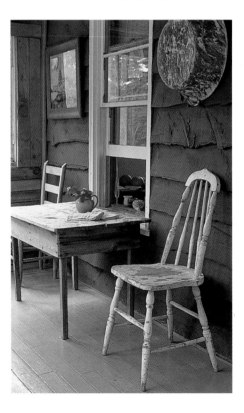

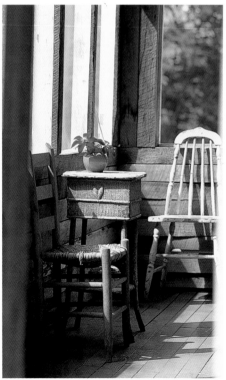

Verandas and porches

I grew up believing that only television characters whiled away warm velvet-dark evenings in rocking chairs on wooden porches, listening to crickets. When I finally visited the USA I saw that it really happens. I am envious that the long, hot summers have made this simple and practical architectural feature a necessity, as well as being a means of enjoying the outside in comfort. Among the neat picket fences and lawns of New England I saw the most charming porches and verandas with pristine white-painted railings and floors. Often enclosed with fine mesh screens to keep out insects, porches are shady retreats where visitors are refreshed with jugs of iced tea and entertained with stories about wild bears. The most stylish and simple porch furniture are informal old wicker chairs and tables, traditional rocking chairs and hammocks, with cushions in faded blue-and-white stripes. Some of the best furniture has been bought for a few dollars from junk/thrift stores. In the absence of the real thing, the porch look is easy and inexpensive to achieve using stylish old furniture revamped with paint in funky colours and chair covers and cushions in natural fabrics.

above and right
Enclosed with green-painted metal railings, this London roof terrace is a welcome sun-trap, which is ideal for growing toma-toes, pots of herbs and nasturtiums. The look is simple and utilitarian, *with basic tools, old chairs and a table with a green-and-white checked plastic cloth.*
opposite *A blue-and-white checked blanket and some big cushions make a white metal bench a more comfortable proposition.*

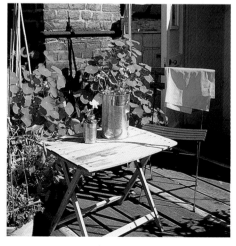

Rooftop space

It wasn't until the railings were fixed around the flat roof in the back yard of my London house that I felt it was really an outside room. Before, there was always a niggling feeling that someone might topple over and, of course, it was out of bounds for children. Apart from installing an outside tap/faucet for watering, which in summer is essential twice a day, the other important task was to lay the pine decking. With a shady courtyard below, the roof is a welcome suntrap, and for that reason I haven't bothered with awnings – on hot days we make do with wide-brimmed hats and sunglasses. To make it more sheltered and secluded, clematis, growing in pots, trails around the railings and over a simple trellis painted with pale minty green emulsion/latex paint. Mixing vegetables with flowers makes gardening a more productive and resourceful occupation, and I like to grow nasturtiums alongside tomatoes and herbs. Even though the garden is no more than 3.5 square metres/35 square feet, there is a sense of space and freedom among the urban rooftops, and there is nothing better than stealing up there to have breakfast on a warm summer's morning.

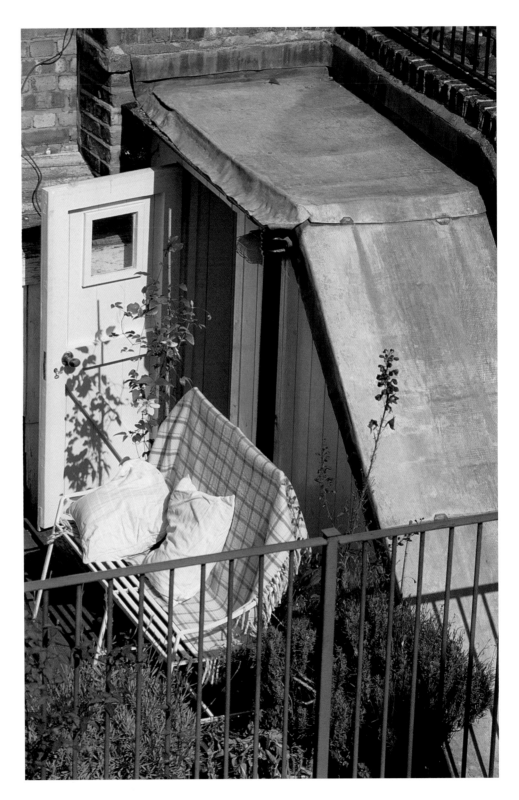

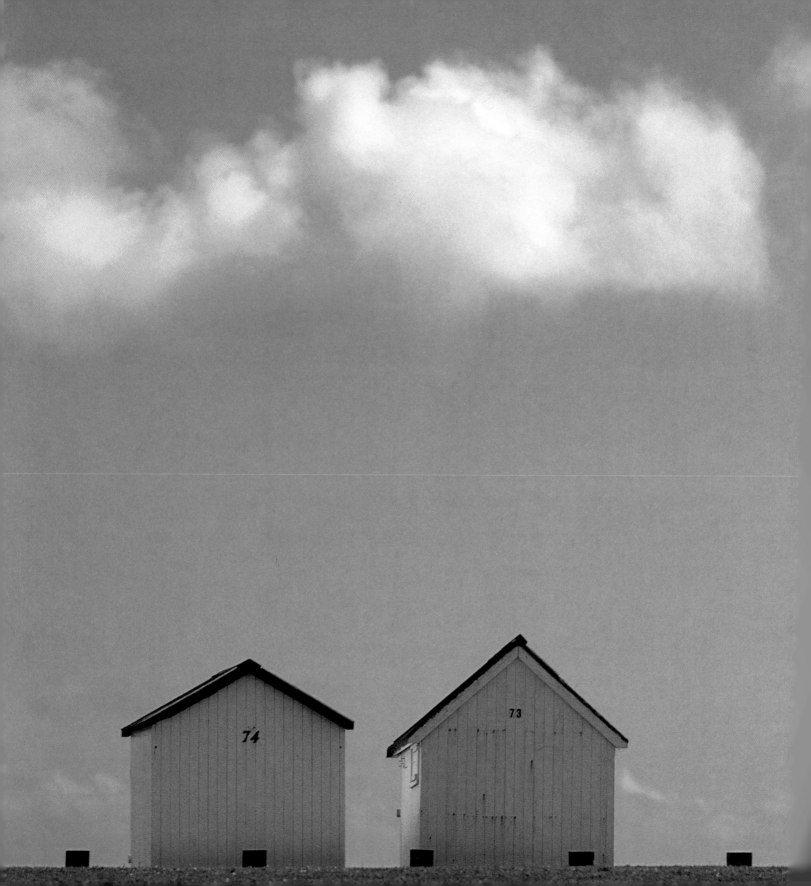

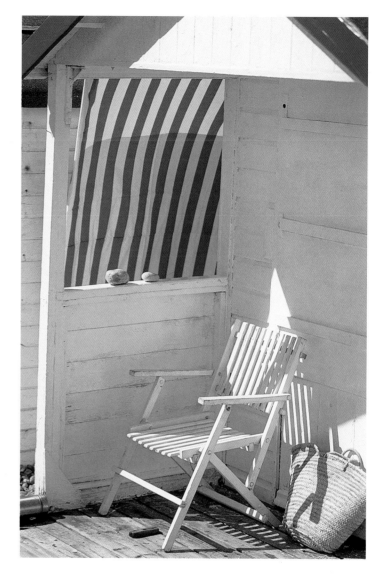

Beach-hut style

Nearly every seaside town around Britain has a stretch of beach or seafront devoted to higgledy-piggledy strings of small wooden huts that allow you to live, albeit temporarily, in a basic fashion without water or electricity beside the sea. Old-fashioned resorts like Swanage, Bognor, Worthing and Whistable have great beach huts – the best ones are in isolated spots away from the town centres. Colours vary from place to place: jaunty blue and white; dark brown creosote; glorious ice-cream shades of pistachio, raspberry and mint; and plain white are all vernacular beach-hut paint schemes which will inspire you to create the maritime look at home. Collect pebbles from the beach to make simple seaside still lifes and grow plants like sea kale, which thrive on pebbly beaches, for greenery and texture. My grandmother rented a beach hut in Devon for wonderful informal picnics with scratchy sand on the floor and fishing nets in the corner. Beach-hut gear was appropriately simple: nautical blue-and-white striped canvas deck chairs; a folding table; plain cotton cloths; functional picnic gear in a wicker basket; a camping stove to brew hot drinks; and a blanket for naps.

opposite

Traditional beach huts, like these at Worthing, give brilliant ideas for painting a shed or furnishing a deck. **above, left to right** *Sea kale growing among pebbles is* *great for creating texture. Paint the walls white and rig up a decorative awning in nautical blue-and-white canvas; for practical, stylish seating, use a white slatted folding chair.*

Hot patio

During the long, hot Andalusian summer, all our outside activities take place on the white patio surrounding our house. Rather than opting for rustic limewash, which needs a new coat every spring, we chose basic white matt exterior paint for the walls. The large terracotta tiles underfoot were bought from the local builder's merchant at a very low cost. Furniture is portable so that chairs and tables can be moved according to the time of day. I go to Seville to buy traditional Spanish country chairs and stools with rush seats, which have a timeless appeal. In contrast to the predominately white feel, I like to add splashes of bright colour with shocking-pink napkins or a bright 1940s green-and-turquoise seersucker cloth. Shade is vital, and I designed basic canvas awnings, punched with eyelets and strung to hooks with nylon rope.

right *This shady terrace, where the predominance of white is offset by splashes of colourful table linen, is a cool evening retreat.* **opposite** *An awning in blue-and-white striped canvas creates shade on the sun-baked patio.*

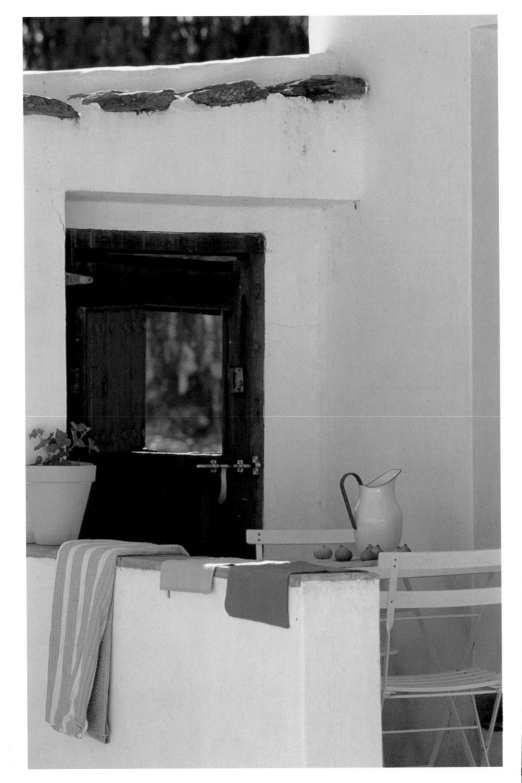

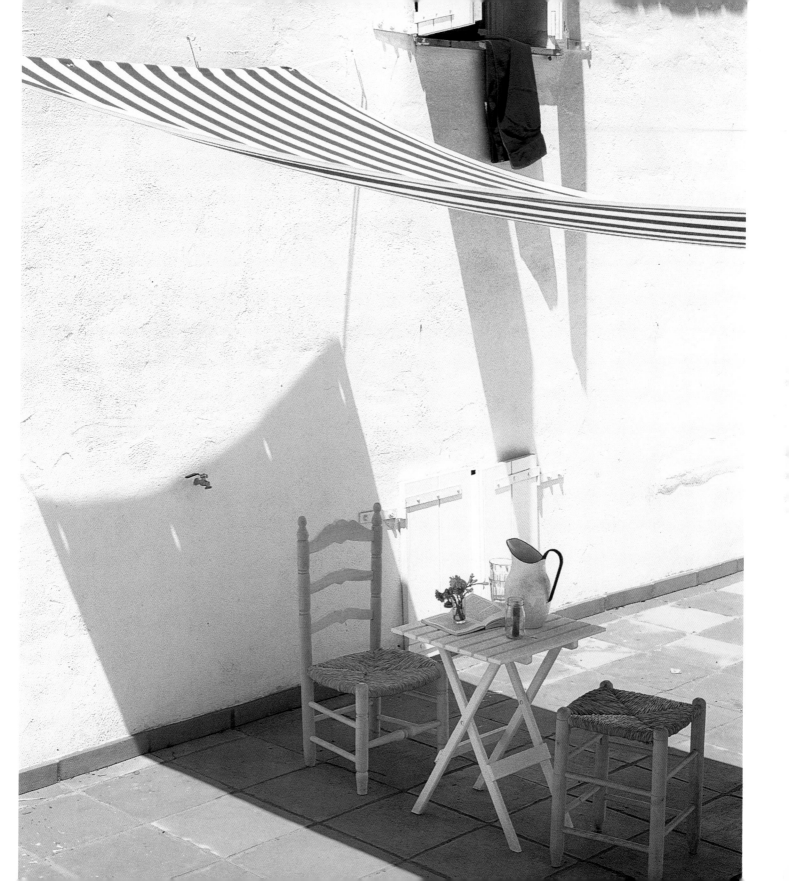

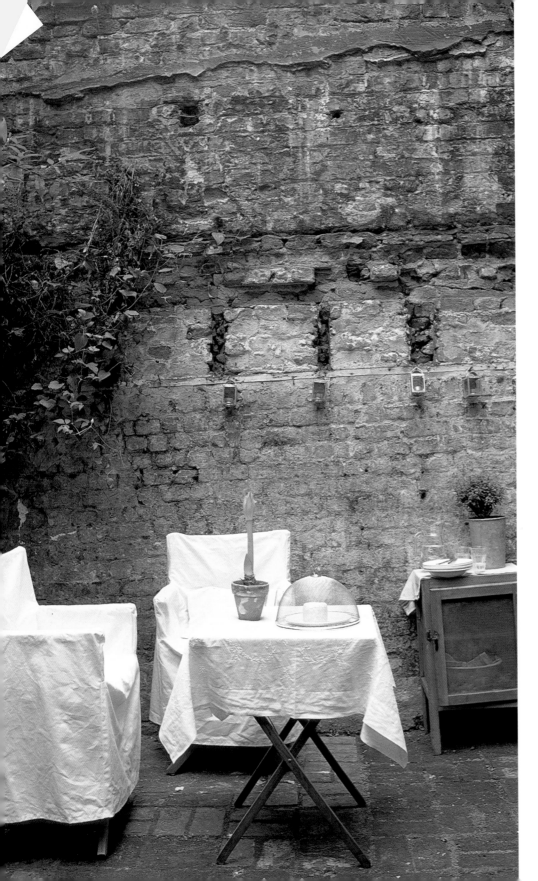

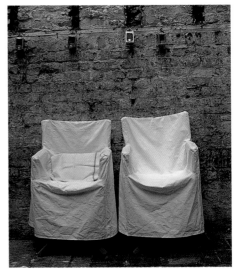

Urban back yard

A plain, simple and utilitarian approach is the key to creating a stylish summer oasis in the confines of a small urban back yard. Rather than being plastered over or repointed, the rough, uneven brick walls have been left to impart their warm, earthy character, together with the worn mossy red-brick pavers that lie underfoot. This natural, neutral backdrop makes cream canvas chair covers an understandable choice, while a simple white cotton cloth dresses up a folding, rather battered, card table. An old wooden meat safe, a mesh food net, a metal flower bucket and tin lanterns hung on the walls are practical and add hard-edged yet decorative detail. An old metal shoe locker makes an impromptu tool shed, with neat

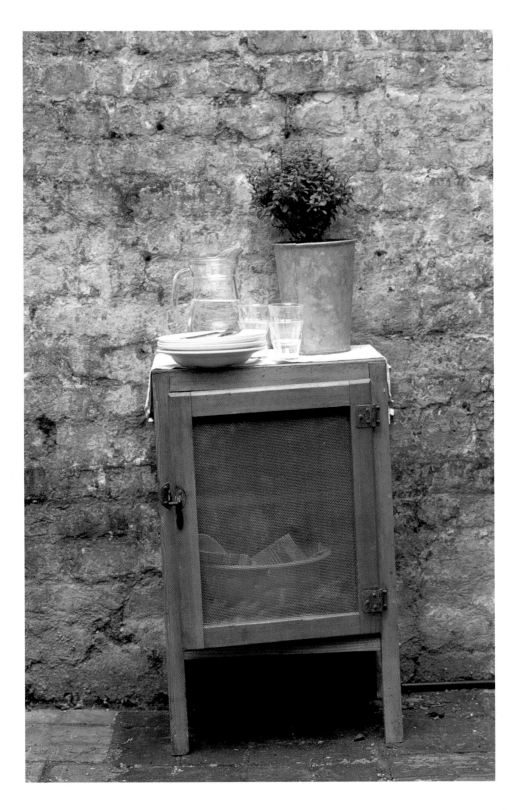

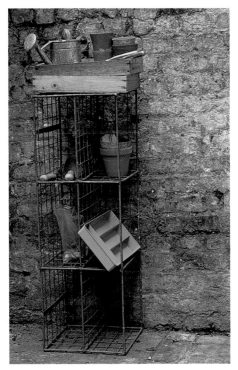

shelves for storing bulbs, pots and tools. A school-room-style jug/pitcher, plain bowls and robust glasses are ideal for the uncluttered look. Greenery is sparse apart from clematis and some rampant buddleia, so anything other than the small topiary box/boxwood and an amaryllis in a roughly moulded terracotta pot would be unnecessary.

opposite, left and above

Utilitarian objects like an old wooden meat safe and a metal shoe locker are useful for storing garden-ing items in the confines of an urban back yard.

above, below and right *Blue-and-white checked table linen, white folding cricket chairs, a vase of pink stocks and a sea-green door add cheerful and contemporary colouring to a shady London courtyard.*
opposite *Instant greenery is provided by a young tomato plant in a terracotta pot and a tall architectural-looking bay standard in a metal bucket.*

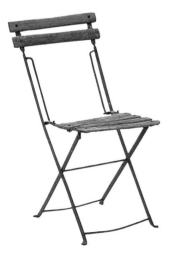

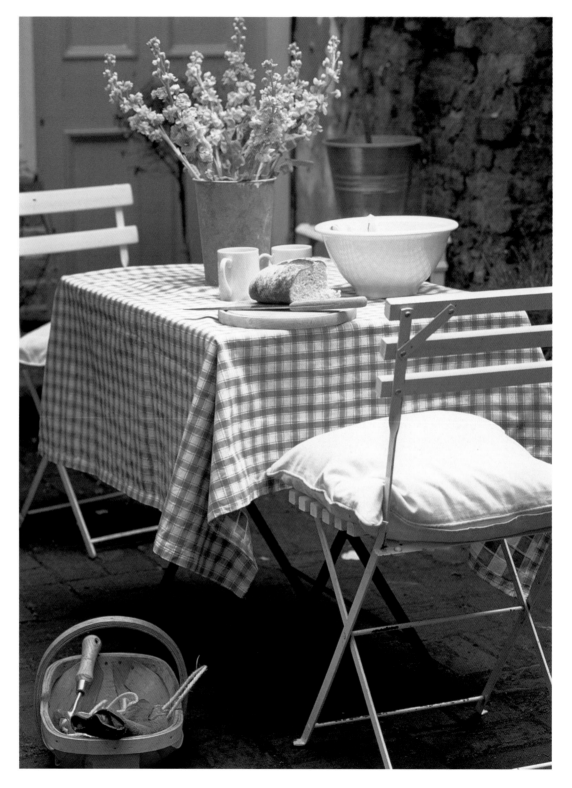

Colourful courtyard

A simple way to relieve the drabness of a shady courtyard is to use colourful paint and fabric. I transformed a door with eggshell paint in greenish blue, a colour that is modern, yet fresh and natural. It looked so good that a wall, rebuilt and pointed with ugly cement, was the next contender for the same colour, but in a durable matt emulsion/flat latex. Ugly water tanks, fences and furniture can also be camouflaged with paint – white is always a good colour to lift a dull, flat environment. Blue-and-white checked cotton is cheerful and smart and I used a favourite from my stash of colourful cloths. In a space devoid of many plants, buy colourful flowers for informal decorations that can be enjoyed outside for several days.

opposite and right *Four gnarled grapevines spread a leafy canopy across the terrace of an Andalusian farmhouse. Bright oranges and pinks for tablecloth, napkins and throw are a perfect match for strong Southern sunlight.*

Vine-covered terrace

A trailing grapevine is a romantic, cool and natural way of shading a terrace. At an ancient Andalusian farmhouse high up among the chestnut and olive groves, four vines, including a knotted and gnarled 20-year-old specimen, have been trained to grow up chestnut posts spaced at 2-metre/6-foot intervals and across a basic framework of supporting sticks. During the long, hot summers everyone eats lunch and dinner under the vines, which sag with bunches of fat, juicy grapes. In early spring when the vines are not in full leaf, the open spaces are filled in with green fabric awning. Locals say that it takes about three years of careful tending and cutting back to make a fully covered vine canopy. Although a vine outside in a colder climate is unlikely to produce such prodigious fruit, it is possible in a sunny, sheltered, south-facing garden to grow impressive leafy examples. There are some garden specialists who import, at vast expense, 50-year-old vines from the South of France. For outside living an assortment of seats, like old country chairs and benches, together with new metal garden chairs from department stores, creates a relaxed look. When there are guests to feed, more tables can be brought out under the leafy awning.

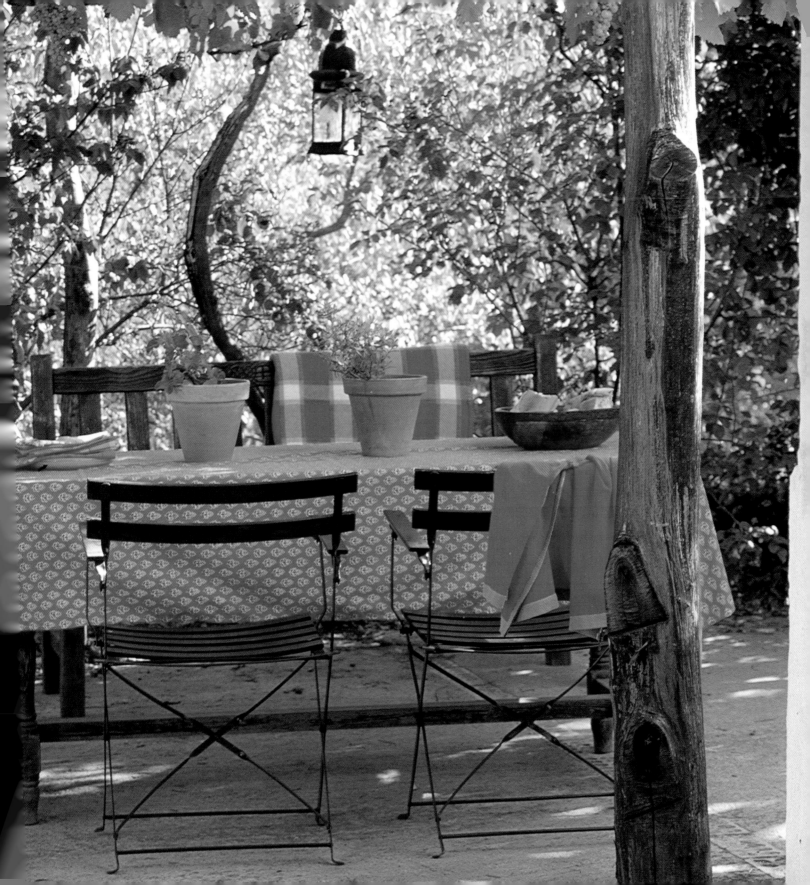

Window-box garden

Close to my London home, tubs and pots teeter along the ledges of highrise buildings, creating brilliant splashes of colour. These miniature gardens yielding herbs and vegetables, or gaudy favourites like geraniums and marigolds are a vibrant sight in an otherwise grim, unrelenting urban environment. Instead of standard containers, be inventive and revamp an old crate with dark green paint and plant textural lavender. Green plastic window boxes look functional, but they can also be transformed with matt/flat-finish paint in soft mint green or powder blue. Don't stick to the same old planting material either: a dwarf hedge of rosemary, white hyacinths, nasturtiums or cherry tomatoes are just some ideas.

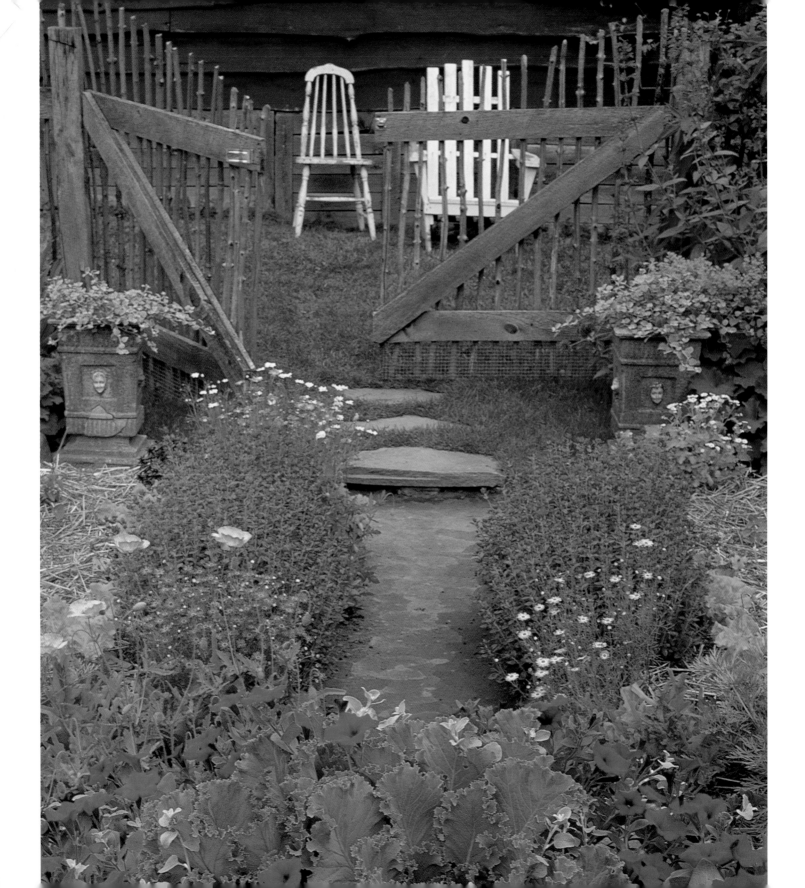

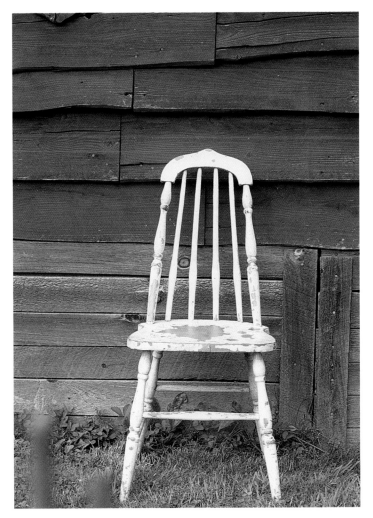

Vegetable and flower plot

There is something so satisfying about tending a garden that yields flowers for colour alongside vegetables to eat. This decorative but utilitarian rectangular plot is bordered by a handmade stick fence and yields a combination of floral and edible produce, including clematis, morning glory, sunflowers, lettuces, cabbages, chards and beetroots/beets. In summer, it is a glorious refuge in the cool of early morning or evening, for watering and weeding, soaking up the scents of herbs and enjoying the fresh, bright colours of the young plants.

above *Simple wooden furniture, like a rustic Adirondack chair (left) and a battered junk kitchen chair complete with flaking paint (right), suit this decorative working garden.*

opposite *A mixture of colourful flowers and vegetables grow together in this little enclosed garden in America's Catskill Mountains – a truly peaceful oasis in which to sit and contemplate.*

Planting ideas

All gardeners have their own ideas about the key elements in planting a successful outside space. I view simplicity of layout, together with texture, colour, shape, scent and the edibility of flowers and plants as the most important considerations. I like a sense of order and have a passion for regimented vegetable patches, which have an appeal similar to that of neatly arranged interior rooms. I also like the use of commonplace plants, rather than fancy, exotic varieties that I am happy to leave to real garden experts. Some of my favourites are traditional cottage-garden flowers like roses, dahlias and clematis, as well as all vegetables – especially cabbages, which look so leafy and decorative. The use of containers, from earthy terracotta flowerpots to galvanized metal florist's buckets, is important when space is limited in back yards and on small terraces and balconies. Choosing a pot the right size, painting it a particular colour, and siting it somewhere appropriate are all important. Planting to create texture and colour with climbing plants, or to make a dramatic statement with tall plants such as sunflowers or topiary trees like box/boxwood and bay, are also elements that I consider vitally important to creating a living, visually appealing space.

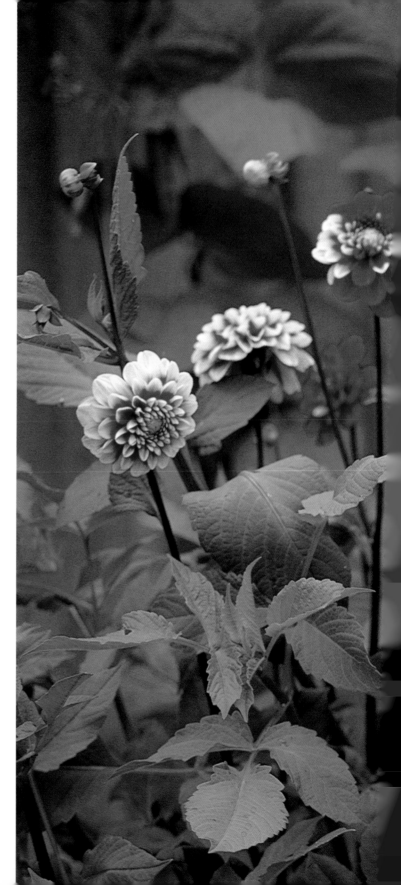

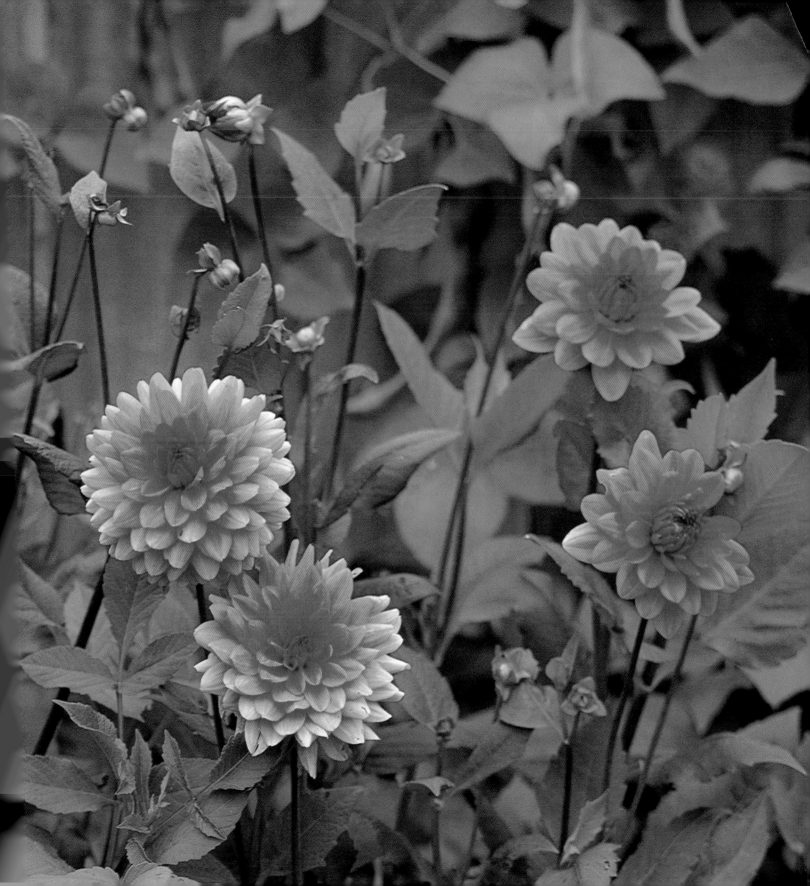

clockwise from near right
Hollyhocks look distinctive against plain white walls; a low white picket fence is bordered by loosestrife for colourful height and detail; sunflowers grow fast and are ideal for creating tall borders; traditionally used for height in herbaceous borders, delphiniums look good in any setting, such as an urban rooftop.
opposite *Leeks that have been left to bolt make a dramatic and decorative architectural statement.*

Creating height

Tall, leggy plants provide drama, height and camouflage. My favourite are sunflowers, which are fun to grow from seed; some varieties reach 3 metres/ 10 feet or more, with flowers the size of large plates. Another passion, grown in pots against a wall, are foxgloves, which shoot up to over a metre/4 to 5 feet and have pretty white, purple or pink bell-shaped flowers which bees love. Delphiniums are easy to grow and also have colourful spiky blooms. Other tall plants that are easy to grow include hollyhocks, which have a timeless appeal and look pretty flanking a doorway.

A sense of order

There is something pleasing about small-scale plots with neat rows of vegetables and herbs, tidy flowerbeds with an array of foliage and blooms in colours that blend together or contrast dramatically, and well-raked, weeded soil. It proves that humans can contain nature if they methodically dig, plant and tidy. Create natural order in a decorative yet functional garden, with devices such as pathways – wide enough for a wheelbarrow – made of wood chippings and bordered with lacy flat-leafed parsley, and rows of wonderful old glass bell jars to nurture seedlings. Enclose the area with commonplace yet stylish wire fencing over which climbers like honeysuckle and trailing tomatoes can be entwined.

top left and right, and opposite *Meticulous and well-ordered planting in a small ornamental and practical vegetable and flower garden.*
above *A makeshift cold frame constructed from salvaged windows is planted with herbs and salad ingredients.*

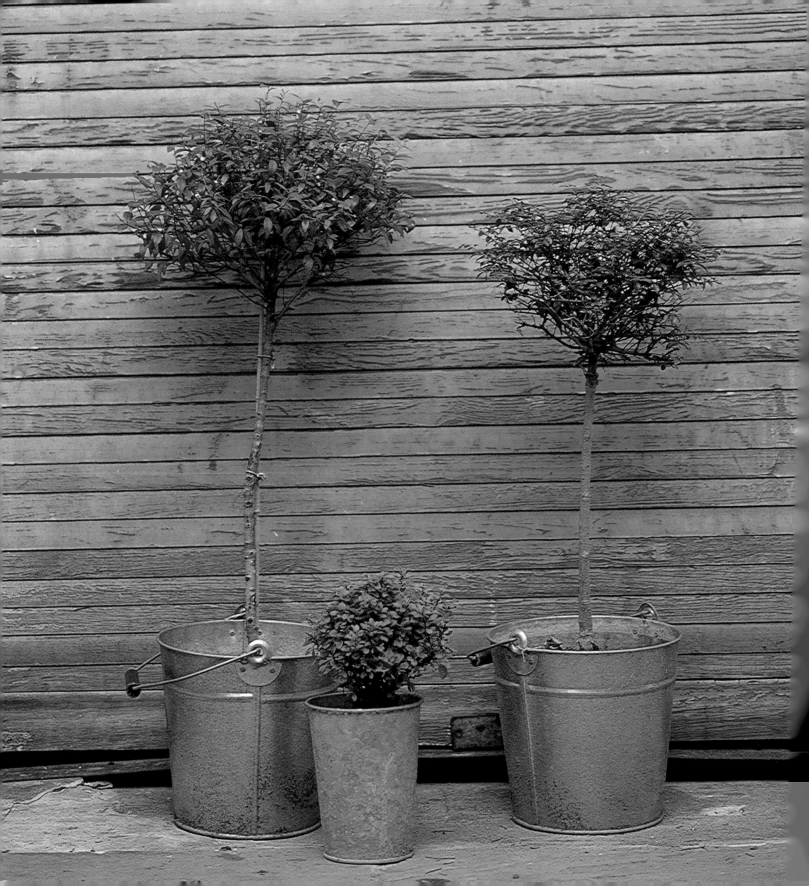

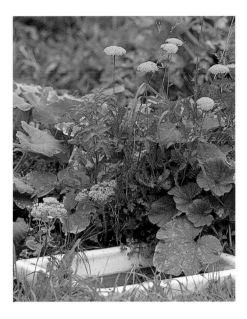

Potting ideas

A terracotta pot is hard to beat as a container for everything from bulbs to shrubs and herbs. The earthiest pots are the old roughly moulded hand-thrown ones that are more textural than machine-produced models. Interesting containers are not difficult to find. Raid your local hardware shop for galvanized metal buckets, which look great with topiary standards of box/boxwood, bay or rosemary, but drill holes for drainage. Bear in mind that the simplest arrangements of only two or three pots can be the most effective. Galvanized troughs look modern and functional on windowsills planted with pretty flowers like narcissi, hyacinths, ornamental cabbages or herbs.

this page *As long as it has an earthy, organic look, almost anything will do as a container for plants and flowers, from galvanized metal troughs or an old sink — either for plants or for a makeshift pond — to traditional terracotta pots.*
opposite *Metal buckets from a hardware shop look effective in small groups.*

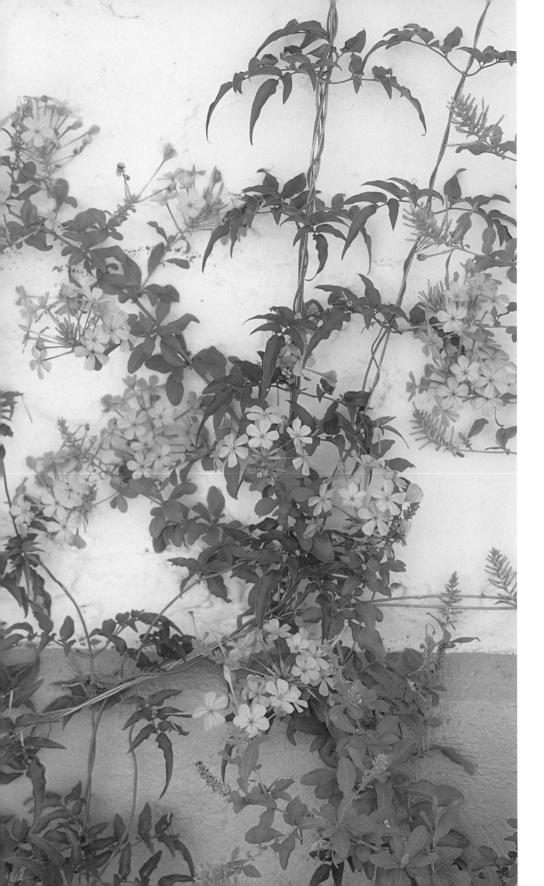

Climbers

Train climbing plants with wire and garden string along walls, fences and trellis, and up pergolas, arbours and tent-shaped structures. As well as creating colour and greenery in a skyward direction, climbers are useful for camouflaging unattractive surfaces. I grow clematis in pots, which runs rampant over the railings around my roof garden and trails up trellis over a section of harsh red-brick wall. The plants soften the hard urban landscape, and exist very well in terracotta pots if they are fed regularly with manure and watered copiously. Other favourite climbers include plumbago, which has beautiful star-like flowers; roses like *Rosa* 'Madame Alfred Carrière' and *R.* 'New Dawn'; grapevines, which are perfect for making shady arbours; jasmine, especially varieties that produce the most wonderful heady scent at night; and passion flowers – I love the purplish blooms and orange fruits. Climbers are also handy if space is short. In a vegetable plot, for example, courgettes/zucchini, tomatoes, cucumbers, nasturtiums and runner beans can be trained up stakes and along fences.

259

Flowers and vegetables

For economic reasons, traditional cottage gardens always contained a mixture of flowers for cutting and vegetables for consumption by the family. Many gardeners, who are not necessarily interested in self-sufficiency, adopt the same approach for purely decorative reasons, since many vegetables and herbs hold ornamental appeal. Others, who enjoy eating the fruits of their labours, delight in growing a combination of the decorative and the edible, with everything from potatoes and beans to roses and sweet peas jostling for position in one patch. I look forward to late summer when tiny plots are ablaze with colour in the form of big, floppy green cabbages and lettuces, together with dahlias in gaudy pinks, yellows and oranges. For dramatic contrast, plant round-headed lettuces next to tall, gangly alliums with their pom-pom flower heads. A combination of parsley chives and mint can be used to create pretty, textural border edgings and the layers of straw mulch, which is used for keeping the soil warm, also look decorative. Tall climbing plants like beans, tomatoes and cucumbers are unusual ideas for attractive green perimeters.

opposite *Floppy green cabbages planted with brilliant dahlias in a working garden in London are good examples of combined floral and edible produce.*

left and above *This ornamental flower and vegetable patch in the Catskill Mountains in America measures just 6.5 x 9 metres/20 x 30 feet. It is bisected with hard-dirt paths and planted with rows of lettuces, chards and cabbages, interspersed with colourful blooms like daisies and marigolds.*

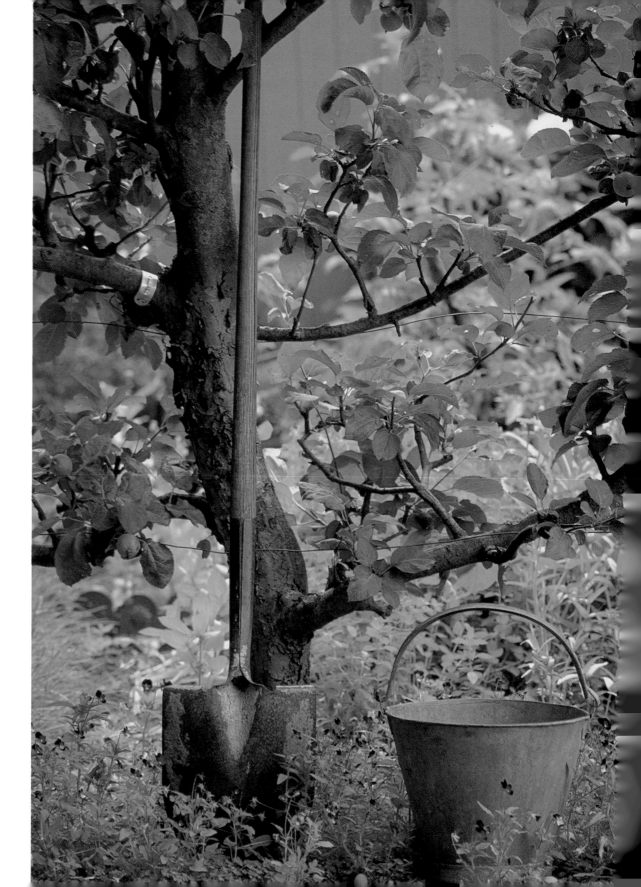

right *An apple tree from an espaliered row encloses a simple vegetable and herb garden.*

opposite, clockwise from top left *A tent-shaped wire topiary frame for climbing plants like ivy, nasturtiums, vine tomatoes or beans; as the plant grows, the stems can be trained around the wire and tied in place with string. An aromatic rosemary standard is trimmed into an architectural shape – the clippings can be dried for use in cooking. A squat box/boxwood ball looks good on its own or arranged with others on a balcony or terrace.*

Clipped and trained

When we think of topiary it is usually yew hedges clipped into the amusing shapes of dogs, cats, chickens, or another favoured animal. On a smaller scale – available from any good garden centre – there are evergreen shrubs like box/boxwood and bay clipped into squat balls or taller, leggy stems with pom-pom tops. These all look good in small paved areas and require very little maintenance apart from watering and regular trimming with shears to keep them in shape. There are topiary wire frames in tent and ball shapes that are good for training things like vine tomatoes, beans and nasturtiums. In the walled gardens of old country houses, you often see the espaliered branches of exotic pear and apple varieties that have been trained to grow flat and spread out in fan shapes. An espalier framework is made with a series of upright posts supporting several wires strained horizontally to secure the branches. An espalier-trained tree is restricted to pairs of branches that stretch out horizontally from the trunk and are secured to the espalier for support. Espaliered trees also make an unusual natural fence or partition in a small garden.

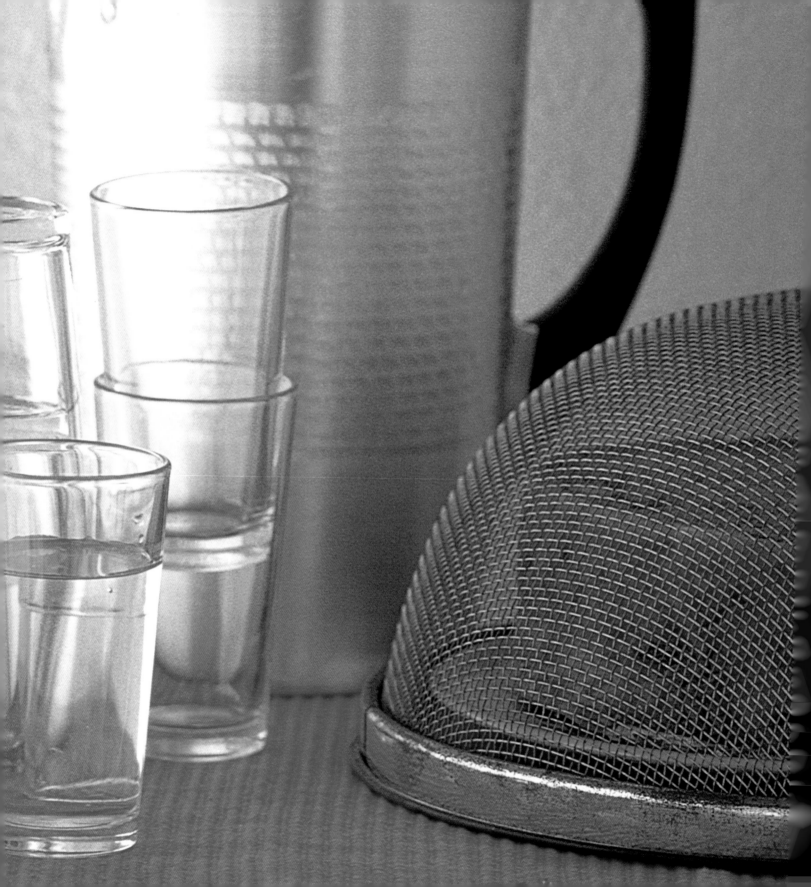

Eating

Eating and drinking are sensual pleasures, and become more so if the ingredients are delicious and the surroundings heavenly. Simplicity is the key to making the most of a balmy evening or a sunny afternoon. Invest in good, basic cooking tools, such as sharp knives, solid mixing bowls and pans with heavy bases/bottoms. Keep tableware simple with plain white china and durable but good-looking glassware. Use white sheets for everyday tablecloths, but for special occasions splash out on beautiful crisp linen. Buy the best cheese, fish, meat, fruit, vegetables and wine that you can afford, and prepare meals that involve minimal preparation. Serve lots of healthy salads and raw vegetables and enjoy experimenting with the addition of home-grown herbs. Set the table in a sheltered, shady environment and keep furniture basic and portable: a trestle table and folding director's chairs are ideal. At night, light candles in lanterns, jam jars or glass holders, and decorate the table with jugs of freshly cut

herbs or flowers such as roses or marigolds. Keep picnic equipment to a minimum, with a cool box/cooler and blanket. Set up camp under a tree or in a sheltered sand dune and build a fire to cook sausages or pack plenty of bagels and good chocolate and fruit.

opposite *A picnic by the sea on the deck of a beach hut is simple and stylish with a white folding chair, blue-and-white napkins and a practical big straw picnic basket.*
right *A perfect picnic: hunks of cucumber; eggs frying on a campfire; and bread with fresh crab.*

Picnics

My family are enthusiastic picnickers who relish the freedom of eating informally outside at any time of year. We head off to Regent's Park or Hyde Park in London, or, when we need to blow away the cobwebs, further afield to a safe, sandy beach such as Camber Sands in Sussex or Studland Bay in Dorset. The best picnics are simple and uncomplicated affairs. For meals by the sea, I pack up a basket with blue-and-white striped napkins, a box of matches and a bottle cooler. In a sheltered spot by a breakwater or in a sand dune, we make a campfire with driftwood and dried seaweed or light a little metal barbecue for a cook-up/cookout after a dip in the sea. Fried eggs or sausages are wedged between chunks of good chewy bread. Sometimes we buy a local dressed crab, which, seasoned with lemon and pepper, we spread onto wholemeal/ wholewheat brown bread. On cold but bright winter days, I pack a warm wool tartan/plaid blanket, bars of chocolate, a flask/thermos of potato and leek soup, and a box of smoked salmon/lox and cream cheese bagels. Other picnic goodies include wedges of delicious cheeses with crackers and cheese straws, chunks of tomatoes dipped in a little salt, a jar of olives, large chunks of cucumber and some crisp apples.

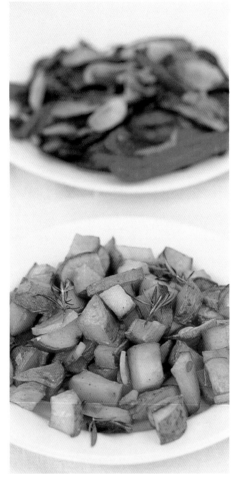

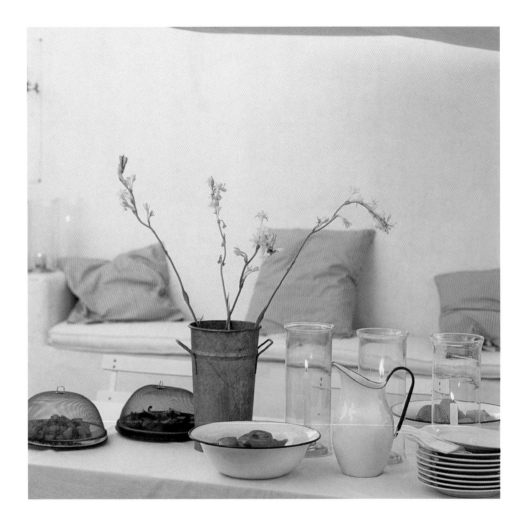

above and opposite Simple food to suit the pared-down look, with a white cloth, basic tableware, practical but attractive mesh food nets, candles in glass holders and a few stems of tuberose, which smell heavenly at night.
right Roasted (bell) peppers and aubergines/eggplant; roast potatoes; tomatoes with basil.

Simple supper

I have a passion for vegetables, especially roasted, and find them one of the simplest, tastiest accompaniments to grilled or barbecued fish and meat. For summer suppers, I chop up potatoes, complete with skins, aubergines/eggplant, red (bell) peppers, onions and courgettes/zucchini, and place them in a flat roasting pan with a good douse of olive oil and lemon juice, some garlic,

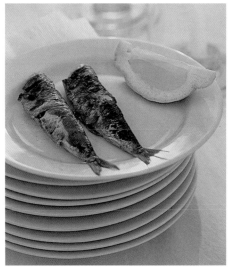

rosemary or basil, and cook them in the middle of a hot oven, turning regularly, for about 45 minutes or until everything is soft and nicely browned. Any leafy green vegetable, such as cabbage, is delicious steamed, then cooked for a minute or so in butter and mint. Staples like baked potatoes, impaled on a skewer for faster cooking, are another favourite served with butter, salt and pepper. Salads of lettuce, rocket/ arugula or other seasonal leaves are essential, as are home-grown tomatoes, chopped up with basil, garlic, salt, olive oil and lemon juice. In keeping with my pared-down approach to cooking, I cover the table with a crisp white cloth and serve food in large white enamelled metal dishes, which look stylish alongside simple plain white dishes.

Lunch break

When I am dashing about for work, grabbing sandwiches to eat on the run, I think wistfully of my Spanish friends who sit down daily to a relaxing and civilized lunch, either at home where they tuck into something like a tortilla, or in a bar that serves delicious tapas of squid or fried fish. Things are happily different on holidays when there is time to sit down to eat and talk in the middle of the day. Pasta is the top request in my household and, as long as there is a good bed of steaming *al dente* spaghetti to mix the sauce in, I can get away with serving ingredients that are otherwise unacceptable to the youngest members, such as strong cheese, herbs and, worst of all, lots of garlic. Tomato sauce, made with tasty home-grown or field tomatoes, is one of the easiest and most delicious things to serve with pasta. Simply fry/sauté three or four large, peeled, chopped tomatoes in olive oil and garlic until they are half cooked. Seasoned with parsley or basil, this highly aromatic, slightly crunchy, tomato sauce is best with a long pasta like tagliatelle or spaghetti. As soon as pumpkins are available in late summer, I cook a kilo/couple of pounds or so of the chopped flesh in salted water until soft. After draining, I fry/sauté it in olive oil and garlic for a few minutes, and then add half a small pot of single cream/¼ cup of light cream, 30 grams/⅓ cup of grated Parmesan, and some nutmeg or basil to bring out the flavour of the pumpkin. Then, I pulverize the mixture in a blender. When heated up, this delicious pale-orange sauce can be served with any pasta. Fresh mushrooms cooked in butter, garlic and parsley are another delicious accompaniment for pasta. Lasagne is also a favourite, and, instead of minced/ground beef, I use cooked courgettes/zucchini, aubergines/eggplant and tomatoes in between layers of béchamel sauce, pasta sheets and grated Parmesan.

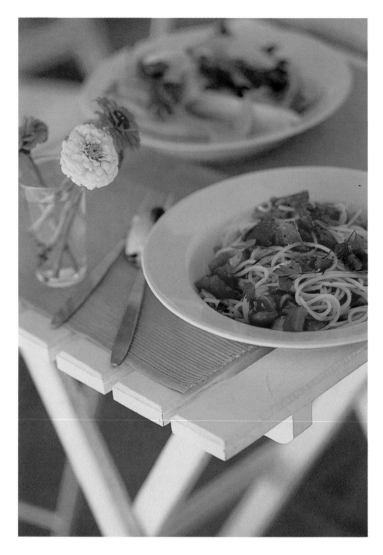

above, left and opposite
Make simple lunch-time pasta treats with chopped home-grown tomatoes and herbs, served with a wedge of fresh bread and a glass of cold white wine.

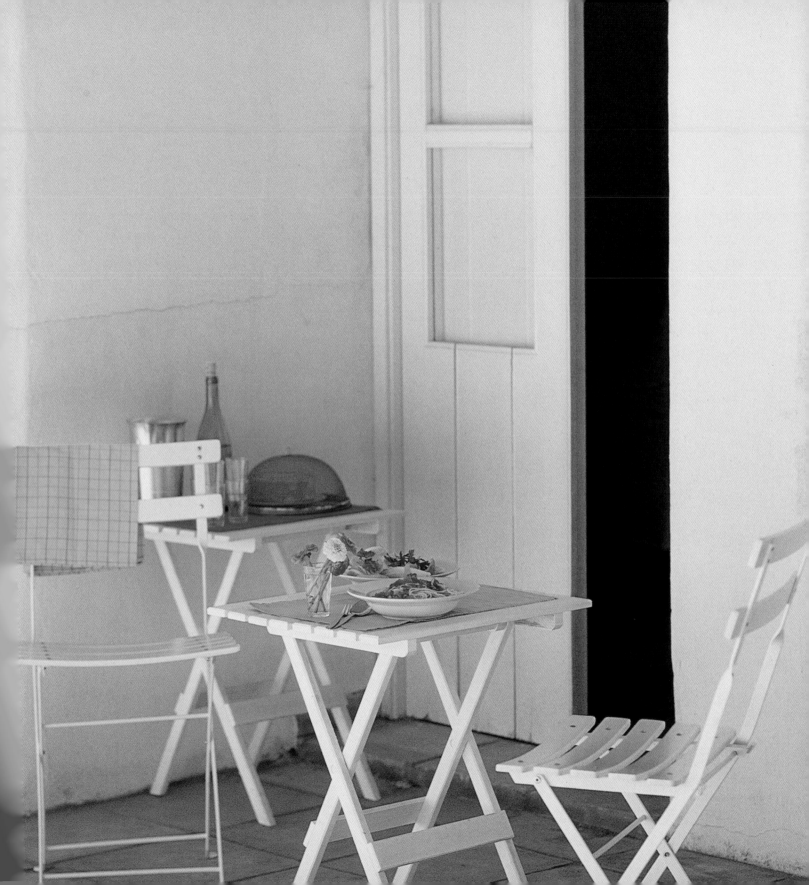

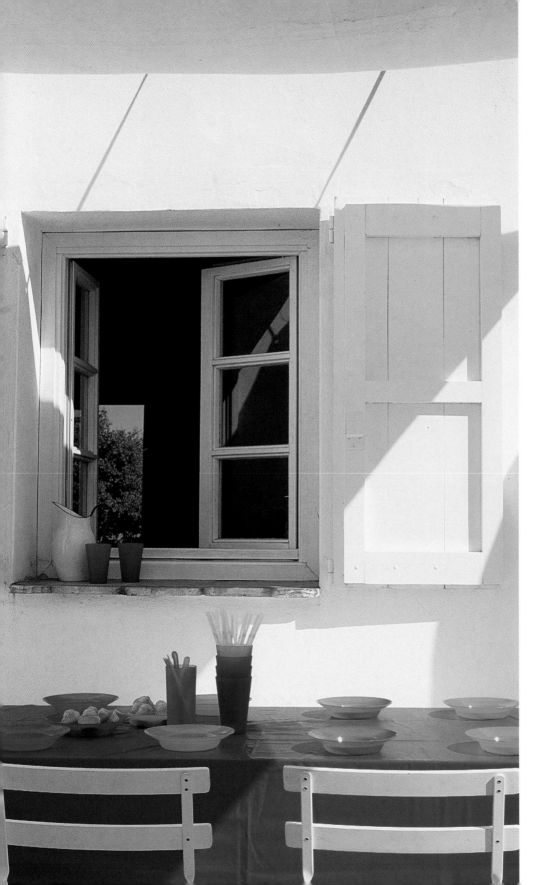

Birthday party

It is wishful thinking to imagine that junk food like crisps/chips, sweets/candy and sodas are not expected at a children's party. When my daughter requested pizza for her sixth birthday party, I felt mean when I refused her the bought kind that ooze preservatives, which she had set her sights on. So I was faced with the challenge of producing healthy pizza that would please a disgruntled birthday girl. I cut thick slices of crusty bread and toasted them on one side. Then I rubbed the uncooked side with garlic, trickled on olive oil, and added cooked chopped tomatoes. I topped the slices with grated Parmesan and placed them under the grill until bubbling – a great success. I gave in and bought bottles of the least violently coloured sodas, but offered jugs/pitchers of iced water, too, which were just as popular. I also served slices of watermelon and orange, cold from the fridge. We made an outrageously rich chocolate cake, which was decorated with blackberries and candles. Rather than using plain paper plates and cups, I bought brightly coloured plastic plates, cups and straws from a local discount shop, and laid the table with bright-blue plastic cloth.

opposite, left and above

Chocolate cake and home-made pizza are key ingredients for a children's birthday party. Practical plastic for the tablecloth, plates, cups and straws is available in lots of bright, cheerful colours that create a fun table setting.

above *Delicious cupcakes decorated with icing/ frosting and fresh marigold petals.*

opposite *A vibrant tea-time table setting with contemporary colour provided by the pink and orange tablecloth, napkins and wool throw. A vase of marigolds and roses adds an extra brilliant touch of colour.*

Tea time

A glorious summer's afternoon is a wonderful excuse to make something sticky and sweet to eat outside in the shade, under a tree or on the terrace, with a cup of steaming and refreshing Earl Grey tea. Make this indulgent treat a vibrant occasion with a jazzy orange tablecloth and a jug/pitcher of bright marigolds, zinnias or roses. For a traditional English tea, make bite-size cucumber and cream cheese sandwiches. Bake some cupcakes – they really are very simple and quick to make. Mix together 125 grams/5 tablespoons caster sugar, 2 eggs and 175 grams/1 cup and 2 tablespoons self-raising-rising flour, then spoon heaped teaspoons of the mixture into little paper cases/cups or greased muffin tins/pans and bake at 180°C (350°F), gas 4, for ten minutes. When the cakes are cool, decorate them with icing/frosting and fresh or crystallized flower petals, like pansy, rose, marigold, nasturtium, geranium, lavender and borage. Other tea-time goodies include freshly baked scones/biscuits, which can be thrown together in a matter of minutes. Simply mix 250 grams/1⅔ cups self-raising/-rising flour, 50 grams/4 tablespoons butter, 50 grams/2 tablespoons caster sugar, 1 beaten egg and 75 ml/⅓ cup milk in a bowl. Roll out the dough, cut it into rounds, then place them on a greased baking tray and cook at 230°C (450°F), gas 8, for ten minutes. Try serving them warm with crème fraîche and home-made blackberry jam.

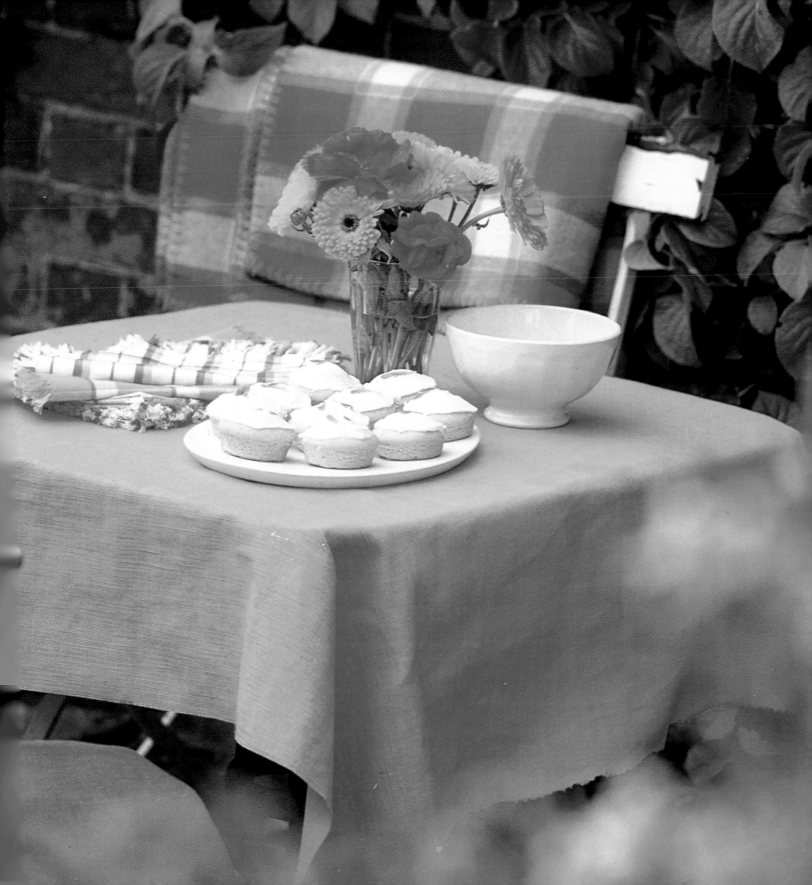

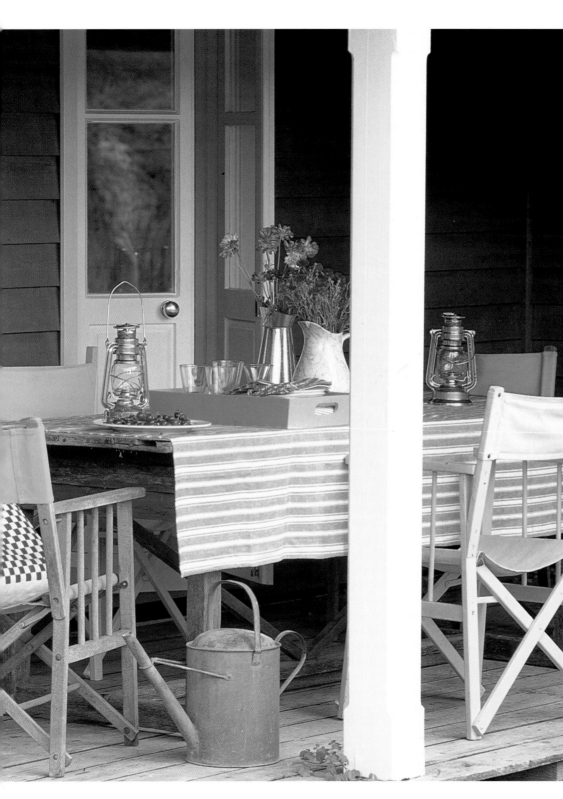

left *Pale blue-and-white stripes combined with minty green is a stylish and understated colour scheme that is perfect for eating out on a wooden veranda. The folding director's chairs are covered in tough canvas and can be stored away easily at the end of summer. Simple metal hurricane lanterns, and jugs of blue scabious and cornflowers/bachelor's buttons complete the simple, relaxed effect.*
opposite *Ideas for tasty summer desserts include raspberry jellies/jellos in chunky 1930s-style glasses that were picked up from a junk/thrift store, and a plum tart.*

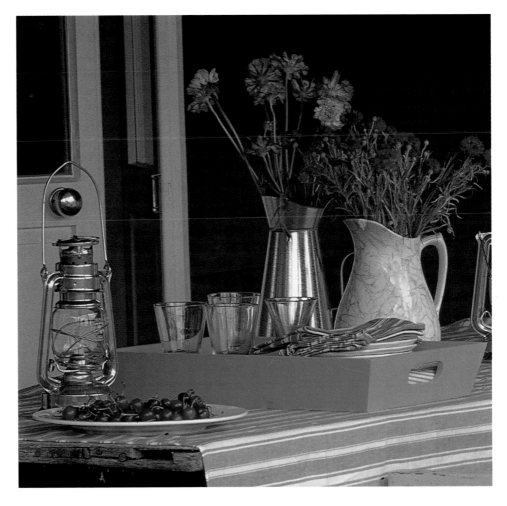

Summer desserts

With so many fruits in season – cherries strawberries, and raspberries – making puddings for summer meals has endless possibilities and can be really simple. My favourite fruit fool/whip, made with thick cream or low-fat fromage frais/blanc, is good old-fashioned strawberry, which I serve with shortbread (cookies); other successful fools/ whips include lemon, quince and blackberry.

Tarts are always a good idea, and, made with plums, peaches or apples in a rich, buttery pastry case/ crust, are delicious hot or cold. Real fruit jellies/jellos made with gelatine and fresh raspberry, strawberry, peach or grape juice, look really pretty in individual glasses. There is also traditional English summer pudding, perfect for when all the berry fruits are in season, like raspberries and blueberries.

Breakfast

Good coffee, fresh bread, butter and home-made jam are my essentials for a civilized breakfast. I like to make strong Italian espresso coffee in an old-fashioned percolator, and, unless the bread is still warm from the baker, I prefer it heated up in the oven or toasted. There are so many fancy breads to choose from nowadays, but toasted hunks from a healthy wholemeal/wholewheat loaf or a crusty white loaf are as tasty as they are filling. Breakfast time is a chance to indulge in eating natural honey and home-made jams and marmalades. When bitter Seville oranges are in season in January, I always promise myself I will make a batch of marmalade, which, interestingly, the Spanish themselves don't eat and consider it a curious British habit. Fresh fruit on the table – figs, watermelon, peaches and apples in the summer, and fat, juicy oranges in the winter – is always a treat, and an easy alternative source of vitamin C is a large glass of unsweetened orange juice. Unless it is the weekend or a holiday, I like breakfast to be a fairly quick and efficient meal, with basic white plates and mugs set on a practical, yet cheery, plastic checked cloth.

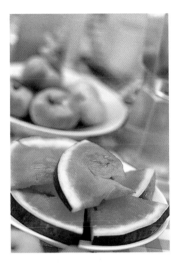

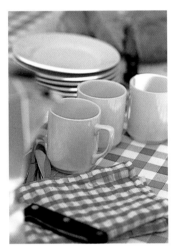

opposite, above and right

An alfresco breakfast of fresh fruit, bread and honey, washed down with a cup of strong black coffee, is a perfect way to start the day. Simple white plates and mugs set on a practical plastic cloth are also key elements, while shade is provided by home-made canvas awnings.

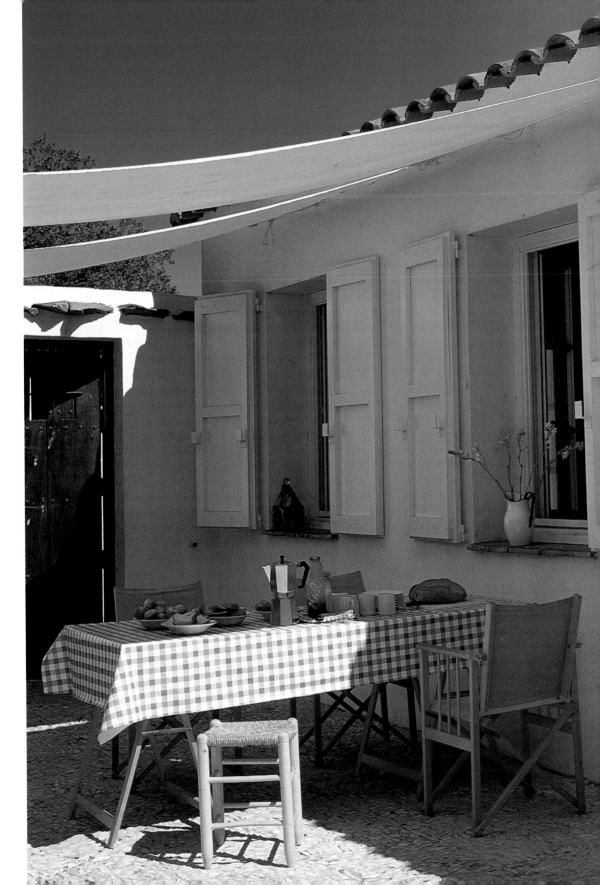

Mood

It might sound like a cliché, but it invigorates the senses to be outside, in touch with nature and the elements that surround you: water, light, scent and texture. It is delicious to be outdoors after a heavy rain storm, feeling the cool, damp air and seeing leaves glistening with water, or rose petals plastered to the ground like wet confetti. On long, hot, sunny afternoons, any shady spot becomes a welcome retreat, and it is a luxury to lie in dappled light under a tree, eating an ice-cream or enjoying a lazy picnic. Gardens smell of so many things: fragrant roses and honeysuckle; aromatic herbs like rosemary and lavender, which are very hardy and can be grown just about anywhere; and the heady aroma of damp earth after a storm. Scents are evocative of a time and place, and the fragrance of cut grass or a particular rose can take me back to my childhood. When temperatures soar, the mere sound of water – a tinkling fountain or a gushing outdoor shower or tap/faucet – is a relief to a hot and bothered body. Try to find the time to hide away outside in the same way as you might curl up with a good book in a comfortable chair by the fire. Take breakfast outside on a warm and sunny summer's morning, or stretch out on a blanket on the grass to read a novel.

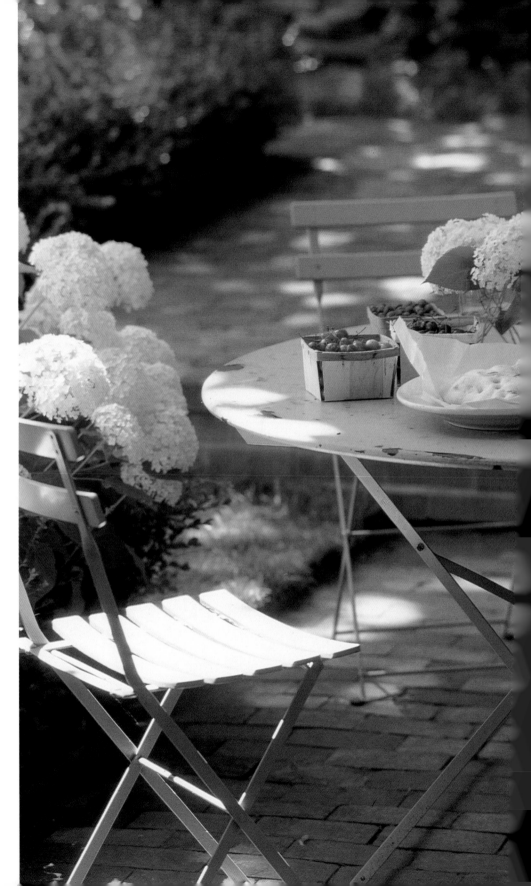

Lazy afternoon

Looking back to my childhood, I recall days when we walked to the park and ate ice-creams on a rug under a leafy tree. The parade of shops opposite, their stripy blinds/awnings lowered, took on a sleepy feel. Afternoons were long and languid, and best spent in the dappled cool of the large apple tree in our garden reading, drinking lemonade and eating biscuits/cookies. Squinting at the afternoon sun from my shady retreat under the awning at our house in Spain, time has passed, but the feeling is the same. With echoes of those carefree days, it is an unsurpassed luxury to soak up the enveloping warmth and enjoy a long, lazy lunch of salads, fresh bread and cheese.

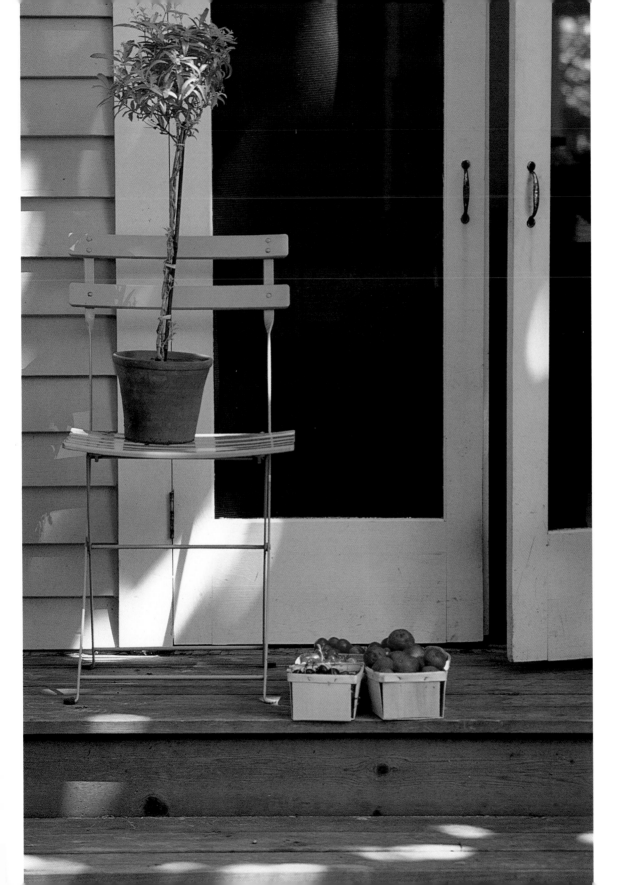

left and opposite

On a long, hot summer's afternoon, keep cool in the dappled light of a shady tree and enjoy a lazy, informal lunch, with plenty of healthy salads, fresh bread and juicy fruit.

283

right *Tranquility in a rain-soaked London garden, with rose petals plastered to the ground and the greenery enlivened and intensified in colour.*
below *Alchemilla bent double with glistening drops of water.*

Rain-soaked garden

Sometimes the summer air becomes stuffy and oppressive. The heat intensifies until you feel the first twinges of a headache; you drink lots of water; clothes feel tight and uncomfortable, and it becomes an effort to attempt the simplest chore. Outside, the air draws closer and the light assumes a dull, flat quality. In the garden there is a sense of anticipation; nothing stirs, and the plants seem stifled by the lack of breeze. The air is thick with the dry, scorched smells of grass and earth. The storm clouds gather and darken, and when the first droplets of rain splash and scatter the dusty surface there is a sense of relief. First one drop, then another, and then the sky empties itself like a giant bucket. The thunder rumbles and roars and lightning snakes through the sky. Heavy rain is wonderfully cleansing and leaves the garden sparkling with wetness. It is intoxicating to walk among the dripping plants and drink in the moist, heady, earthy air. Under bare feet the soaking grass feels spongy, cool and more accommodating. Vegetation is greener, and leaves and petals are shiny like pebbles washed by the tide, and the wet paths house small light-reflecting pools. Serious gardeners dread summer storms, which mostly arrive when gardens are at their peak. Yet although it may be disastrous for prize blooms, voluptuous flowers, with drooping petals ready to fall, assume a fragile rain-sodden beauty after being buffeted and bruised by the elements.

Scent

The intoxicating smell of rambling roses, heady jasmine, or the lingering sweetness of cut tuberoses are, like all garden smells, evocative of a time and place. From my childhood I particularly remember the golden *Rosa* 'Peace' blooms in our garden, which smelt like delicious soap; the fresh, sweet hay-like scent of newly cut grass; and the strange herby smell that lingered on your hands after picking tomatoes. Some of the most aromatic plants are lavender, thyme, camomile and rosemary. Lavender is a hardy evergreen that is easy to grow in pots, or as a decorative hedge or border edging. The spiky stems with delicate purple flowers are typical of summer and smell delicious when brushed against. Lavender can be hung in bunches to dry and the flowers used to fill cotton

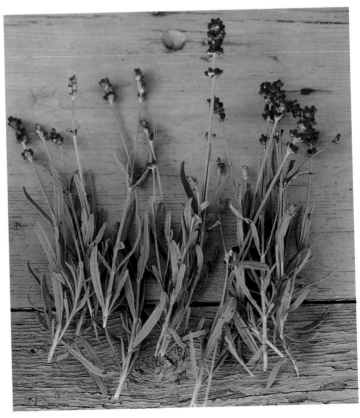

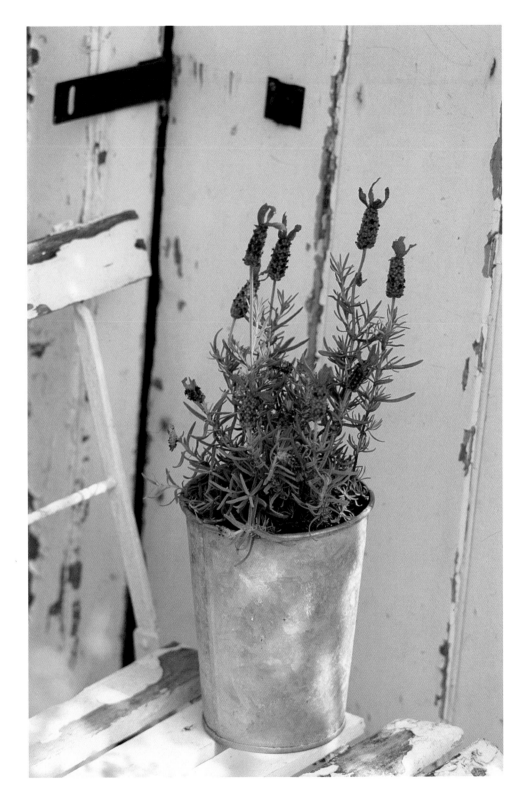

bags/sachets to scatter among clothes in drawers. Lavender is also useful for giving scent and bulk to potpourri. Hardy thyme and camomile are pretty, compact plants that are easy to grow between paving stones and emit fresh, herby fragrances when crushed underfoot. A carpet of camomile on an area of lawn is another delicious way to impart scent. Thyme is a valuable herb for flavouring meat and fish, while camomile makes a delicious tea. Rosemary is another wonderfully aromatic plant that is easy to grow and looks pretty either as low hedges, in pots or clipped into topiary standards. I dry stems of rosemary and hang them by the oven for flavouring everything from pasta to chicken. I also use jugs/pitchers or vases of fresh rosemary stems to decorate summer tables.

opposite far left *Thyme planted in cracks between paving stones is a simple way to add soft greenery and a delicious scent when crushed underfoot.*
left and opposite *Lavender is aromatic while it is growing, and the dried flowers can be used in sachets for drawers and in potpourri mixes.*

above *Nestling in the shade of an olive tree, a lightweight folding chair, dressed in a simple cotton pull-on loose cover, makes a peaceful retreat – the perfect place to enjoy a quiet hour or two catching up with your novel.*

right *A shady patch of grass, beneath leafy branches strung with metal candle lanterns, is furnished with a traditional moss-encrusted wooden bench. Next to it, on an old metal table spread with a pink-and-white checked cotton cloth, are bowls of radishes for healthy nibbling.*

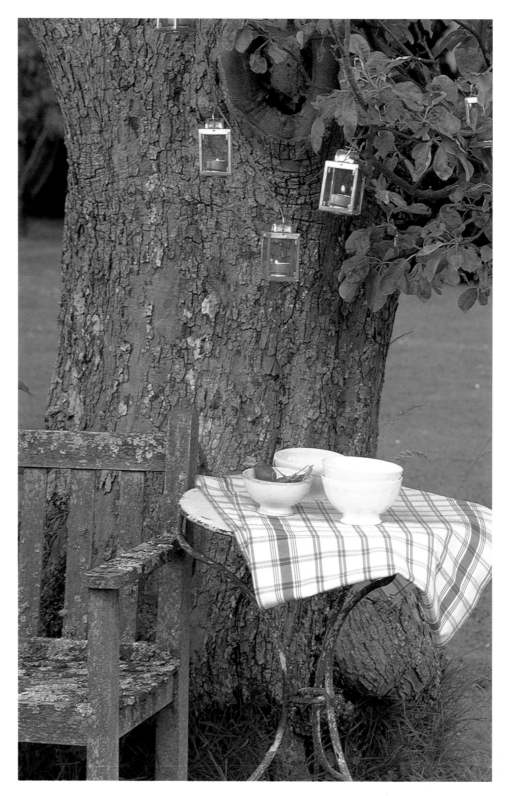

Simple retreats

Caught up in the demands of work and domestic life in an age that demands our immediate reaction to every bleep of a mobile phone or email notification, it is important to find time and space to sit, reflect, read a book, or do nothing but soak up the beauty of a warm evening. Make your own peaceful retreat with a favourite chair in the most sensuous part of your garden: by a scented rose, perhaps, or in a spot that gets lots of sun, or in a patch of wild grass and flowers. Set up a table and eat lunch there – a sandwich full of good things like grilled/broiled vegetables or crisp lettuce leaves and tasty cheese, with fresh strawberries to follow. My place to hide away from daily demands is my tiny rooftop garden, which is cool and refreshing in the early morning and the perfect place to enjoy breakfast with the newspaper. In the middle of the day I can stretch out on a blanket on the decking and soak up some warm sunshine. At dusk I like to watch the sky turn pink, light some candles and relish the peace, which is shattered only from time to time as an ambulance or police car shrieks towards another urban drama.

Top *Simple folding chairs in pretty colours are practical for use in the house and outside, and they are easy to carry to a favourite patch of garden to sit in comfort among wild flowers and uncut grass.*
bottom left and right
A traditional bench painted a basic garden green can be equipped with cushions for extra comfort.

Water

It is refreshing to cool off in the heat of the day with an invigorating swim or cold shower. In the scorching midday sun, even the sound of water is a relief to a hot, sticky body. It makes life so much easier if you can install a tap/faucet outside for watering plants and to fill bowls of refreshing water to splash you down or soak your feet when the heat becomes too intense. Few of us have the available space or funds required for a swimming pool, but an outside shower is a reasonably inexpensive luxury. Freestanding or fixed to a wall or fence, a simple shower head with a wooden deck beneath is the perfect way to make you feel as if you've just had a reviving dip.

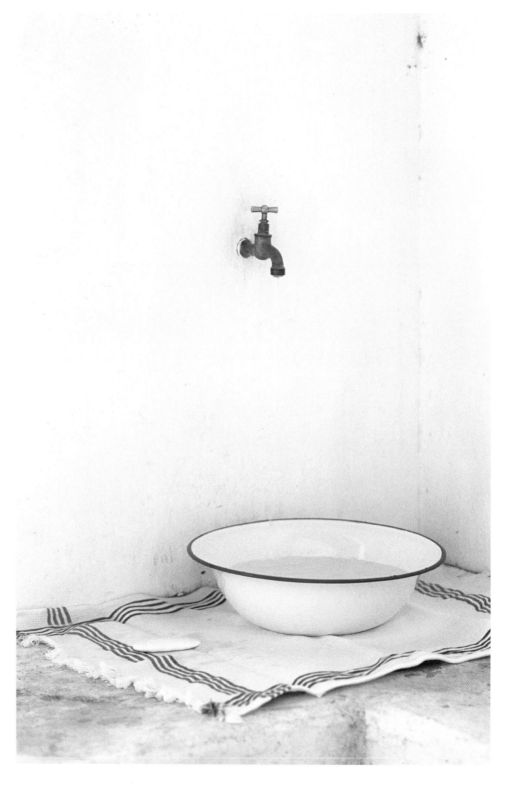

above and right

Install an outside shower to refresh yourself in the height of summer. For maximum style, choose simple, functional shapes for shower heads and pipes, mount them on a wall or fence tucked away in a secluded corner, and plan a suitable surface for drainage, such as a ceramic shower tray or hardwood decking.

opposite *Keep cool with an outside tap/faucet, such as this one which was bought cheaply from a plumbing supplier. As well as making watering easy, you can make an impromptu outside washing area with a simple metal bowl, a soft towel and your favourite soap.*

Shady summer's evening

On a balmy evening, move outside to watch the softening light, lengthening shadows and intensifying hues of a technicolour sunset. As dusk falls, it is a peaceful time to sit and reflect on the day's activities. In keeping with this tranquil mood, make your outdoor room a calm oasis furnished in neutral whites and creams. These colours are my favourites for fabrics and furniture on the patio of our house in Spain, where evenings in summer are spent enjoying the fragrant warm air. The table is laid with candles in metal lanterns and vases of tuberoses, and I bring out cream canvas director's chairs, which are really comfortable for lazing in. We light the barbecue, load it with fish steaks and make simple salads of tomatoes and green leaves. In the courtyard, which is lit with more candles in jam jars and lanterns, bench seating is covered with assorted cushions in plain and blue-and-white striped canvas – ideal for stretching out on after a hearty supper.

right *Neutral fabrics on the terrace at dusk.*
opposite *Soft cushions to relax on, in white and understated stripes.*

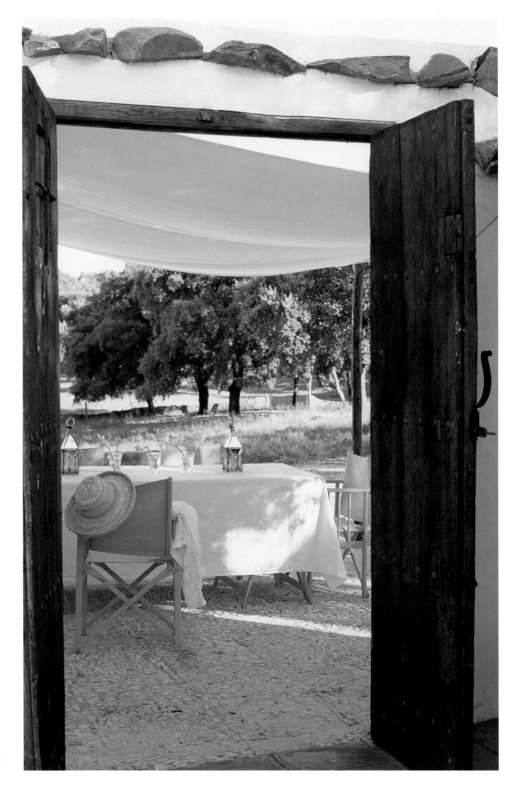

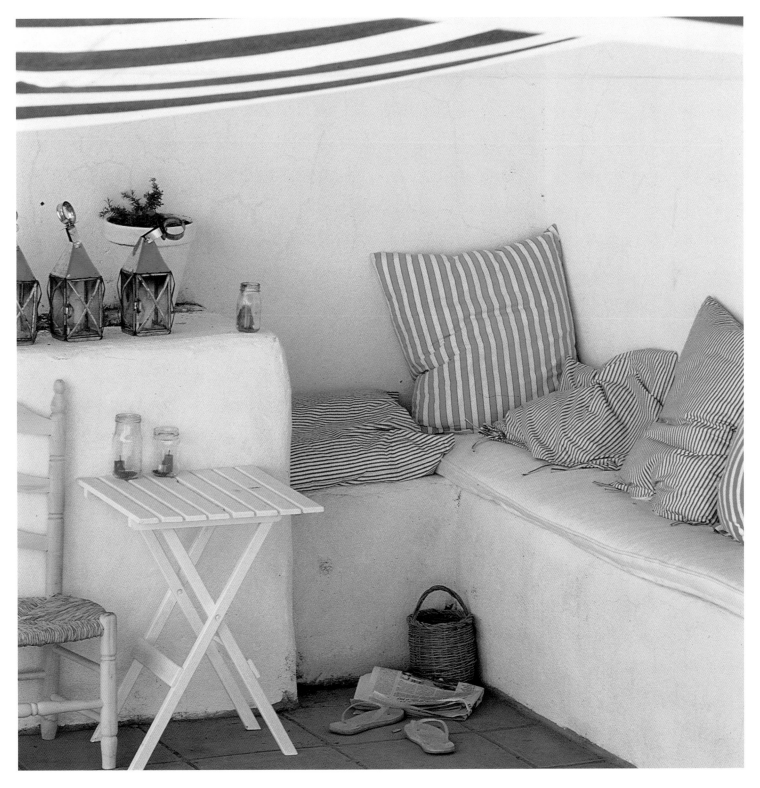

right *Picnic on the grass with a blue and white theme on a sunny late-summer's afternoon: a crisp checked cotton cloth, and deck chairs covered in cheerful plain and striped cotton.*

opposite *Pack up a picnic tea in a traditional metal lunch box and choose tea-time favourites like bagels and jam or slabs of fruitcake.*

Soft grass

Grass is the perfect outdoor surface for lying on and gazing up at a cloudless summer sky. It comes in many guises: a luxurious stretch of immaculately tended, manicured green lawn, a scorched and bristly field, a lush uncultivated sweep of tall swaying grasses and poppies, or a clipped and cosseted park. It is good to feel grass between your toes, or tickling your hands as you idly pick clover and daisies to make into chains. Then there is the wetness of grass early in the morning, glistening with silvery drops of dew, or the soft dampness of a refeshed lawn after a summer rain storm. Pitching camp on a patch of soft, spongy grass is one of the most relaxing ways to spend a hot afternoon at the weekend, and a long, languid picnic will invigorate the soul and improve your mood after the stresses of the week. Some of the best picnics are to be had on a visit to a local park, where you can nearly always find a welcoming shady tree or a secluded sunny patch. Essentials for picnics on the grass are a good cloth to lay your food on and a woolly blanket or, if you prefer, some lightweight deck chairs on which to sit.

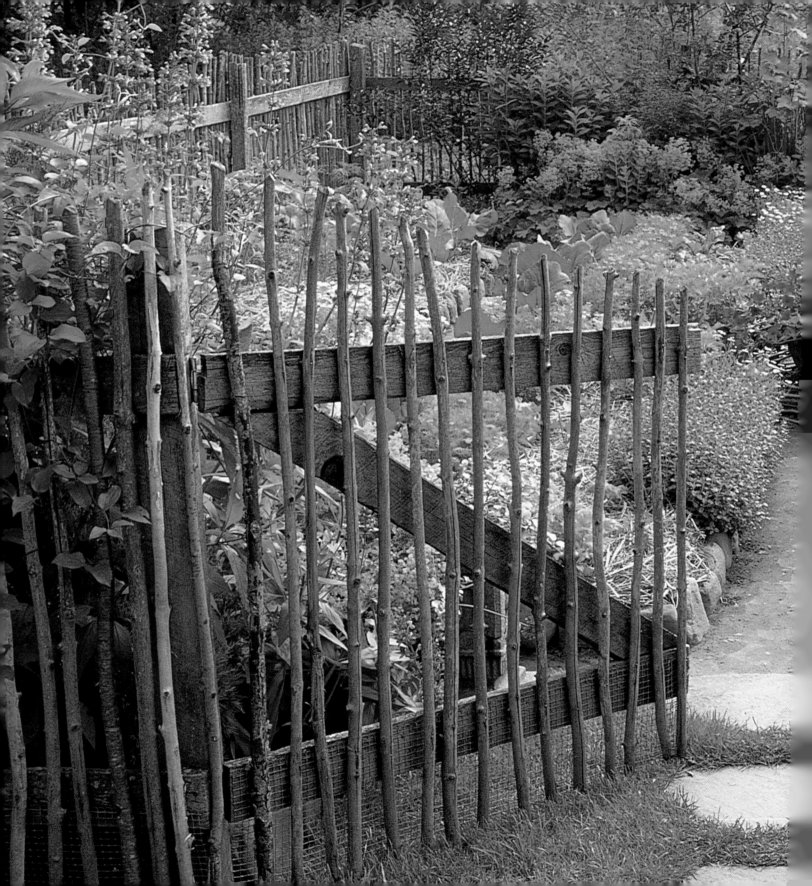

Credits

page 6 room painted in Nantucket Benjamin Moore USA.

page 20 paint swatches from top: Sanderson Spectrum 22-1 Lavender White: Sanderson Spectrum 7-13 Marble White; Dulux 0005-Y White; Dulux 0705-Y Sunbleached; Sanderson Spectrum 04-09 Neutral; chair cover fabric Laura Ashley; plastic lunch box Muji; plates and jugs from a selection at Pottery Barn, USA.

page 21 ribbed glass The Conran Shop; enamel jugs Ruby Beets Antiques, USA; tea towels Wolfman Gold & Good Co., USA; candles Price's Candles; bowl Habitat.

page 22 plastic beaker Heal's; striped table mat Crate & Barrel.

page 23 paint swatches from top: John Oliver Winter Sky; Dulux 1520-B10G Relaxation; Sanderson Spectrum 26-04 Lupine Blue: Dulux 1030-R80B Bridesmaid; Sanderson Spectrum 24-11 Wood Hyacinth; junk chair painted in , Sanderson Spectrum 24-04 Swiss blue eggshell; plate Anta: checked tray John Lewis.

page 24 paint swatches from top: Sanderson Spectrum 41-03 Springtime; Sanderson Spectrum 40-04 Sunny Green; Sanderson Spectrum 39-03 Salad Green; Dulux 1520-G Lily Root: Farrow & Ball 23 Powder Blue: Farrow & Ball 32 Cooking Apple Green; paper napkins Ikea.

page 25 coffee cup and saucer and checked cushion cover Designers Guild.

page 26 lavender paper and folder from a selection at Paperchase; plastic brush Designers Guild.

page 27 paint swatches from top: Sanderson Spectrum 23-09 Fascination: Sanderson Spectrum 21-10 Fidelity; Sanderson Spectrum 21-17 Lavender Lave: Sanderson Spectrum 21-04 Lilac; Dulux 1040-R70B Harlequin; Bunny chair Designers Guild; cushion fabric Manuel Canvas.

page 28 paint swatches from top: Dulux 2030-Y70R Campfire; Farrow & Ball 39 Fowler Pink; Farrow & Ball 45 Sand; Dulux 3050-Y50R Free Range; Sanderson Spectrum 50-23 Salisbury; terracotta pots Clifton Nurseries.

page 29 napkins Habitat.

page 30 throw Coiefax & Fowler.

page 31 paint swatches from top: Dulux 0030-Y10R Jigsaw; Dulux 1030-Y Spring Butter; Farrow & Ball 44 Cream; Sanderson Spectrum 6-23 Gobi Tan; Farrow & Ball 15 Bone; chair cover fabric Habitat; wall painted in Country Cream, Dulux.

pages 32-33 plate Ruby Beets Antiques, USA.

page 34 galvanized metal storage box Ikea; wooden and metal cutlery from a selection at Wolfman Gold & Good Co., USA; pendant light After Noah.

page 35 sisal mat John Lewis.

page 40 plastic yellow bowl Heal's.

pages 42-43 fabrics from top: cotton stripe; cotton check; cotton check; cotton check (all by Designers Guild): plain green cotton The Conran Shop, cotton roller towel by Universal Towel Company; cotton by The Conran Shop; cotton mix stripe by John Lewis; cotton ticking by Russell & Lewis; cotton check by Ikea; cotton ticking by Ian Mankin; cotton stripe by Laura Ashley.

pages 44-45 1 cotton sheeting John Lewis 2 cotton voile Textiles 3 cotton Muriel Short 4 polyester/cotton muslin Laura Ashley 5 cotton muslin Wolfin Textiles 6 cotton check The Conran Shop 7 cotton check The Conran Shop 8 cotton check The Conran Shop 9 self-checked cotton voile Habitat 10 silk Pongees 11 cotton voile check Habitat 12 cotton voile check Laura Ashley 13 printed cotton tana lawn Liberty 14 cotton chambray McCulloch & Wallis 15 cotton calico Wolfin Textiles 16 cotton Wolfin Textiles 17 cotton muslin Muriel Short 18 cotton stripe Ian Mankin 19 cotton muslin 20 cotton Designers Guild 21 polyester/cotton muslin Laura Ashley 22 linen Wolfin Textiles 23 natural linen Wolfin Textiles 24 cotton muslin Muriel Short 25 cotton muslin Muriel Short 26 cotton The Conran Shop 27 cotton voile check Designers Guild 28 voile check Designers Guild 29 cotton striped voile Habitat.

pages 46-47 30 printed cotton Cath Kidston 31 wool mix felt J.W.Bollom 32 cotton stripe The Blue Door 33 cotton stripe Pukka Palace 34 cotton check Coiefax & Fowler 35 cotton check Coiefax & Fowler 36 cotton stripe The Blue Door 37 cotton stripe Habitat 38 cotton chambray R. Halstuk 39 linen check The Blue Door 40 cotton ticking Ian Mankin 41 cotton stripe The Blue Door 42 printed floral cotton Manuel Canvas 43 cotton viscose check Manuel Canvas 44 cotton check The Blue Door 45 cotton stripe The Malabar Cotton Co. 46 cotton stripe Habitat 47 printed cotton stripe Laura Ashley 48 & 49 linen herringbone The Blue Door 50 pink cotton check Ian Mankin 51 green cotton check Ian Mankin 52 & 53 cotton checks Ian Mankin 54 printed cotton floral Jane Churchill 55 linen The Blue Door 56 cotton check Habitat 57 cotton check Designers Guild 58 cotton check Ikea 59 cotton check Habitat 60 cotton check Ian Mankin 61 cotton check Designers Guild 62 cotton check Ian Mankin 63 & 64 cotton checks The Malabar Cotton Co. 65 cotton drill Wolfin Textiles 66 cotton stripe Habitat 67 roller towel Universal Towel Company.

pages 48-49 68 cotton mix stripe John Lewis 69 cotton denim Z.Butt Textiles 70 cotton ticking Russell & Chapple 71 & 72 cotton Habitat 73 cotton stripe Designers Guild 74 linen Muriel Short 75 cotton calico Wolfin Textiles 76 cotton Pierre Frey 77 check Ian Mankin 78 wool tartan Ian Mankin 79 wool tartan Anta 80 wool check Anta 81 cotton Osborne & Little 82 cotton duck Russell & Chapple 83 cotton canvas Wolfin Textiles 84 cotton gingham daisy Sanderson 85 cotton check Designers Guild 86 cotton check Habitat 87 self-patterned cotton/viscose Marvic Textiles 88, 89 & 90 cotton Osborne & Little 91 cotton The Conran Shop 92 cotton check Designers Guild 93 cotton check gingham daisy Sanderson 94 cotton Habitat 95 cotton check Coiefax & Fowler 96 linen Wolfin Textiles.

pages 50-51 drawer Ikea; chairs left to right painted in 39-03 salad green eggshell Sanderson Spectrum; covered in floral Spectrum; cotton print Manuel Canvas; painted in 24-04 Swiss blue eggshell Sanderson Spectrum; painted in 21-10 fidelity Sanderson Spectrum.

page 52 clockwise from top:

CREDITS

folding chair The Reject Shop: church chair Castle Gibson; Bunny chair Designers Guild; junk shop chair fabric Cath Kidston; pine occasional table Ikea; Montecarlo chair The Conran Shop: birchwood ply trestle table McCord; stool Habitat.

page 53 *clockwise from top:* pine Lantula dining room table Ikea; white folding chair Ikea; metal kitchen table The Conran Shop: table folding chair Ikea; wooden kitchen table Decorative Living; factory chair After Noah, zinc-top table Cath Kidston; Nicole chair Habitat; chair cover fabric Habitat; Ikea table painted in Colour World E5-16 Bromel eggshell, J.W. Bollom.

page 54 *top:* wrought iron bed After Noah; *left:* Douglas Fir bed in Pawson House, London, designed by John Pawson; *right:* four-poster bed frame Ikea.

page 55 *clockwise from top:* Chesterfield sofa A Barn Full of Sofas and Chairs; Coward sofa SCP; Swedish cot sofa Sasha Waddell; armchair George Smith.

page 56 cardboard storage boxes Muji; metal mesh wardrobe Action Handling Equipment; filing cabinet B.S. Sales.

page 57 kitchen units Ikea; boxes Muji; metal mesh wardrobe Everything, USA; wardrobe junk shop; dresser Colette Aboudaram, France.

pages 58-59 Misu glass tumblers Ikea; metal mesh basket Crate & Barrel, USA.

page 60 *clockwise from top:* wooden pot stands Divertimenti: wooden chopping board Woolworths; gingham knife Designers Guild; wooden spoons Divertimenti; glass lemon squeezer Woolworths; corkscrew Divertimenti; scissors John Lewis; Sabatier stainless steel knife Divertimenti: espresso maker McCord; stainless steel pedal bin Divertimenti.

page 61 *clockwise from top:* Le Pentole steamer Divertimenti: Le Creuset pot, Divertimenti.

colander Woolworths: fish kettle Gill Wing: garlic crusher, whisk, crab crackers Divertimenti: Le Pentole frying pan Divertimenti: kettle Staines Catering: grater, Divertimenti: sieve Divertimenti: cutlery McCord.

page 62 *clockwise from top:* chandelier Robert Davies: storm lamps similar at Crate & Barrel, USA: nightlights Ikea: candle holder Habitat: paper shade and brass candle holder The Dining Room Shop: lantern Habitat.

page 63 anglepoise lamp After Noah; pendant light After Noah; Flexi lamp The Conran Shop.

page 64 *clockwise from top:* vegetable crates painted in Colour World E9-23 green J.W. Bollom; laundry basket Tobias and the Angel; blanket Melin Tregwynt; blue and green cotton fabric The Conran Shop; storage chest Ikea; boxes Habitat painted in pottery JWB86, J.W. Bollom; peg rail Ikea.

page 65 *clockwise from top:* glass storage jars Divertimenti; pine cupboard Ikea painted in blue eggshell; butchers hooks Divertimenti: buckets The Conran Shop and hardware stores: galvanized steel storage boxes Muji; shoe rack Ikea, beaker Muji; clothes rail B.S. Sales; shoe boxes fabric Manuel Canovas.

page 66 picture frames Ikea.

page 67 plates English Country Antiques, USA; picture frames Habitat; pudding basins Divertimenti: shadow boxes Habitat.

page 68 *clockwise from top:* mug Habitat; tartan plate Anta; white coffee cup and saucer Habitat; blue-and-white china Crate & Barrel, USA; dinner plate Heal's; Champagne flute The Conran Shop; Duralex tumbler Spanish supermarket; ripple glass Designers Guild; tumbler Crate & Barrel, USA; Misu tumbler Barrel, USA; Cornishware plate Heal's.

page 69 *clockwise from top:* gingham bowl McCord; jug Divertimenti: blue-and-white bowl Habitat: spotty bowl Designers Guild: cream cup and saucer by Veronique Pichon at Designers Guild: white plate Wedgwood: Poole Pottery jug Designers Guild.

pages 72-73 enamel jug Ruby Beets Antiques, USA.

pages 74-75 saucepans Brick Lane Market; tartan plates Anta; sink and taps Aston Matthews.

pages 76-77 Swedish stove Jotul; interior design Susie Manby; trug Clifton Nurseries.

pages 78-79 tins painted in Farrow & Ball 44 cream eggshell; crates painted in Colour World E6-46 (yellow) J.W. Bollom. Colour World E9-23 (green) J.W. Bollom, Pottery JWB86 (blue) J.W. Bollom; flower pots painted in White matt emulsion J.W. Bollom and vinyl matt emulsion Lavender Lave 21-17 Sanderson Spectrum.

pages 80-81 Kilner jars After Noah; cake tins Brick Lane Market; white metal chair Brimfield Market USA.

pages 82-83 white Carrara marble work surface, sink and spout, lacquered mdf cupboards and drawer units in Pawson House, London, all designed by John Pawson; pasta pan Divertimenti.

pages 84-85 chair cover fabric similar at Universal Towel Company; white bowls from a selection at Wolfman Gold & Good Co., USA.

page 86 *below left:* Provencal chairs Paris junk shop.

page 87 table and chairs similar at After Noah; flower pots Clifton Nurseries: white china Gill Wing.

pages 88-89 The Conran Shop: metal table Russell & Chapple; chair cover fabric Designers Guild: white plates Wedgwood; lilac paint Sanderson spectrum vinyl matt emulsion Fascination 2309M.

pages 92-93 *left:* wicker parlour chairs Palecek: myrtle topiary Christian Tortu at Takashimaya;

white table junk shop; *right:* laminated Saarinen table and Tulip chair Frank Lord.

pages 94-95 *left and top right:* room and furniture in Pawson House, London, designed by John Pawson; *below right:* loft dining area by James Lynch.

pages 96-97 blind fabric Colefax & Fowler; plastic tablecloth John Lewis; wool throw Anta; chandelier Robert Davies; wall paint Country Cream Dulux.

pages 98-99 sofa fabric Sanderson: green cotton check cushion Laura Ashley; cushion in blue cotton The Conran Shop; cushions in blue check JAB; throw Anta.

pages 100-101 fabric swatches: narrow and wide cotton stripes Habitat; cotton check The Conran Shop; *main picture:* floral cotton covers; striped cotton blinds, linen and cotton rug Ralph Lauren, USA; ticking cushion fabric Ralph Lauren, USA and antique samples; *right:* metal daybed Colette Aboudaram, France; antique ticking on cushion fabric Bryony Thomasson.

page 102 *main picture:* chair and sofa cover: cotton rug and paint Ralph Lauren, USA; cushion cover fabric Designers Guild.

page 103 *left:* paint Olive and Calke Green matt emulsion mixed together Farrow & Ball, candle holder and side cupboard After Noah; *right:* blue cotton sofa fabric The Conran Shop, Paris; terracotta cotton armchair fabric Ian Mankin; interior design by Susie Manby.

pages 104-105 Butler's tray table Crate & Barrel, USA, painted in Sanderson Spectrum Satinwood 50-23; *main picture:* blinds in checked cotton Designers Guild: wing chair covered in Tulipan Marvic Textiles; cream paint Buttermilk Dulux; white table Brick Lane market; *right:* checked terracotta fabric on sofa Manuel Canovas; wooden chest and metal planter Tobias and The Angel.

pages 106–107 cotton calico Wolfin Textiles.

page 108 *top*: sofa Nick Plant; *left*: light Lieux, Paris; wool appliqué cover Siécle, Paris; *right*: basket chair Alfies Antique Market; mirror from Cligoncourt Market, Paris.

page 109 wall paint colour Nantucket, Benjamin Moore USA.

pages 110–111 main picture: wool blankets Anta; cotton rugs Habitat; cupboard Ikea; checked cotton chair covers Ian Mankin ; chairs A Barn Full of Sofas and Chairs; chandelier Wilchester County; shades The Dining Room Shop.

pages 112–113 cotton drill Z. Butt Textiles.

pages 116–117 *left*: chair in antique ticking Bryony Thomasson; interior design Susie Manby; *centre*: sofa Ikea; *right*: filing cabinet B.S.Sales; trestle table McCord; filing boxes, frames Ikea; metal chair and cover in cotton check Habitat; Bunny chair Designers Guild; wastepaper basket The Conran Shop.

page 118 *left*: curtain fabric The Conran Shop.

page 119 linen curtain fabric from a selection Rosebrand Textiles, USA; myrtle tree Christian Tortu at Takashimaya, New York; sofa from a barn sale; wall paint Nantucket Benjamin Moore, USA.

page 124 bed Portobello Road Market; chair Alfies Antique Market; white paint John Oliver.

page 125 old linen Judy Greenwood.

pages 126–27 cotton Laura Ashley.

page 128 table Colette Aboudaram, France.

page 129 striped cotton pillowcase Ralph Lauren, USA; patchwork quilt on bed Ruby Beets Antiques, USA; quilt on wall, Brimfield Market, USA.

page 130 mosquito net Mombasa Net Canopies, USA.

page 131 Tom Dixon light Gladys Mougin, Paris; Indian cotton bedspread Living Tradition, Paris.

page 132 bolster pad John Lewis; cotton striped fabric Laura Ashley; wooden box Tobias and The Angel.

page 133 bed Jim Howitt; antique quilt Judy Greenwood; pillowcases in cotton lawn Liberty; linen fabric on seat cushions Laura Ashley; white bedlinen John Lewis; paint Dulux Sandstone eggshell.

page 134 muslin curtains Pottery Barn, USA; bedlinen Designers Guild; wool blanket Melin Tregwynt.

page 135 bunkbeds Habitat Paris.

page 138 *left*: shower curtain similar at Crate & Barrel, USA; *below right*: drawstring bag fabric Russell & Chapple; starfish Eaton Shell Shop.

page 139 antique cupboard Colette Aboudaram, France; interior design Susie Manby.

pages 140–41 bathroom cupoard Ikea; painted in Beryl Green 35-16 Sanderson Spectrum.

page 142 wooden duckboard Habitat.

page 143 *left*: peg rail Robert Davies; chair Alfies Antique Market; *top right*: shoe rack, pine mirror, butcher's hooks After Noah; brushes, soaps The Conran Shop; towels Muji; galvanized bucket The Conran Shop; medicine bottles junk shop; *bottom right*: linen basket Habitat.

pages 144–45 cotton ticking Russell & Chapple; tea towels Divertimenti.

page 146 jug from a selection at Sage Street Antiques, USA; peg rail Ikea.

page 147 taps and bath Lassco; wooden bath rack Habitat; towels John Lewis

page 148 nail brush John Lewis

page 149 *top left*: tap and stone basin in Pawson House, London, designed by John Pawson; *top right*: outdoor brass taps from builders' merchants; *bottom*: taps and bath Lassco; bath rack Habitat.

page 150 *left*: towels, flannels and robe Designers Guild; *right*: towels John Lewis.

page 151 bathroom by James Lynch ; bath Lassco; shower taps Nicholls and Clarke; tins Alfies Antique Market.

page 160 Paint swatches from top: Marston & Langinger Warm White; Sanderson Spectrum 4–19 Winter White; Sanderson Spectrum 3–19 Sunny White; Marston & Langinger Ivory; Jelly glass, After Noah.

page 161 Wooden picket-fence window box, Jerry's Home Store.

page 162 Blue-and-white checked place mat, Crate & Barrel, USA.

page 163 Paint swatches from top: Marston & Langinger Silver Blue; Sanderson Spectrum 24–15 Blue Day; Sanderson Spectrum 25–22 Columbine; Sanderson Spectrum 54–23 King's Blue.

page 164 Paint swatches from top: Marston & Langinger Pistachio; Sanderson Spectrum 40–04 Sunny Green; Sanderson Spectrum 34–20 Grey Green Light; Farrow & Ball no. 32 Cooking Apple Green.

page 167 Wool rug, Designers Guild; cricket chair, IKEA; tulips, McQueens; paint swatches from top: Brats no. 105 Constantinople; Sanderson Spectrum 21–10 Fidelity; Sanderson Spectrum 21–04 Lilac; Sanderson Spectrum 23–05 Easter Egg.

page 168 Paint swatches from top: Marston & Langinger Verona Pink; Brats no. 100 Cairo; Brats no. 108 Seville; Marston & Langinger Terracotta; flowerpots, Smith & Hawken, USA.

page 169 Scented candles, Price's Patent Candle Co; napkins, Designers Guild; plastic plate and cutlery, Woolworth's; pumpkins, Wayside Organics.

page 170 Paint swatches from top: Marston & Langinger Sand; Marston & Langinger Bamboo; Farrow & Ball no. 51 Sudbury Yellow; Sanderson Spectrum 6–23 Gobi Tan; napkin and place mat, Crate & Barrel, USA.

page 171 Yellow bowl, El Corte Ingles, Spain.

pages 172–73 House of Ellen O'Neill, Long Island, NY, USA.

page 180 Stick border (bottom left) and stick fencing (bottom right) in the garden of Dean Riddle, Phoenicia, NY, USA.

page 181 Location: garden of Timothy Leese and Robert Chance, Norfolk; blue and green PVC, Habitat; deck chair in checked cotton fabric by Designers Guild; gate in the garden of Nancy McCabe, northwest Connecticut, USA.

page 182–83 Garden of Nancy McCabe, northwest Connecticut, USA.

page 184 Shed in the allotment garden of John Matheson, London.

page 186–87 Planting by Nancy McCabe in her garden in northwest Connecticut, USA.

page 188 Fence painted in Prion outdoor paint by Crown-Berger in the garden of Vanessa de Lisle, Fashion Consultant, London.

page 189 Trellis (top left) painted in Prion outdoor paint by Crown-Berger; twiggy supports (far right, top and centre) in the garden of Nancy McCabe, northwest Connecticut, USA; stick fencing (bottom right) in the garden of Dean Riddle, Phoenicia, NY, USA.

page 190 Clockwise from top left: old shears, Avant Garden; trowel, dibber and fork, Clifton Nurseries; besom broom, Avant Garden; trug, Clifton Nurseries; plastic apron and gardening gloves, Homebase.

page 191 Clockwise from top left: plastic refuse bag, Homebase; holdall, Homebase; Andalusian pitchfork and old spade, Avant Garden; Wellington boots with leather lining, Avant Garden; wooden plant labels, The Conran Shop; raffia and string, Homebase.

page 192–93 Metal plant trough, The Conran Shop.

page 194 Weathered terracotta flowerpots, General Trading Company.

page 195 Clockwise from centre: low planter, Avant Garden; rhubarb forcer, Avant Garden; long tom, Avant Garden; old flowerpot with amaryllis, The Conran Shop; hanging pot, Clifton Nurseries, with a wash of white and terracotta emulsion by Cole & Son.

page 196 Clockwise from top left: metal planter, The Conran Shop; metal lunch box, Muji; metal bucket, IKEA; metal bucket with lavender, Paula Pryke Flowers; metal bucket, G J Chapman.

page 198 Green and blue plastic flowerpots, The Conran Shop.

page 199 Wooden picket-fence window box, Jerry's Home Store; plastic window box, Clifton Nurseries, painted in powder blue emulsion by Farrow & Ball; ornamental cabbages, McQueens; wooden seed tray, The Conran Shop.

page 216 Bench painted in colour 819 by Benjamin Moore & Co, USA.

page 218–19 I ribbed cotton, The Conran Shop; 2 cotton, Sanderson; 3 linen, Sanderson; PVC-coated cotton, John Lewis; 5 checked sheer cotton, Habitat; 6 washed cotton, The Conran Shop; 7 plain dye canvas cotton, John Lewis; 8 cotton duck, Whaleys Ltd; 9 cotton, Habitat; 10 cotton, Designers Guild; 11 ribbed cotton, The Conran Shop; 12 silk, Designers Guild; 13 ribbed cotton, stylist's own; 14 ribbed cotton, The Conran Shop; 15 cotton ticking, Ian Mankin; 16 cotton, Ian Mankin; 17 striped cotton, Laura Ashley; 18 checked cotton, Ian Mankin; 19 cotton ticking, Ian Mankin; 20 PVC-coated viscose and polyester, John Lewis; 21 solid rib caustic cotton, Habitat; 22 plain cotton, Designers Guild; 23 cotton check, Designers Guild; 24 sheer cotton, Habitat; 25 PVC, Habitat; 26 PVC Habitat; 27 PVC, Habitat.

page 220 Clockwise from top left: blue wooden bench, IKEA; aluminium-frame rocking chair, Graham & Green; wooden folding table painted in white emulsion, Habitat.

page 221 Clockwise from top left: potting bench, IKEA, painted in Monsoon 1030, Dulux Definitions; deck chair, Jerry's Home Store; folding table, IKEA; old deck chair in green cotton check, Designers Guild; sun-lounger with aluminium frame, Graham & Green.

pages 222–23 Jug, Ruby Beets Antiques, USA.

page 224 Clockwise from top right: glass storm lamps, Jerry's Home Store; nightlight, IKEA; lantern, B'zar; hurricane lantern, Jerry's Home Store; candles, Price's Patent Candle Co; glass storm lamp, The Dining Room Shop.

page 226 Clockwise from top left: white plastic bowl, Divertimenti; wooden tray, Habitat, painted in Sanderson Spectrum 23–05 Easter Egg; plastic mug, Debenhams; Duralex glass, The Conran Shop; tin plate, Blacks Camping Shop; plastic lunch box, Divertimenti; water jug, Staines Catering Equipment; food net, Divertimenti.

page 227 Clockwise from top left: plastic plate, knife and fork, Woolworth's; Greek barbecue, Young & D; gingham paper napkins, Paperchase; orange-and-pink checked napkin, Designers Guild; metal jug, Jerry's Home Store; white bowl, Staines Catering Equipment; kettle, stylist's own; bottle cooler, Blacks Camping Shop.

page 230–31 Chairs and cotton covers, The Conran Shop.

page 232 Blue-and-white striped cotton cushion covers, Ralph Lauren Home Collection, USA; location (top): house of Ellen O'Neill, Long Island, NY, USA; location (bottom left and right): house of Dean Riddle, Phoenicia, NY, USA.

page 233 House of Ellen O'Neill, Long Island, NY, USA.

page 234 Metal sieve, After Noah; chair and wooden trellis painted in Sanderson Spectrum 39–03 Salad Green; checked plastic fabric tablecloth, John Lewis; watering can, Tobias and the Angel.

page 235 Blue checked wool blanket, Melin Tregwynt.

page 238 Blue-and-green cloth, Tobias and the Angel; jug, The Conran Shop; folding cricket chairs, Habitat.

page 239 Wooden folding table, Habitat.

page 240 Folding chairs, Habitat, with covers made in cotton duck from Whaleys Ltd; food net, Divertimenti; wooden food safe, After Noah.

page 241 Metal shoe locker, After Noah.

page 242 Cloth in blue checked cotton, Designers Guild; white bowl, The Conran Shop.

page 243 Metal bucket, IKEA; bay tree, Clifton Nurseries.

page 244–45 Garden of Nick and Hermione Tudor, Finca El Moro, Spain.

page 246 Plastic window boxes, Clifton Nurseries, painted in powder blue emulsion by Farrow & Ball.

page 247 Cedar window box, Clifton Nurseries; location: house of David and Carolyn Fuest, London.

page 248–49 Vegetable and flower plot of Dean Riddle, Phoenicia, NY, USA.

page 252 Location (bottom right): allotment garden of John Matheson, London.

page 253 Blue bench, IKEA.

page 254 Vegetable and flower garden of Nancy McCabe, northwest Connecticut, USA.

page 256 Metal buckets, IKEA and G J Chapman; small metal bin, Paula Pryke Flowers.

page 257 Metal planters, The Conran Shop.

page 259 Chicken coop in the garden of Nancy McCabe, northwest Connecticut, USA; stick fencing in the garden of Dean Riddle, Phoenicia, NY, USA.

page 261 Vegetable and flower garden of Dean Riddle, Phoenicia, NY, USA.

page 262 Herb and vegetable garden of Nancy McCabe, northwest Connecticut, USA.

page 265 Glasses, El Corte Ingles, Spain; food net, Divertimenti.

page 268 Food nets, Ruby Beet Antiques, USA; storm lamps, Habitat; jug and bowl, The Conran Shop; metal flower bucket, The Conran Shop.

page 271 Folding cricket chairs and wooden folding tables painted in white emulsion, Habitat.

page 272–73 Tablecloth in blue PVC fabric from Habitat; straws, IKEA.

page 274 Checked rug and checked napkins, Designers Guild; cloth in orange cotton fabric from The Conran Shop.

page 276 Metal hurricane lanterns, Jerry's Home Store; metal jug, Jerry's Home Store; striped cloth and napkins, Jerry's Home Store; folding chairs, Old Town.

page 277 Jelly glasses, After Noah; tray, Habitat, painted in Sanderson Spectrum 23–05 Easter Egg.

page 278 White plates, IKEA.

page 280–81 Garden of Vanessa de Lisle, Fashion Consultant, London.

page 282–83 Garden of Lisa Bynon and Mona Nehrenberg, Sag Harbor, NY, USA.

pages 284–85 Garden of Vanessa de Lisle, Fashion Consultant, London.

page 288 Cloth in checked cotton by Designers Guild.

page 290 Bowl and cotton towel, The Conran Shop.

page 291 Location (right): garden of Lisa Bynon and Mona Nehrenberg, Sag Harbor, NY, USA.

page 292 Folding director's chairs, Heal's.

page 293 White folding table painted in white emulsion, Habitat; cushions in bold striped cotton by Laura Ashley and narrow striped cotton by Ian Mankin.

page 294 Checked cloth, Divertimenti.

page 295 Metal lunch box, Muji.

pages 296–97 Vegetable and flower garden of Dean Riddle, Phoenicia, NY, USA.

Suppliers

PURE STYLE HOME

UK SUPPLIERS

Bedlinen

The Chelsea Linen Co.
PO Box 6, Chalford, Stroud
Gloucestershire GL6 8XR
www.chelsealinen.co.uk

Cologne & Cotton
791 Fulham Rd, London SW6 5HD
(mail order)
www.cologneandcotton.com

Damask
Broxholme House, New King's Road
London SW6 4AA
www.damask.co.uk/

Designers Guild
267–271 & 277 King's Rd, London
SW3 5EN
www.designersguild.com

Judy Greenwood Antiques,
657 Fulham Rd, London SW6 5PY

Habitat
196 Tottenham Court Rd, London
WIT 7LG
www.habitat.co.uk

Heal's
196 Tottenham Court Rd, London
WI
www.heals.co.uk

Ikea
2 Drury Way, North Circular Rd,
London NW10 0TH
www.ikea.com

Ralph Lauren Home Collection
1 New Bond Street
London W1S 3RL
www.ralphlaurenhome.com

The Monogrammed Linen Shop
168 Walton St, London SW3
www.monogrammedlinenshop.com

The Shaker Shop
322 Kings Road, London SW3 5UH

Tobias and The Angel
68 White Hart Lane, London
SW13 0PZ
T +44(0)20 8878 8902
www.tobiasandtheangel.com

Melin Tregwynt
Castle Morris, Haver-fordwest
Pembrokeshire SA62 5UX
www.melintregwynt.co.uk

The White Company
261 Pavilion Road, London
SW1X 0BP
T: +44 (0)20 7881 0783
www.thewhitecompany.com

Fabric

Anta
Fearn, Tain, Ross-shire, Scotland,
IV20 1XW
T: +44 (0)1862 832 477
www.anta.co.uk

Laura Ashley
256–258 Regent Street, London
W1B 3AF
T: +44 (0)20 7437 9760
www.lauraashley.com

The Blue Door
77 Church Rd, Barnes, London
SW13 9HH
T: +44 (0)20 8748 9785
www.bluedoorbarnes.co.uk

Jane Churchill
110–112 Fulham Road, London
SW3 6HU
T: +44 020 7244 7427
www.janechurchill.com

Colefax and Fowler
39 Brook St, Mayfair, London
W1K 4JE
+44 (0)20 7493 2213
www.colefax.com

The Conran Shop
Michelin House, 81 Fulham Rd,
London SW3 6RD
T: +44 (0)20 7589 7401
www.conran.com

Pierre Frey,
251–53 Fulham Road, London
SW3 6HY
T: +44 (0)20 7376 5599
www.pierrefrey.com

R.Halstuk Textiles
35 Brick Lane, London E1 6PU
T: +44 (0)20 7247 4957

JAB International
Floor 1, Chelsea Harbour Design
Centre
London SW10 0XE
T: +44 (0)20 7349 9323

Cath Kidston
8 Clarendon Cross, London
W11 4AP
T: +44 (0)20 7221 4000
www.cathkidston.co.uk

Liberty
Regent Street, London W1B 5AH
+44 (0)20 7734 1234
www.liberty.co.uk

McCulloch & Wallis
25 Dering Steet, London W1S 1AT
T: +44 (0)20 7629 0311
www.macculloch-wallis.co.uk

Manuel Canovas
2 North Terrace, Brompton Rd,
London SW3 2BA
T: +44 (0)20 7225 2298
www.manuelcanovas.com

Malabar Cotton Co.
31-33, The South Bank Business
Centre, Ponton Road, London,
SW8 5BL
T: +44 (0)20 7501 4200
www.malabar.co.uk

Marvic Textiles
Chelsea Harbour Design Centre
26G Chelsea Harbour, Chelsea,
London, SW10 0XE
T: +44 (0)20 7352 3119
www.marvictextiles.co.uk (also
stocked at Liberty)

Osborne & Little
304–308 Kings Rd, London
SW3 5UH
T: +44 (0)20 7352 1456
www.osborneandlittle.com

Flooring

Crucial Trading
79 Westbourne Park Rd, London
W2 5QH
T: +44 (0)20 7221 9000
www.crucial-trading.com

Fired Earth
117–19 Fulham Rd, London SW3 6RL
T: +44 (0)20 7589 0489
www.firedearth.co.uk

Hardwood Flooring Co
146–152 West End Lane, London
NW6 1SD
T: +44 (0)20 7328 8481
www.hardwoodflooringcompany.com

Junkers
Unit 3–5, Wheaton Court
Commercial Centre, Wheaton Rd,
Witham, CM8 3UJ
T: +44 (0)1376 517512
www.junckershardwood.com

Lassco
30 Wandsworth Road, Vauxhall,
London SW8 2LG
T: +44 (0)20 7394 2100
www.lassco.co.uk

Roger Oates
The Long Barn, Eastnor, Ledbury,
Herefordshire HR8 1EL
T: +44 (0)1531 632718
www.rogeroates.com

Paris Ceramics
583 Kings Rd, London SW6 2EH
T: +44 (0)20 7371 7778
www.parisceramics.com

Sinclair Till
791–793 Wandsworth Rd, London
SW8 3JQ
T: +44 (0)20 7720 0031
www.sinclairtill.co.uk

Walcot Reclamation
108 Walcot Street, Bath BA1 5BG
T: +44 (0)1225 335532
www.walcot.com

Waveney Apple Growers
Common Road, Aldeby, Beccles,
Suffolk NR33 0BL
T: +44 (0)1502 679155

Furniture/accessories

Action Handling
The Maltings, Industrial Estate,
Station Rd,
Sawbridgeworth, Herts CM21 9JY
T: + 44 (0)1279 724989
www.actionhandling.co.uk

ARAM
110 Drury Lane (nr. Aldwych),
Covent Garden
London, WC2B 5SG
T: +44 (0)20 7557 7557
www.aram.co.uk

Aero
347–349 King's Road, London
SW3 5ES
T: +44 (0)20 7351 0511
www.aeroplus.com.au

Aria
Barnsbury Hall, Barnsbury Street,
London N1 1PN
T: +44 (0)20 7704 6222
www.aria-shop.co.uk

Egg
36 Kinnerton Street, London
SW1X 8ES
T: +44(0)207 235 9315

Angela Flanders
96 Columbia Road, Shoreditch,
London E2 7QB
www.angelaflanders-perfumer.com
T: +44 (0)20 7739 7555

The Holding Co.
243–245 King's Road, London
SW3 5EL
T: +44 (0)20 7352 1600
www.theholdingcompany.co.uk

Next Home
220-224 Tottenham Court Road,
London, W1T 7PZ
T: +44 0844 8445130
www.next.co.uk

Muji
187 Oxford Street, London W1R 1AJ
Tel: +44-(0)20 7437 7503
www.muji.co.uk

Paperchase
213–215 Tottenham Court Rd,
London W1T 7PS
T: +44 (0)20 7467 6200
www.paperchase.co.uk

V.V. Rouleaux
54 Sloane Square, Cliveden Place,
London SW1W 8AX
Tel: 020 7730 3125
www.vvrouleaux.com

SCP
135–139 Curtain Rd, London
EC2A 3BX
T +44 (0)20 7739 1869
www.scp.co.uk

George Smith
587–589 Kings Road, London
SW6 2EH
+44 (0)20 7384 1004
www.georgesmith.co.uk

Viaduct
1–10 Summer's Street, London
EC1R 5BD
T: +44 (0)20 7278 8456
www.viaduct.co.uk

Sasha Waddell
269 Wandsworth Bridge, London
SW6 2TX
T: +44 (0)20 7736 0766
www.sashawaddell.co.uk

Kitchen/dining
Ideas for equipment, china and glass:

Divertimenti
227-229 Brompton Road, London
SW3 2EP
T: +44 (0)20 7581 8065
www.divertimenti.co.uk

Graham & Green
4 Elgin Crescent, London W11 2HX
T: +44 (0)20 7243 8908
www.grahamandgreen.co.uk

Jerry's Home Store
163–167 Fulham Rd, London
SW3 6SN
T: +44 (0)20 7581 0909

John Lewis
278–306 Oxford Street, London
W1A 1EX
T: +44 (0)20 7629 7711
www.johnlewis.com

David Mellor
4 Sloane Sq, London SW1 8EE
T: +44 (0)20 7730 4259
www.davidmellordesign.com

The Pier
200 Tottenham Court Rd, London
W1T 7PL
T: +44 (0)20 7637 7001
www.pier.co.uk

Peter Jones
Sloane Square, London SW1W 8EL
www.peterjones.co.uk
T: +44 (0)20 7730 3434

Summerill and Bishop,
100 Portland Rd, London W11 4LN
T: +44 (0)20 7221 4566
www.summerillandbishop.com

Gill Wing Cook Shop
190 Upper Street, London N1 1RQ
+44 (0)20 7503 7963
www.gillwing.co.uk

Kitchens and bathroom fittings

CP Hart
Newnham Terrace, Hercules Rd,
London, SE1 7DR
T: +44 (0)20 7902 1000
www.cphart.co.uk

Aston Matthews
141-147 Essex Rd, London, N1 2SN
T: +44 (0) 20 7266 7220
www.astonmatthews.co.uk

Stovax
Falcon Road, Sowton, Industrial
Estate, Exeter, EX2 7LF
T: +44 (0) 1392 474011
www.stovax.com

Lighting

The Dining Room Shop
62 White Hart Lane, London
SW13 0PZ
T: +44(0)208 878 1020
www.thediningroomshop.co.uk

Price's Candles
47a Clarks Village Street, Somerset
BA16 0YL
T: +44 (0) 1458 440006
www.prices-candles.co.uk

Purves & Purves
80-81 & 83 Tottenham Court Rd,
London W1T 7PZ
T: +44 (0) 20 7580 8223
www.purves.co.uk

SKK
34 Lexington St, London W1F 0LH
+44 (0) 20 7434 4095
www.skk.net

Paints
Manufacturers with an interesting
range of colours:

Farrow & Ball (check website for
stockists)
www.farrow-ball.com

Cole & Son (Wallpapers) Ltd (see
website for stockists) www.cole-and-
son.com

Dulux (see website for stockists)
www.dulux.co.uk

John Oliver
33 Pembridge Rd, London W11

Second hand and markets

After Noah
121 Upper Street, London, N1 1QP
T: +44 (0) 20 7359 4281
www.afternoah.com

Alfies Antique Market
13-25 Church Street, London
NW8 8DT
T: +44 (0) 20 7723 6066
www.alfiesantiques.com

Castle Gibson
106a Upper Street, London N1 1QN
T: +44 (0) 20 7704 0927

Decorative Living
55 New King's Rd, London SW6 4SE
T: +44 (0) 20 7736 5623
www.decorativeliving.co.uk

Markets that yield interesting finds:
Bermondsey, London SE1 (London
Bridge tube) Held early Friday
morning; antiques plus junk
furniture and accessories.

Brick Lane, London E1 (Liverpool
Street tube)
Held every Sunday morning; junk
chairs, tables, kitchenware.

Portobello Road, London W11
(Notting Hill Tube)
Held every Friday & Saturday;
sprawling array of stalls selling junk
furniture and accessories.

US SUPPLIERS

Home

ABC Carpet & Home
881-888 Broadway, New York,
NY 10003
T: 212-674-1144
www.abc.home

Bed, Bath & Beyond
620 Avenue of the Americas,
New York, NY 10011
T: 212-255-3550
www.bedbathandbeyond.com

Crate & Barrel
646 N Michigan Avenue, Chicago,
IL 60611
T: 800-996-9960
www.crateandbarrel.com

Fishs Eddy
889 Broadway, New York, NY
10011
T: 212-420-2090

Garnet Hill
P.O. Box 262, Main Street,
Franconia, NH 03580
www.garnethill.com

Hold Everything
1309-1311 Second Avenue, New
York, NY 10021
T: 212-879-1450
www.williamssonoma
.com/brands/brands.clm

IKEA
1800 East McConnor Parkway
Schaumburg, IL 60173
www.ikea.com

Paleček
The Design Pavilion #27, 200
Kansas Street
San Francisco, CA 94103
T: 800-274-7730
www.palecek.com

Pier One Imports
71 Fifth Avenue, New York, NY
10003
T: 212-206-1911
www.pier1.com

Portico Bed & Bath
139 Spring Street, New York, NY
10012
T: 212-941-7800

Pottery Barn
600 Broadway, New York, NY
10012
T: 800-922-5507
www.potterybarn.com

Restoration Hardware
935 Broadway, New York, NY
10011
T: 212-260-9479
www.restorationhardware.com

Takashimaya
693 Fifth Avenue, New York, NY
10012
T: 212-350-0100

Waverly
Dealer locations:
T: 800-423-5881
www.waverly.com

Williamsburg Marketplace
Catalogue
The Colonial Williamsburg
Foundation
Department 023, P.O. Box 3532
Williamsburg, VA 23187
T: 800-414-6291
www.williamsburgmarketplace.com

Williams-Sonoma
121 East 59th Street, New York,
NY 10022
T: 800-541-1262
www.williams-sonoma.com

Fabrics

Laura Ashley Home Store
171 East Ridgewood Avenue,
Ridgewood, NJ 07450
T: 201-670-0686
www.laura-ashleyusa.com

Calvin Klein Home
At Calvin Klein
645 Madison Avenue, New York,
NY 10021
T: 212-292-9000

Fabrics To Dye For
Two River Road, Pawcatuck, CT
06379
T: 800-322-1319
www.fabricstodyefor.com

Hancock Fabrics
2605A West Main Street, Tupelo,
MS 38801
T: 662-844-7368
www.hancockfabrics.com

On Board Fabrics
Route 27, P.O. Box 14
Edgecomb, ME 04556
T: 207-882-7536
www.onboardfabrics.com

Salsa Fabrics
3100 Holly Avenue, Silver Springs,
NV 89429
T: 800-758-3819
www.salsafabrics.com

Modern Furniture

B & B Italia USA
150 East 58th Street, New York,
NY 10155
T: 800-872-1697
www.bebitalia.it

Design Within Reach
455 Jackson Street, San Francisco,
CA 94111
T: 800-944-2233
www.dwr.com

Full Upright Position
T: 800-431-5134
www.fup.com

MOMA Design Store
44 West 53rd Street, New York,
NY 10022
T: 800-447-6662
www.momastore.org

Workbench
Flagship location:
470 Park Avenue South, New
York, NY 10016
T: 800-380-2370
www.workbenchfurniture.com

Paints

Janovic
1150 Third Avenue, New York, NY
10021
T: 800-772-4381
www.janovic.com

**Ralph Lauren Paint
Collection**
At Ralph Lauren
867 Madison Avenue, New York,
NY 10021
T: 212-606-2100

Benjamin Moore Paints
Product Information Center:
51 Chestnut Ridge Road,
Montvale, NJ 07645
T: 800-334-0400
www.benjaminmoore.com

**Martha Stewart Paint
Collection**
At Kmart
T: 888-627-8429
www.bluelight.com

Secondhand and Antiques

Ruby Beets Antiques
Poxybogue Road, Bridgehampton,
NY 11932
T: 516-537-2802

Victor DiPaola Antiques
Long Island, NY
T: 516-488-5868
www.dipaolaantiques.com

English Country Antiques
Snake Hollow Road,
Bridgehampton, NY 11932
T: 516-537-0606

Tri-State Antique Center
47 West Pike, Canonsburg, PA
15317
T: 724-745-9116
tristateantiques.com

**Up The Creek's
American Antique Furniture
Market**
120 South Tower, Centralia, WA
98531
T: 360-330-0427
www.amerantfurn.com

A listing of over 40,000
addresses of Antiques Shops
throughout the country exists at
www.curioscape.com.

Flea Markets

Brimfield Antique Show
Route 20
Brimfield, MA 01010
T: 413-245-3436
www.brimfieldshow.com

For listings of flea markets held
throughout the country, go to
www.fleamarketguide.com.

PURE STYLE GARDEN

UK SUPPLIERS

Containers

The Chelsea Gardener
125 Sydney Street, London
SW3 6NR
T: +44 (0)20 7352 5656
www.chelseagardener.com

Clifton Nurseries
5a Clifton Villas, London W9 2PH
T: +44 (0)20 7289 6851
www.clifton.co.uk

Fencing, trellis and gates

Buckingham Nursery
57 Tingewick Road, Buckingham
MK18 4AE, www.hedging.co.uk

Clifton Nurseries
5a Clifton Villas, London W9 2PH
www.clifton.co.uk

English Hurdle
www.hurdle.co.uk

Hard surfaces

Dorset Reclamation
www.dorsetrec.u-net.com

Fired Earth
www.firedearth.co.uk

Adrian Hall
The Garden Centre, Feltham Hill
Road, Feltham, Middlesex
TW13 7NA
T: +44 (0)20 8890 1778

Habibi
1c, Greyhound Road, London
NW10 5QH
T: +44 (0)20 8960 9203
www.habibi.co.uk

Outside eating

Leisuredeck Ltd
www.leisuredeck.co.uk

Debenhams
www.debenhams.co.uk

The Dining Room Shop
62–64 White Hart Lane
T: +44 (0)20 8878 1020

Divertimenti
www.divertimenti.co.uk

Graham & Green,
4 & 10 Elgin Crescent, London
W11 2JA
+44 (0)20 7727 4594
www.grahamandgreen.co.uk

David Mellor
4 Sloane Square, London
SW1W 8EE
T:+44 (0)20 7730 4259
www.davidmellordesign.co.uk

The Pier
www.pier.co.uk

Plants and seeds

David Austin Roses
www.davidaustinroses.com

Blooms of Bressingham
Bressingham, Diss, Norfolk, IP22 2AB,
T: +44 (0)1379 688 585,
www.bloomsofbressingham.co.uk

Clifton Nurseries
5a Clifton Villas, London W9 2PH
T: +44 (0)20 7289 6851
www.clifton.co.uk

Columbia Road Flower Market,
Columbia Road, London E2 (Bethnal
Green or Old Street tube)
Market held every Sunday morning –
cheap bulbs, cut flowers and plants.

Croftway Nursery
www.croftway.co.uk

Future Foods
www.futurefoods.co.uk

Grooms
www.grooms-flowers.co.uk

Halls Nursery
www.hallsofheddon.co.uk

Hexham Herbs
www.chesterswalledgarden.co.uk

Langley Boxwood Nursery
www.boxwood.co.uk

Parkers Dutch Bulbs
www.jparkers.co.uk

Reads Nursery
www.readsnursery.co.uk

Cottage Garden Roses
www.cottagegardenroses.com

Sandeman Seeds
www.sandemanseeds.com

Scotts Nurseries
Merriott, Somerset TA16 5PL
T: +44 (0)1460 72306

Simpson's Seeds
www.simpsonsseeds.co.uk

Thompson & Morgan
www.thompson-morgan.com

Sheds and greenhouses

Garden Chic
www.gardenchic.co.uk

Greenhouses Direct
www.greenhousesdirect.co.uk

Homebase
www.homebase.co.uk

Langhale Gardens
www.langhalegardens.co.uk

Soil and manure

Banks Horticultural Products
Angel Court, Dairy Yard, High Street,
Market Harborough, Leicestershire
LE16 7NL
T: +44 (0)1858 464346

Fairfield Turf
Fairfield Court, Brookland, Romney
Marsh,
Kent TN29 9RX
T:+44 (0)1797 344731

The Organic Gardening Catalogue,
www.organiccatalog.com

Tools and other accessories

Alitag Plant Labels
131 Bourne Lane, Much Hadham,
Hertfordshire SG10 6ER
T:+44 (0)1279 842685

The Essentials Company,
www.essentialscompany.co.uk

The Garden Trading Company,
www.gardentrading.co.uk

The General Trading Company
2–6 Symons Street
London SW3 2GT
T:+44 (0)20 7730 0411
www.general-trading.co.uk

Gone Gardening
www.gonegardening.com

Haws Watering Cans
www.haws.co.uk

The Hevingham Collection
www.hevingham.co.uk

Hortus Ornamenti,
www.hortus-ornamenti.co.uk

Labour and Wait,
www.labourandwait.co.uk

Manufactum,
www.manufactum.co.uk

Windrush Mill Catalogue
House 2 Rivers Est, Witney, Oxford,
Oxon, OX8 6BA
T: +44 (0)1993 770500

US SUPPLIERS

Fabrics

Calico Corners
203 Gale Lane, Kennett Square, PA
19348
T: 800-213-6366
Visit www.calicocorners.com for
details of your nearest store.

Laura Ashley Home Store
171 East Ridgewood Avenue,
Ridgewood, NJ 07450
T: 201-670-0686
Visit www.lauraashley.com for details
of your nearest store.

Hancock Fabrics
Call 877-Fabrics (877-322-7427) or
visit www.hancockfabrics.com for
details of your nearest store.

On Board Fabrics
Route 27, PO, Box 14, Edgecomb, ME
04556
T: 207-882-7536
www.onboardfabrics.com

Ralph Lauren Home Collection
Call 888-475-7674 or visit
www.rlhome.polo.com for details of
your nearest store.

Rose Brand Textile Fabrics
75 Ninth Avenue, New York, NY
10011
T: 800-223-1624
www.rosebrand.com

Rue de France
78 Thames Street, Newport, RI
02840
T: 401-846-3636
www.ruedefrance.com

Martha Stewart Signature
Visit www.marthastewart.com for
details of your nearest stockist

Furniture and accessories

Anthropologie
Call 800-309-2500 or visit
www.anthropologie.com for details
of your nearest store.

Brown Jordan Co.
Visit www.brownjordanfurniture.com
for details of a retailer near you.

Williamsburg Marketplace catalog
www.williamsburgmarketplace.com

Crate and Barrel
650 Madison Avenue, New York, NY
10022
T: 212-308-0011
Visit www.crateandbarrel.com for
details of your nearest store.

Fishs Eddy
889 Broadway, New York, NY 10011
T: 212-420-9020
Call 1-877-347-4733 or visit
www.fishseddy.com for their other
two store locations.

Gardener's Eden
Westport Village Square, 185 Main
Street,
Westport, CT 06880
T: 203-341-0855
Call 800-822-1214 or visit
www.gardenerseden.com for details
of your nearest store.

Hold Everything
Call 800-421-2285 or visit
www.holdeverything.com for details
of your nearest store.

Home Depot
Call 800-553-3199 or visit
www.homedepot.com for details of
your nearest store.

Ikea
Visit www.ikea-usa.com for details of
your nearest store.

Barbara Israel
21 East 79th Street, New York, NY
10021
T: 212-744-6281
www.bi-gardenantiques.com

Palecek
Call 800-274-7730 for details of a
retailer near you.
www.palecek.com

Pier 1 Imports
Call 800-245-4595 or visit
www.pier1.com for details of your
nearest store.

Pottery Barn
Call 888-779-5176 or visit
www.potterybarn.com for details of
your nearest store.

Smith and Hawken
Call 800-940-1170 or visit
www.smith-hawken.com for details
of your nearest store.

Plants, seeds, and bulbs
*Many of the sources listed below offer
plant or seed catalogs. Call for details.*

Blue Meadow Farm
184 Meadow Road, Montague, MA
01351
T: 413-367-2394

Burpee Seed Company
Call 800-333-5808 or visit
www.burpee.com to order a catalog.

Cultus Bay Nursery
4000 E. Bailey Road, Clinton, WA
98236
T: 360-579-2329
www.cultusbaynursery.com

Jackson & Perkins
Call 877-322-2300 or visit
www.jacksonandperkins.com to
order a catalog.

Johnny's Selected Seeds
305 Foss Hill Road, Albion, ME 04910
T: 207-437-9294
www.johnnyseeds.com

Old House Gardens
536 Third Street, Ann Arbor, MI
48103
T: 313-995-1486
www.oldhousegardens.com

Park Seed Company, Inc.
1 Parkton Avenue, Greenwood, SC
29647
T:800-845-3369
www.parkseed.com

Renee's Garden Seeds
www.reneesgarden.com

John Scheepers
23 Tulip Drive, Bantam, CT 06750
T: 860-567-0838
www.johnscheepers.com

Select Seeds Antique Flowers
180 Stickney Hill Road, Union, CT
06076
T: 860-684-9310
www.selectseeds.com

Shady Oaks Nursery
1601 Fifth Street SE, Waseca, MN
56093
T: 507-835-5033
www.shadyoaks.com

K. Van Bourgondien and Sons
T: 800-622-9959
www.dutchbulbs.com

Wayside Gardens
1 Garden Lane, Hodges, SC 29695-
0001
T: 800-845-1124
www.waysidegardens.com

White Flower Farm
Route 63, P.O. Box 50, Litchfield, CT
06759
T: 800-503-9624
www.whiteflowerfarm.com

Winterthur Museum and Gardens
Winterthur, DE 19735
T: 800-767-0500
www.winterthur.com

Speciality paints
*While latex paint can be mixed to
nearly any color and is available in
a number of finishes at paint and
hardware stores and home centers
nationwide, the following specialty
paints are noteworthy for their soft
finishes and unique colorations.*

Ralph Lauren Paint Collection
Visit www.rlhome.polo.com for
details of your nearest retailer.

Benjamin Moore Paints
Visit www.benjaminmoore for details
of your nearest retailer.

Martha Stewart Paint Collection
Available at Kmart. Visit
www.kmart.com for full details.

Index

Acknowledgements

I want to say a huge thank you to Jacqui Small, Anne Ryland, David Peters, Sian Parkhouse, Sophie Pearse, Penny Stock, Janet Cato and everyone at RPS, who have worked like Trojans to produce *Pure Style Home & Garden.*

I am indebted to Henry Bourne, whose stunning photographs have captured the spirit of the book so perfectly.

Fiona Craig-McFeely and Alice Douglas have been superb assistants. Thanks also to Clair Wayman, Jen Gillman (our wonderfully versatile nanny), Lynda Kay and Robert Davies for his expert help in Spain.

Together with energy, humour and enthusiasm, photographer Pia Tryde has produced beautiful and descriptive images. I must also thank Nick Pope and Ian Skelton for the splendid cut-out photography.

Thanks to Tessa Brown for making up the soft furnishing projects, and to Jacqueline Pestell for illustrating them.

I would like to thank the following people for allowing us to photograph their homes for inclusion in *Pure Style Home & Garden:* Shiraz Manecksha; Ilse Crawford; James Lynch and Sian Tucker; John and Catherine Pawson, The Pawson House, London; Marie Kalt; John and Claudia Brown; Peri Wolfman and Charles Gold, Wolfman Gold & Good Co.; Mary Emmerling; Gary Wright and Sheila Teague; John and Colleen Matheson; The Manor Gardening Society; Nancy McCabe; Dean Riddle; David and Carolyn Fuest; Humphrey and Isabelle Bowden; Nick and Hermione Tudor; Vanessa de Lisle; Karl and Pia Sandeman; Lisa Bynon and Mona Nehrenberg; Timothy Leese and Robert Chance. Special thanks to my New York friend, Tricia Foley, for her help, guidance and hospitality, and to Ellen O'Neill, who very generously let me invade her Long Island home once more.

My family have been unfailingly supportive, and have put up with many months of upheaval. Big hugs for my husband Alastair, my children Tom, Georgia, and Grace, and my mother and my father.